Process in the Arts Therapies

Children's Stories in Play Therapy
Ann Cattanach
ISBN 1 85302 1 362 0

Art-Based Research
Shaun McNiff
ISBN 1 85302 620 4

Dramatherapy
Clinical Studies
Edited by Steve Mitchell
ISBN 1 85302 304 2

Art Therapy with Adolescents
Shirley Riley
Foreword by Gerald D. Oster
ISBN 1 85302 636 0

Music Therapy – Intimate Notes
Mercedes Pavlicevic
ISBN 1 85302 692 1

Researching the Arts Therapies
A Dramatherapist's Perspective
Roger Grainger
ISBN 1 85302 654 9

Music Therapy Research and Practice in Medicine
From Out of the Silence
David Aldridge
ISBN 1 85302 296 9

Clinical Applications of Music Therapy in Developmental Disability, Paediatrics and Neurology
Edited by Tony Wigram and Jos De Backer
ISBN 1 85302 734 2

Clinical Applications of Music Therapy in Psychiatry
Edited by Tony Wigram and Jos De Backer
ISBN 1 85302 733 2

Process in the Arts Therapies

Edited by Ann Cattanach

Jessica Kingsley Publishers
London and Philadelphia

First published in the United Kingdom in 1999 by
Jessica Kingsley Publishers Ltd,
116 Pentonville Road,
London N1 9JB, England
and
325 Chestnut Street,
Philadelphia PA 19106, USA.

www.jkp.com

Copyright © 1999 Jessica Kingsley Publishers

Library of Congress Cataloging in Publication Data
Process in the arts therapies / edited by Ann Cattanach.
p. cm.
Includes bibliographical references and index.
ISBN 1 85302 624 7 (hbk. : alk paper). -- ISBN 1 85302 625 5
(pbk. : alk. paper)
1. Art therapy. 2. Music therapy. 3. Dance therapy.
4. Psychodynamic psychotherapy. I. Cattanach, Ann.
RC489.A72P76 1999
98-45891
616.89'165--dc21

British Library Cataloguing in Publication Data
Process in the arts therapies
1. Arts –Therapeutic use 2. Occupational therapy
I. Cattanach, Ann
616.8'9165

ISBN 1 85302 624 7 hb
ISBN 1 85302 625 5 pb

Printed and Bound in Great Britain by
Athenaeum Press, Gateshead, Tyne and Wear

Contents

Introduction

Ann Cattanach

The arts therapies can be defined as action therapies in that they are not talking therapies, as such: instead, clients explore issues and experiences through the medium of an art form. It is this intentional use of the art form as healing process which makes the interventions therapeutic rather than simply participations in dance, music, drama, play or art, for their own sakes.

In this book, experienced clinicians and academics in the field of the arts therapies map some aspects of their therapeutic work. All the authors teach some aspects of their work on one of the arts therapy training courses at Roehampton Institute, London, which offer courses in dramatherapy, dance movement therapy, music therapy and play therapy. Research opportunities are offered up to PhD level. The authors describe ways of using each of these art forms as therapy, so that readers can explore what actually happens when a group, trainee or individual meets the therapist.

Steve Mitchell and Brenda Meldrum both explore a theatre model of dramatherapy but use different aspects of the theatre experience. Steve Mitchell uses the ritual-drama form as a basis for his theatre of self-expression and he describes how two aspects of this form – the Ritual of Transformation and the Rite of Initiation can be processed in a Dramatherapy group. The process encompasses the client finding safety in the group, acquiring theatre skills to enable satisfactory enactments to take place in the group and, finally, attention given to returning to everyday life. It is hoped that a new point of view explored and presented in the therapy could be manifested and maintained back in the everyday world.

Brenda Meldrum sees theatre as a metaphor for the therapeutic process. In the acts of auditioning, rehearsing, performing and ending, creativity is developed. Meldrum considers that both theatre and therapy processes are

concerned with creativity within boundaries, expression of feelings, exploration of process and negotiation of endings. She describes how she used the text of the play *The Skriker* by Caryl Churchill for the personal development of a group of trainee dramatherapists. Through the distance provided by the text, the group was enabled to find insights into emotional difficulties, face fears and work with potentially destructive patterns of behaviour but all the while knowing they were only 'playing'. This concept of using the distance provided by the art form is at the heart of process in all the arts therapies.

Chris Daniel describes the place where play therapy happens in her practice. For children, place and the way play materials are set out and presented are critical to finding the safe space which is a constant theme for children. The way in which some of her clients have used the space is described so the therapy is experienced in a particular place with special toys and objects to facilitate the process.

In my chapter, on co-constructing narratives with children, I describe a process of helping them in two ways. First, to story or re-story themes of their lived experience through making up imaginary tales which contain fictional characters with connections to the child's world; and, second, helping children with narratives of their lived lives, perhaps to re-story some elements for better outcomes.

Cathy Ward describes how she uses the processes of art therapy in both her personal and professional development. She emphasizes the importance for the arts therapist to be constantly creative in his or her art form, for the client cannot move forward without the flow of the therapist's developing creativity. The themes explored through art therapy are the central role of the body, the externalization of processes of change through transformation of media, the influence of race and culture on how and what a person chooses to make and the birth of meaning from these choices. Cathy describes the physical struggle between the body and the media to make some form and how that can shape the client's and therapist's sense of who they are and how they have 'made their mark'.

Kay Sobey and John Woodcock write about the training of music therapists at Roehampton Institute. It is a journey towards using music to make the relationship with the client. Perhaps one of the strengths of action therapies is the opportunity it gives to clients to be expressive and share this with the therapist. The impact of strong emotions can be stressful for the therapist, who wants to dispel difficult feelings in order to make things more

tolerable. Part of training is to learn to hold on to what the client brings and deal with the anxieties associated with not knowing the answer. The nature of non-verbal relationships is explored and is connected to those interactions in early development which may bring many intense feelings into the therapeutic space.

Sara Bannerman-Haig describes a dance movement intervention with Frank, who has severe learning difficulties. She writes about the kind of movement and dance sequences she used to build her relationship with Frank, and how he began to gain confidence in himself and start to initiate his own movement ideas. He defined his time with Sara as his own place and space where he could dance. He found a quality of experience through the actions of dancing and moving together with someone watching or participating, and has expanded the roles he can use in his life.

The final chapters examine the similarities and differences between the arts therapies at present practised in the UK, and how research can be developed in action therapies which is appropriate to the method of working with clients. Professional issues are explored in relation to the present situation, where some arts therapies are 'state registered' with the Council for Professions Supplementary to Medicine, and to the implications this has for those professions and for training in the arts therapies now and in the future.

There is a developing recognition of action therapies like arts therapies as dynamic interventions with a wide variety of people who are experiencing difficulties. The arts therapists emphasize the healthy aspects of their clients' lives. Their clients are people who would like to explore issues through action methods rather than talking therapies. Arts therapies offer such a space and place for restructuring lives, helping people gain some personal autonomy and, above all, finding creative solutions through artistic endeavour.

Reflections on Dramatherapy as Initiation through Ritual Theatre

Steve Mitchell

The aim of therapy is the development of a sense of soul, the middle ground of psychic realities, and the method of therapy is the cultivation of imagination.

(Hillman 1983, p.12)

It has always been the prime function of mythology and rite to supply the symbols that carry the human spirit forward, in counter action to those other constant fantasies that tend to tie it back. In fact, it may well be that the very high incidence of neuroticism among ourselves follows from the decline among us of such effective spiritual aid. We remain fixated to the unexorcised images of our infancy, and hence disinclined to the necessary passages of our adulthood.

(Campbell 1949, p.11)

I see the work I'm doing as different from modes of therapy that attempt to fix people up so they can function better. Although that may come as a result of the work people do in my groups, it is not the main focus of my work. My process is to join with people in their attempts to discover the moreness of their own being. By confronting and exorcising the demons of self-negation and helplessness, people become better able to enter into the yes of their own unique being in all its potentialities.

(Rebillot and Kay 1979, p.68)

A whole new psychiatric approach opens up possessing great aetiological and therapeutic potential, if one but adopts van Gennep's view of the mode of the progression which characterizes the human life-cycle. Then, emotional disturbance and social maladjustment may be seen as arising directly from individual failure to meet one's archetypal destiny, to link the sacred with the profane, and pass from one stage of the life-cycle to the next – in other words, from a failure of initiation.

(Stevens 1982, p.152)

Introduction

In this chapter I want to reflect on some of the ideas behind the ritual theatre form The Theatre of Self-Expression. I gave a brief résumé of each of the approaches and some of the structures a client, whom I call the animateur, becomes engaged with in my essay published in *The Journal of The British Association for Dramatherapists* (Spring 1998). Here I will flesh out some of the philosophical and theoretical sources which frame this particular approach to dramatherapy and illustrate the work with clinical vignettes.

I will suggest that following a process of healing and change in the dramatherapy studio, if this is to be carried-over into life, a process of initiation may be required. Anthony Stevens, a Jungian analyst (1982), states that the psyche is reluctant to move towards maturation partly because of fear, and he argues for the return of initiation rites to help the archetypal process contained in human development take place. I will begin with the anthropological studies of Van Gennep and Turner to demonstrate how ritual process operates, before exploring James Hillman's notion that 'gods' of the interior guide our destiny. To explore the substance of the ritual-drama of dramatherapy I will focus on the mythologist Joseph Campbell, who argues that the 'images of our infancy' are kept in place by a mythical figure at the entrance to 'a region of supernatural wonder' and this has to be overcome if healing is to take place. I will also look to the work of Paul Rebillot, who, by translating in his workshops Campbell's notion of the hero's adventure, turns it into a form of therapeutic initiation. I will close with clinical reflections which consider some of the conundrums the dramatherapist may meet when working in-depth with this ritual theatre form.

Ritual process

What is a ritual? According to Van Gennep (1909), a ritual is a passage of consciousness from one particular state which becomes altered to another state. The essence of ritual is this process of 'transition' that has three specific phases: separation, transition and incorporation. Often each of these phases will include a number of ceremonies and preparatory ritual actions. Turner in *From Ritual To Theatre* states:

> The first phase of *separation* clearly demarcates sacred space and time from the profane or secular space and time. (It is more than just a matter of entering a temple – there must be in addition a rite which changes the quality of *time* also, or constructs a cultural realm which is defined as 'out of time'.) It includes symbolic behaviour – especially symbols of reversal or inversion of things, relationships and processes secular – which represents the detachment of the ritual subjects from their previous social statuses. During the intervening phase *transition*, called by van Gennep 'margin' or 'limen' (meaning 'threshold' in Latin), the ritual subjects pass through a period and area of ambiguity, a sort of social limbo which has few (though sometimes these are most crucial) of the attributes of either the preceding or subsequent profane social statuses or cultural states. The third phase, called by van Gennep, 'reaggregation' or 'incorporation' includes symbolic phenomena and actions which represent the return of the subjects to their new, relatively stable, well-defined position in the total society.
>
> *(Turner 1982, p.24)*

Perhaps the most important phase of a ritual is where the candidate is engaged in what Turner calls 'limenal phenomena'. This involves intense periods of disorientation, of psychologically letting go of what is known, when a certain form of 'flow' takes place; Rebillot calls this time 'the mysterium' (1993, p.15) – a time that is not dissimilar to dreaming, even though the candidate is fully awake. Roose-Evans takes up this analogy of a dream:

> like dreams, they continue to nourish and instruct us long afterwards. A dream has to be lived with. It is not a puzzle waiting to be solved by the intellect. It is, rather, a living reality and must be experienced.
>
> *(Roose-Evans 1994, p.3)*

The difference between ritual and ceremony

The vital difference between ritual and ceremony is that a ceremony is a planned sequence of actions, one following the other, leading to a specific end which does not allow for major emotional exploration through structures that offer 'liminal' processes of discovery. Turner (1982) states: 'Ceremony *indicates*, ritual *transforms*, and transformation occurs most radically in the ritual "pupation" of liminal seclusion – at least in life crisis rituals'. Turner continues his analysis by arguing:

> Ritual is, in its most typical cross-cultural expressions, a synchronization of many performative genres, and is often ordered by *dramatic* structure, a plot, frequently involving an act of sacrifice or self-sacrifice, which energizes and gives emotional colouring to the interdependent communicative codes which express in manifold ways the meanings inherent in dramatic *leitmotiv*. In so far as it is 'dramatic', ritual contains a distanced and generalized reduplication of the agonistic process of the social drama. Ritual, therefore, is not 'threadbare' but 'richly textured' by virtue of its varied interweaving of the productions of the mind and senses.'

(Turner 1982, p.81)

The Theatre of Self-Expression is defined as a ritual theatre form and this is specifically presented in the first activities of a group session. The members of the group participate in a simple cover ritual at both the start and end of each session. When they enter the dramatherapy studio a circle of cushions surrounds a decorative cloth and at the centre is an unlit candle. The first act of each session is to light the candle, followed by a focusing exercise where each participant closes their eyes and attends to their physical, emotional and thinking state. The candle is silently passed around the circle and then once more for the sharing of any business – holidays, apologies for absence etc. – before being returned to the centre and the agenda for the evening's activities agreed. The candle and cloth are then moved to a safe place at the side of the studio and the initial warm-up activities begin.

At the close of a session, the candle, cloth and cushions once more take their place in the centre of the studio; the group once more focuses on the candle in the centre and the group is reminded of the evening's events. The candle is passed around the group twice. When participants have the candle they can choose to share their feelings, support others in the group or remain silent and simply pass the candle on. When the candle has been round twice,

the person who has lit the candle can lead a dedication that closes with the candle being extinguished and this symbolizes the close of the session. By employing this cover ritual the culture of ceremony and ritual becomes an important container for the ensuing sessions.

The Theatre of Self-Expression has seven approaches or group tasks and in this chapter I am going to focus particularly on what I call Approach 6: Rituals of Transformation and Approach 7: Rites of Passage, as they are particularly relevant to the subject of initiation. The other Approaches 1–5, I view as offering group members the opportunity of learning the basic vocabulary of theatre tools, as well as defining what specific archetype needs attention plus the important process of building an ensemble that are pre-requisites to the dramatization of 'Rites of Passage'. For further details of how these earlier Approaches operate in groups see my essay 'The Theatre of Self-Expression: seven approaches to an interactional ritual theatre form' (1998) in *The Journal of The British Association For Dramatherapists* and for working one-to-one see my chapter 'The Ritual of Individual Dramatherapy' in *Dramatherapy: Clinical Studies* (Mitchell 1996).

In my clinical work I have found repeatedly that once the animateur has the means to devise their own rituals, they know what they need to do and to what depth. The skill of the dramatherapist is to bring the individual or the group member to this point of departure. So, what is needed to be able to make such a journey? I believe there are three essential conditions: (1) a safe place, (2) expressive tools, (3) internal resilience. In the early stages of a dramatherapy group I believe these are the first three essential goals of work, which continue to spiral back through the life of the group, allowing the animateur to deepen his or her inner work. The first five Approaches of The Theatre of Self-Expression are designed to meet these three essential conditions. But once an animateur is thus equipped, the work shifts to the Approaches I have defined as 'Approach 6: Rituals of Transformation' and 'Approach 7: Rites of Passage' (Mitchell 1998), which may use dramatic metaphors or work with projected significant figures from the client's life.

The imaginal world of James Hillman

A ritual is often associated with embracing, embodying, a religious phenomenon or as Roose-Evans defines a 'sacred ritual' in contrast to a 'profane ritual' that has a more secular intent. However, I believe that Hillman offers a solution, a middle way, where a 'secular ritual' has meaning. In his psychology, at the heart of the psyche, is the 'soul' and this is populated by

archetypal forces he refers to as 'Gods'. By manifesting and taking notice of these 'Gods' the psyche can tolerate its different dimensions. A 'secular ritual' could therefore be said not to embrace the external divine but a process to journey inward and to consciously surface the 'Gods' of the unconscious.

I find in Hillman a resonance that makes sense of the clinical material I meet in daily practice as a dramatherapist. What I particularly like is his questioning of the dogma of psychology and psychotherapy theory, in his erudite and critical analysis of this field (1972, 1975, 1983b). It yields an exciting new perspective which is particularly relevant to arts therapists. He presents an evolution of Jung's 'archetypes'. He views them as 'the deepest patterns of psychic functioning' (1975, p.xix). The archetypes reveal themselves in images. The image he states is the basic unit of the psyche and he therefore believes we live in an 'imaginal world'. He advocates a 'poetic basis of the psyche', and, in so doing, views the purpose of therapy as the means to nurture this rather than to interpret it or reduce it to theories that he believes are themselves myths, myths of the twentieth century. He prefers to celebrate the diversity of psychic reality and follows the Greek model of a polytheistic, pluralistic, structure of the unconscious instead of the European monotheistic tendency towards determinism.

In his work with archetypes, where Jung called them 'the little people' Hillman conversely sees them as 'Gods' that have the power to guide human destiny:

> By considering the personified archetypes as Gods, they become more than propensities and instinctual patterns of behaviour, more than ordering structures of the psyche, the ground of its images and vital organs of its functions. They become now recognizable as persons, each with styles of consciousness. They present themselves each as a guiding spirit (*spiritus rector*) with ethical positions, instinctual reactions, modes of thought and speech, and claims upon my feelings. These persons, by governing my complexes, govern my life.
>
> *(Hillman 1975, p.35)*

The task is to capture the archetype that reveals itself in images and to personify them in mythic dimensions. Therefore for Hillman one of the primary aims of therapy is that:

> … as a method [it] is imaginative. Its exposition must be rhetorical and poetic, its reasoning not logical, and its therapeutic aim neither social

adaptation nor personalistic individualizing but rather a work in service of restoration of the patient to imaginal realities.

<div align="right">*(Hillman 1983b, p.12)*</div>

He believes that most of our memories of childhood are not literal memories, but facts that are interwoven with fantasy as depicted by archetypal dimensions of the psyche.

> For example, memories of childhood are not quite the reminiscences of actual persons that they seem to be. This Freud discovered at a quite early date. A child's memories are always inextricably mixed with and further fabricated by fantasy images. Thus the scenes we 'remember' from childhood are personified complexes, personified wishes and dreads which we place back then, calling them Mother, and Sister, Father and Brother. These persons are less historical humans from a historical past than soul fantasies returning in human guise. We would like to take them literally, believing that they 'really happened' and that the Mother is the reminiscent image of the actual mother, because then the discomfort of psychic reality can be avoided. It is easier to bear the truth of facts than the truth of fantasies; we prefer to literalize memories. For to realize that the psyche fabricates memories means to accept the reality that experiences themselves are being made by the soul out of itself and independently of the ego's engagement in its so-called real world. It means, in short, that *personifing is going on all the time*; persons in scenes are continually being 'invented' by the soul and presented to us all in the guise of memories.

<div align="right">*(Hillman 1975, p.18)*</div>

Therefore within the therapeutic process it is important he suggests not to ask the client the usual questions of 'Why?', 'How?' or 'What?' from their personal biography is the current problem, but 'Who?' in their psychic world is presently demanding attention:

> To what god or hero must I pray or sacrifice to achieve such and such a purpose? The questions of why things are as they are, how they came about, and how to settle them find ultimate issue in revelation of the particular archetypal person at work in the events. Once we know at whose altar the question belongs, then we know better the manner of proceeding.

<div align="right">*(Hillman 1975, p.139)*</div>

In a similar way to Campbell he sees parallels with archetypes in traditional myths and by finding this parallel in the projected image of a myth or modern story, the 'who' which is trying to surface will identify itself.

The Theatre of Self-Expression offers the animateur an arena where these 'personifications of the gods' can surface and the conflicts between them be dramatized. Instead of seeking solutions where unconscious material is integrated by being made conscious, the goals of therapy become the ability to hold the tension between different psychic forces. As Landy (1993) states 'ambivalence and paradox' are primary states of the human condition. The aim of the therapy becomes a place to enable the animateur to make explicit these internal conflicts and in so doing gives the option for change. One method of surfacing the emerging archetype in this format is what I call Approach Two: The Vision where the animateur creates a *fable*.

> I asked my animateur to create a drawing on paper, while wearing a blindfold and drawing with the opposite hand she normally uses (Anna Halprin suggests that by so doing it helps move to right brain activity and fools the censor who might attempt to limit the work). As she moved the crayons across the paper, I asked her to be aware of her present feelings: to imagine a mythic landscape, a figure or creature who would go on a heroic journey, meet an adversary, find some supernatural force which might give a gift which would help overcome the trials experienced the adventure, and, once all the tests of the hero had been overcome, how the reward would be symbolized and received; finally, how such a reward would be brought back and manifest in their hero's community.
>
> After a short period of drawing with a blindfold over the eyes, I asked her to take the blindfold off and, with her usual hand, continue the picture but now begin to consciously shape it into elements of what would become her fable. The plot she came up with involved a meek Mouse, who befriended a Lion, who was attacked by a cruel Dragon-Bird, but is helped by a Snake and given a gift of three magic rings. The creation of this story was very powerful and in the writing of the fable a process of restoration took place. As she detailed the development of the characters' adventures in fiction, her own ability to face adversity also took place – she empowered herself.

In this case, the very writing of the story allowed the necessary healing to take place and there was no need to elaborate her fable through ritual-drama. The creation of the story was enough to inspire a corresponding change in

her life. Unfortunately, this happens rarely, because at this time a complication can arise to stop the animateur moving towards manifesting their hoped-for goal. The personification within the psyche that wants to emerge may be in conflict with other opposing forces whose aim is to sabotage any change and maintain the current *status quo*.

Hero monomyth

Campbell in his study of hero myths of world mythology in *The Hero with a Thousand Faces*, suggests that these myths all reveal a similar pattern:

> The standard path of the mythological adventure of the hero is a magnification of the formula represented in the rites of passage: separation–initiation–return: which might be named the nuclear unit of the monomyth. A hero ventures forth from the world of common day into a region of supernatural wonder: fabulous forces are there encountered and a decisive victory is won: the hero comes back from this mysterious adventure with the power to bestow boons on his fellow man.

> *(Campbell 1949, p.30)*

It is necessary for the hero to be equipped for his or her adventure, otherwise two contrasting outcomes are possible. The first is to overcome successfully what Campbell calls the 'Threshold Guardian'. This mythical monster appears at the very start of the journey 'at the entrance to the zone of magnified power' (1949, p.77). If the hero fails to conquer this figure all will be lost and the second outcome will take place: the hero will be caught in the 'belly of the whale': 'The hero, instead of conquering or conciliating the powers of the threshold, is swallowed into the unknown, and would appear to have died' (Campbell 1949, p.90).

One of the assessments a dramatherapist has to make before embarking on in-depth work, concerns whether there is an inner tolerance, an ability within a client's own ego boundaries to contain the stresses that a therapy can entail. A client may present keenly for therapy but find that the endeavour is too frightening and withdraw. I see this as an important moment, because the decision may pre-empt falling into the 'belly of the whale' and suggest that more work needs to be given to their hero prior to attempting to move deeper into their interior.

For the past ten years I have worked with Paul Rebillot, an American, who offers Theatre of Healing workshops that follow Campbell's ideas of the 'Hero Monomyth'. In one of his structures, participants are led on their own Hero's Journey. The work begins with creating a Hero who is supported by a Spirit Guide. In Rebillot's work the Hero represents the positive aspects of the psyche. However, there is also another aspect, the psychological equivalent to Campbell's 'Threshold Guardian', which Rebillot calls 'The Demon of Resistance':

> At one stage in the journey you construct the Demon of your own Resistance – the part of you that is continually saying 'You can't do it,' 'You're not good enough,' 'You're not smart enough.' That is the Demon who sabotages the Hero – the one with the goal. There comes a time when the Hero and the Demon have a confrontation. The actor, so to speak, goes through his/her initiation rite as both Hero and Demon of their own drama, and does so with a supporting cast to intensify the inner theatre aspect of this relationship.

> *(Rebillot 1987, p.4)*

The aim of this confrontation is, as Campbell suggested earlier, for some reconciliation between these two aspects of the psyche, rather than working against each other; in Rebillot's terms 'to find a new arrangement' where both the Hero/Demon can move forward but in an integrated manner. At this point, both in Campbell's and Rebillot's work, the new Hero moves into a place of initiation or mysterium where further trials that may psychologically reflect archaic wounds are encountered. Finally, they face the Supreme Ordeal, a fear that needs to be conquered if the Hero is to claim the reward and return safely back to the everyday world.

As part of the Return it is important for the Hero to let go of their magical powers and plan practical steps to take their 'boon' into daily life. Rebillot and Campbell believe that at this stage 'initiation' of the candidate into his or her new state is vital. For whatever has been found within their interior needs to be brought out into the world and this, like all the previous steps, can be a difficult challenge.

The need for initiation

It is not enough to simply bring new possibilities to consciousness. Anthony Stevens, a Jungian psychotherapist, believes there is a further resistance to change which is related to fear:

> Jung maintained that development could become arrested and distorted not only by events in the history of the maturing individual, but also by his fear of taking the next step along the path of individuation. Should that fear attain a high intensity, then the psychic reaction is one of recoil to an earlier stage of development at which the individual may remain fixated and without some form of social or psychotherapeutic intervention, be incapable of further maturation.
>
> *(Stevens 1982, p.148)*

To avoid this regression when the psyche is at a turning-point, the previous pattern having lost some of its power, yet what has been found is still young and tender, putting down roots, like a fledgling plant, there is a need for external support to nurture what is still fragile into fuller bloom. Anna Halprin also has found that after participants in her workshops had released affect or had a catharsis when working with core personal material, she discovered that by subsequently working with animal images, this enabled the participant to carry over the therapeutic re-structuring into personal life. Halprin (1995) cited the initiatory traditions of the Native Americans whose *shamans* would identify a 'power animal' to fortify their warriors. The warriors would then spend time in the wilderness observing the animal and imitating its behaviour. On returning to the village, costumes and masks were made and a ritual dance-drama ensued that depicted the spirit of the animal. This was done on important occasions before a major task – the dance-drama would be repeated as a ritual to prepare the psyche for a future event where courage, physical and psychological strength were required.

Initiation through Personal Theatre

In the ritual theatre sequence, the animateur, having identified his or her issues and subsequently 'exorcised' them through Rituals of Transformation, now addresses the process of initiation, a rite of passage between the private domain of the dramatherapy studio and the public domain of their everyday lives. At such a time, I return to Brook's concept of a 'holy theatre' (1968). Here the animateur creates a Personal Theatre piece that serves as Grotowski

might call a 'vehicle' (1995) for this initiation to take place. The animateur selects from the dramatic canon a character who embodies the energies (Hillman's 'Archetypal Gods') that need to be brought into their lives. During the rehearsal, the animateur works through the Stanislavsky mode employing their 'emotional memory' to draw out the archetypal energy into the persona of their character. By working with the craft of acting, the animateur will enter the 'liminal' period of this initiation rite and there meet obstacles to be overcome. By overcoming these during the rehearsal period, the animateur will, similarly to the method actor, incarnate a new personality trait that had previously not been allowed to surface. The intensity which accompanies a Personal Theatre performance before the group becomes, what Turner calls the 'reincorporation' of a ritual process. It enables in psychological terms the new psychic energy to become implanted in the synapses of the mind.

However, before the animateur can conceive of initiating anything new, there must be acceptance, acknowledgement and recognition by the group of how their current problems are afflicting them. It is as if there is a need to dramatize the life-crisis and thereby demonstrate to the group 'how it is'. The Theatre of Self-Expression enables this to take place in Approach Three: Ritual Enactment. The animateur is asked to create a Personal Theatre 'Play'. Often they choose to depict their wounds and, through dramatizing their 'agony', it becomes fully witnessed and present in the group.

> The animateur chose a scene from Hardy's *Tess of the d'Urbervilles*. The closing scene is where Tess kills the man who raped her, Alec d'Urberville, by stabbing him to death. She then spends just a few hours of happiness with Angel Clare prior to being arrested and hung for murder. For my animateur there was a sense of 'freedom' from all her moral dilemmas when she stabbed Alec. At this stage she wanted to show her personal sense of tragedy, that of having been an alcoholic, and her sense of stuckness as she struggled with the issue of daring to construe a life without an alcoholic husband. At this time she felt such shame that her present situation was a form of punishment and one that she felt she would never be free of. Like Tess, fate would arrest her, jail her and she would only be released by execution. At this stage the animateur deflected any attempt by the group to encourage her towards a different point of view. It seemed she needed the group to know her despair, and, unlike Angel, who does not forgive Tess's confession of Alec's rape on their wedding night, to accept and love her simply as she was.

This phase of dramatherapy is very difficult. The animateur may want to dwell in this place for weeks or months, testing out the group and the dramatherapist in a number of ways. Any form of constructive resolution is defended against. It is during this phase that some leave therapy or avoid moving on, by terminating the therapy and moving elsewhere, or changing from group to individual therapy; forever repeating the need for the story of pain to be heard and blaming others for their present condition, while resisting any form of responsibility and initiating personal change. As I view the whole journey of healing as similar to the phases of ritual process, I understand this 'hesitation', as Stevens refers to it, as being at the first threshold where the animateur faces Campbell's 'Threshold Guardian' which at some point their hero will need to face rather than avoid if the journey is to continue. It is at this time that the Rituals of Transformation in Character I have described take place. The animateur, having demonstrated to the group his or her intense human suffering, begins to seek a way out of the impasse and starts to work on developing a dramatic hero. This character has the strength, the resilience, and the inner capacities to take on another character who represents the 'Threshold Guardian' and, within an improvised play, the hero confronts this saboteur until a new arrangement between them can be found.

> The animateur had been stuck. She was in the middle of life, had suffered both emotional and sexual abuse and had, as a consequence, great difficulty with relationships with men. After a period when the process of therapy was going in circles, she mentioned Ibsen's *Doll's House* as a particular favourite. We began to work on the scene where Nora informs her husband Torval that she is leaving him. The scene was examined and the character of Nora created, employing the ownership of positive projections the animateur places on others in her life. The character of Torval personified the 'Demon of Resistance', the inner critic, the part of her that held her back, took her power and told her she was wrong to aspire towards her goals of being a creative artist. This was 'selfishness' and should be suppressed in the course of duty of the mother who sacrifices all for her children.
>
> The scene was improvised with the animateur playing first Nora, then Torval and then again Nora, exploring the fullness of Nora's determination, her contempt and anger towards her husband who demanded that she be his 'little bird' and at his beck and call. In personifying Nora she began to reclaim her power as a woman and

informed Torval that she would leave him and made her own demands as to what future contact between them would be. Nora exited triumphant! The animateur over a period of weeks rehearsing and playing this scene conquered her 'threshold guardian' who in her imaginal world was personified by the character traits she gave Torval.

Once the animateur has crossed this all-important threshold I find the work takes on a different character. The animateur now enters the liminal phase of healing, the mysterium, and often there is a need to work on various issues in a literal way rather than through the distance of dramatic reality. I call this phase Approach 6: Rituals of Transformations and employ the post-theatre work of Grotowski's Laboratory Theatre to give both theoretical and dramatic form to its *modus operandi.*

Para-Theatrical Activity

In essence, Para-Theatrical Activity is a process that employs theatre ideas to animate what Grotowski called 'a search for what is most essential life'. He stated that through both fear and culturalization we hide behind roles, what he calls 'armour'. This armour is necessary to maintain ourselves in everyday life. However, it can become a problem, 'like a dead skin' that limits and creates barriers between people. Para-Theatrical Activity was designed as an arena where those who wished to work towards 'disarming' could do so and celebrate their 'openness' in a creative 'meeting' with others.

The research projects developed by the Laboratory Theatre between 1970–1983 investigated a number of contrasting ways to search for this 'meeting'. Some of the workshops, that Grotowski referred to as 'work-flow meetings', had the quality of Eastern spiritual disciplines about them. For example, in the workshop of Zygmunt Molik in Acting Therapy, or Ryzard Cieslak's Theatre of Roots, Stanilaw Scierski's Workshop Meetings, participants were required to use the exacting 'Exercises Platique'. These were previously employed by the Laboratory Theatre to train the actor during their Poor Theatre period, but now they were employed over extended periods of time to search, through the body, for moments of stillness where perception was only focused on what was immediately happening. On other occasions, as in Cieslak's Special Project, arduous outdoor activities replaced the physical exercises to achieve the same aim, 'disarming'. Later workshops, including Cieslak's Labyrinth, Cynkutis's Events, Flaszen's Meditations Aloud, and Mirecka's Acting Energies,

developed a format where participants 'invited or proposed' to the group specific activities that focused on a personal issue which was experienced as a block to releasing creativity in their lives. The 'proposal' would involve actively exploring through physical actions the associations and personal images related to the particular issue. By active engagement with their interior world, the participant was in effect guided by the workshop leaders through a spontaneous ritual that followed the pattern of rites of passage previously mentioned. The aim was for the participant to liberate his or her attachment and thus be free to experience the world more directly. This 'freedom' was celebrated in an organic improvisation where Grotowski's vision of 'meeting' and 'holiday' took place. I have previously recorded a personal example of this work in 'Therapeutic Theatre: a para-theatrical model of dramatherapy' (Jennings 1992). For further accounts by other participants I recommend Kolankiewicz (1979) *On the Road to Active Culture*; this collection of personal experiences was privately published by the Laboratory Theatre.

When working with an animateur during this phase I ask the animateur how s/he wants to express themselves: what is their proposal? I ask them how they want to structure their own passage of healing. I will use my knowledge of ritual process, where necessary, to help guide and contain their work (see Mitchell 1998), but essentially it is their Ritual of Transformation.

> I was working with an animateur, who was rationally defended and particularly found expressing anger difficult; he was quiet and reserved. Whenever he got near to expressing himself he became asthmatic and lost his power. However, in his Ritual of Transformation in Character he found the power and resources to recognize this ploy of his saboteur by moving his body and drawing from his 'body-memory' the capacity to be in his feelings and to express his anger. As he moved into the phase of 'The Mysterium', tests to his new found power emerged and at times overwhelmed him again. Then, on one occasion when he was beginning to explore his anger towards his partner, he became agitated, breathing began to be difficult; his power was ebbing away into psychopathology. I asked him what he wanted to do. 'Sleep', was his answer. I said he could do that if he wished but would that be helpful. 'How can I change this?' What do you feel you need to do? 'Move'. So move. He got up and began to move round the room. I noticed he was putting his feet down heavily and suggested he developed the action and see where it went. He did; little by little he began to stomp around the floor. He wanted to make

more noise. He got up on to a wooden desk and stamped loudly; the rest of the group stamped on the floor. I accompanied him with a drum. I encouraged sound. He took this up and led the group in a vocal chant that had his character shouting at someone. This continued for some time... Then he stopped, the group was quiet... He was still above us... sweating... full of power... he simply looked at us all with a strength that defied interruption.... After a few moments he told us he was coming down from the desk above us. The group welcomed him back and we all sat in a circle silently until he broke the silence and said in a clear resonant voice that he had never ever been allowed to make a noise as a child and that the activity had reversed for him many injunctions he had lived by. The choice not to be quiet and 'good', had rendered him feeling invisible, but he now felt he could move towards being more visible by making sure he had his say and not suffocating his wish to participate in events.

On occasions I have found that a Ritual of Transformation may be composed of elements that have a correspondence to activities that might take place in the experimental therapies, such as a focus on a particular psychological issue. This issue is creatively worked through by ventilating in movement or through devising structures that release affect. For example, one person chose to throw and break glass bottles into a skip outside to release feelings towards a parental figure. Other rituals have had a more cerebral character and have employed projective work, separating out different aspects of the self, or using writing, active painting or creating sculptures out of materials, chairs, tables or whatever is at hand represent feelings and a changed point of view. On other occasions the rituals devised by an animateur have a very close resemblance to the 'experiences' of Para-Theatrical Activity.

I had been working with an animateur for over two years. She had had a very damaged childhood and both self-mutilated and had periods of bulimia with a presention that included horrific flashbacks that hinted towards ritual satanic sexual abuse. She had been in the psychiatric services for years, and many attempts to help her through counselling, occupational therapy or psychodynamic psychotherapy had failed.

During the first two years we built up the therapeutic alliance by engaging with dramatizing many stories. Slowly it emerged that any form of expression of anger was banished, not simply suppressed, but repressed. The thought of even dramatizing this anger terrified her. At the same time the hero within her wanted to change this but every time

she dared in a session to contemplate this area she froze. The source of her fear was concern that the 'truth' might emerge, and it was 'better to have suspicions rather than to know' was the message from her saboteur. At this stage I was clinically concerned about continuing in this direction even though she was at the time persistent.

While we were confronting this dilemma she took a week off in the Lake District and, to her surprise, enjoyed herself and presented with a greater resilience in her psychological sense of Self. I asked her how she had spent her holiday. 'Playing in woods and streams'. As she told me what she had been up to there was both an embarrassment about sharing her simple playful activities as well as a vital enthusiasm about them. I encouraged her to follow this path instead of focusing on psycho-pathology and her habitual 'patient' role. A series of enterprises was planned in sessions that she did as homework during the week, going out to the moors, the woods, the mountains and playing with the elements.

As the weeks passed her strength gained ground, there were of course set-backs as her saboteur began to lose power and wanted to maintain its position, but as she worked in nature, she developed inner capacities that sustained her momentum to change and resist the seductive power of her resistance. She successfully employed working in the outdoors as her Ritual of Transformation without moving into her 'mysterium' that was too painful a place for her. But through adapting Para-Theatrical Activ-ities in a manner that was appropriate to her needs, her psychopathology waned and life became tolerable to the point where twice weekly therapy was reduced, and, little by little, she weaned herself off the need to meet with me. I was replaced by nature after four years' work.

Clinical considerations

I want to conclude this chapter with some of the practical concerns for a dramatherapist when engaged with helping the animateur both design and perform a Ritual of Transformation or Rite of Initiation. When the animateur proposes such a task, the dramatherapist may use their theatre and therapy resources to help collaborate in its construction. But the animateur must make the final decisions. At times this might confound the therapist's internal map of what 'should' happen. I believe it is important for the therapist to put their 'knowledge' of procedure aside and trust that the animateur knows their interior better than any sophisticated models of therapy the dramatherapist may wish to follow. For example, an animateur devised a

ceremony rather than a ritual as a Rite of Passage. I chose simply to let her do this, even though I was aware that the process banished any emotional exploration. But it was right for her at that time and signalled that she may not have been ready to open up particular painful areas of her life.

The ritual's animateurs devise will reflect the three primary conditions of safety/expressive tools/resilience. It may be that the therapist's feelings are accurate and that for defensive reasons the expression of certain feelings are avoided. But this may be because the client cannot tolerate these emotions or the images which might be uncovered if they expressed them. It is a sign that, at that point in therapy, their own resilience, in psychological terms of containment, might be overwhelmed and throw them into emotional chaos.

When working in-depth, much of the work, the ritual process, is coming to terms with loss. Often in loss there is denial or defences which surface to protect the client from experiencing the pain of losing someone and the pain of losing a projected part of the Self; the path to healing is coming to terms with the issues that are being suppressed. Therapy can, from one perspective, be viewed as a grief process, a process of transition, identifying and experiencing the pain of a lost state, idea, person, childhood etc. Therapeutic process is concerned with identifying the energy behind certain defences, working-out and releasing the pent-up feelings – that may have been blocked at a younger age and need to be released in a childish manner – and then initiating new potentialities into life. The essence of designing a Ritual of Transformation is for the animateur to separate out what issue of loss needs to be addressed, to work with that issue and to express all the contradictory feelings that might be associated with it. This becomes the transitional (liminal) phase of the ritual, and to reach a point where it is possible to say 'goodbye' to those aspirations, projections, people etc. or, if it is uncompleted, mark the work and acknowledge unfinished business; or the fact that the animateur is not willing to 'goodbye'. Finally, there is the need to cross a threshold with a new state of awareness, where the witnesses acknowledge the work that has taken place and the animateur makes plans to make concrete changes in their life (incorporation). For the details of creating the ritual structure see Mitchell (1998) in which I detail some of the important stages of this form of Ritual of Transformation.

A note on The Ordeal

Sometimes it can be very useful to the animateur, when structuring a *Ritual of Transformation*, to include a process I call *The Ordeal*. This is an activity which

will involve the animateur in an effort, for example a physical task, or the risk of something at an emotional level, so that by participating in the structure it demands full 'here and now' absorption of their attention. It is often at this time that the liminal phase of the ritual is truly experienced and new powers are found.

> For example, an animateur, in a group in which I had been identifying 'shoulds' to do with touch and sexuality, had been trying to free herself from their insidious power, as part of the 'tests' section in her ritual structure. At one stage she had said they 'suffocated her' and she wanted to 'break away from them'. To help her experience these suffocating images and to nurture the release from them, she agreed to incorporate into the crossing of the threshold the following Ordeal: she lay face down on the floor and witnesses who were substituting the negative messages, came one by one and lay across her torso. When they were on top of her she employed all her physical energy to throw the message off – the substitute representing the message had to try and stay on. One by one, she conquered each 'message' until she stood upright in the space and created a spontaneous victory dance celebrating her right to be a sexual woman. Prior to the ordeal she had addressed each of the messages, expressed various feelings towards them, but it was the Ordeal that moved the energy, because she chose to engage fully with her feelings and to use her power of physical strength to enter fully her Hero and overcome what had been previously oppressing her.

Facilitating the performance of a 'Ritual of Transformation'

What I mean when using the term 'performance' needs clarification. Turner sees the difference between the aim of '*poiesis*, rather than *mimesis*: making not faking'. He states:

> I find it useful, because I like to think of ritual essentially as performance, enactment, not primarily as rules or rubrics. The rules 'frame' the ritual process, but the ritual process transcends its frame. A river needs banks or it will be a dangerous flood, but banks without a river epitomize aridity. The term 'performance' is, of course, derived from old English *parfournir*, literally 'to furnish completely or thoroughly'. To perform is thus to bring something about, to consummate something, or to *carry out* a play, order, or project. But in the 'carrying out', I hold, something new is generated. The performance transforms itself. True, as I said, the rules may 'frame' the performance, but the 'flow' of action and interaction

within that frame may conduce to hitherto unprecedented insights and even generate new symbols and meanings, which may be incorporated into subsequent performances. For there is undoubtable transformative capacity in a well-performed ritual, implying an ingress of power into the initial situation; and 'performing well' implies the co-involvement of the majority of its performers in a self-transcending flow of ritual events.

(Turner 1982, pp.79–80)

Another view of ritual 'performance' comes from Rebillot, who stated in his *Theatre of Healing Workshop: Rituals of Transformation* (Roehampton 1994) that it is important for the participant to be present to the process of the rite and not act the part, but allow the structure to surprise, and for genuine responses, feelings and emotions to inhabit the moment by moment pathway through the ritual structure. I am also reminded of Cieslak's pronouncements on participating in Para-Theatrical Activities. He said, 'It is easy to act, far more courageous to respond' (Labyrinth Workshop – Frankfurt 1984). It also recalls Brook's instructions to his actors when preparing Shakespeare's *A Midsummer Night's Dream* when he informed the company not to *act* their parts but to re-discover the play with the audience, by attending to the energy of the moment, rather than offering something previously tried and tested. Therefore the 'initiate' in the ritual is encouraged to be spontaneous and, as in an 'organic improvisation' in Para-Theatrical Activity, be present and allow the material contents of the present moment to be channelled into the ritual process. This then acts as the vehicle of the transformative powers of a Ritual of Transformation.

During the 'performance' of a ritual, the task of the dramatherapist is to facilitate the animateur in meeting their needs, as outlined either when designing their ritual or at the start of the ritual process. It is important that the therapist is clear what the task is, what the contract is between the animateur and the facilitator in relation to the objective of the ritual, for this understanding will inform in what way the dramatherapist functions during the ritual performance.

The usual functions of a facilitator identified by Rebillot (Masterclass 1992) are: (1) To observe: in what way can the dramatherapist augment the experience of the client by feeding back to them what they see? The client may be saying one thing, whereas their body language may suggest something else. (2) To reflect: the dramatherapist can usefully mirror for the animateur their attitudes, their language (see Language transformations),

their energy and check out if this is what they mean or wish to express. (3) To support: the dramatherapist can be accepting and empathic but must be careful not to smother or rescue, or do the work for the animateur. The animateur needs to find the resources from within to move – if it always comes from the outside, the animateur will be dependent on others rather than taking their own independent power and responsibility. (4) To guide: the animateur needs to find their way. At the same time, the dramatherapist may suggest some experiment or inspire the animateur to stay engaged with the energy and both encourage, or intensify the action, to help the animateur deepen their participation in the process. (5) To clarify: the dramatherapist needs to be clear what is going on so the ritual keeps on track and does not get blown off course. He needs to help the animateur understand their progress - even if this means acknowledging not knowing. (6) To frustrate defences: this depends upon the contract between the dramatherapist and the animateur: a balance needs to be struck between respecting the anima- teur's personal obstacles and facilitating an engagement with the issues being explored. If an animateur is seeking to change their psychological point of view, this will mean re-organizing their defence system as part of the process of transformation.

RESISTANCE TO CHANGE

As has been demonstrated it is natural for the hero approaching a difficult task to meet the Demon of Resistance. The Demon represents another aspect of the psyche, whose job is to stop the Hero aspect at all costs, thereby protecting the vulnerable parts of the psyche from re-experiencing archaic pain. Therefore, during the 'performance' of a ritual, it is likely that resistance will emerge in the guise of this saboteur. Does the dramatherapist 'collude' with this or use techniques to push their client through the resistance? Here is where danger lies for both the therapist and animateur. Who is to say that the therapist's perception of 'resistance' is correct? If the therapist accepts the 'resistance', are they colluding with the psychopathology? If they are pro-active and encourage the animateur to 'work through the resistance' are they in danger of pushing the animateur into areas which will overwhelm them? This is the conundrum of meeting resistance.

I am guided by Rebillot:

> Often, therapists operate from a fixed idea of what is right for their clients. The therapist is convinced that s/he knows better than the client what is right for her; the right way to behave, the right decisions for her

to make, and so forth. S/he then provokes the client to do these things. A therapist who takes it for granted that s/he knows better than the client, and then acts on this certainty without informing the client of what s/he is going to do, is treating the client as a child, incapable of making decisions or taking responsibility. This is not the way I like to work. To me, the main job of the therapist is to continually and gently turn back the responsibility into the hands of the client, help people discover the things they are doing to make themselves unhappy, and then remind them, or help them to discover by themselves, what options they have to make their lives work more effectively. Of course, this requires that people be able to experience their feelings. This is important to any kind of therapy. A person who doesn't feel anything has desensitized themselves and therefore will have no taste for life. So I encourage the people I work with to contact their feelings. I might even need to provoke them sometimes. However, I would never do so without their agreement. In my workshops, whenever I do stress-type exercises that might provoke hidden feelings, an explanation of the intent of the exercise is always given. People can choose not to do the exercise before it begins or they can drop out of it if it becomes too frightening. This gives the responsibility and the power into the hands of the people who are working. And that's the issue! It's the question of where the power is. If the power is in the hands of the therapist who then provokes the client in order to prove a theory, that is abusive: even if the client benefits in some way from it, it creates dependency. The client comes as a supplicant, looking for help or clarification. This necessarily thrusts the therapist into a position of power. If the therapist feels weak or lacks confidence in his or her abilities, s/he can make use of his position in order to feel powerful. In theory, it may be that the client would feel better doing what the therapist wants. However, in actuality the expression of anger, for example, could open a door that the client is not ready to open; this could be harmful. The first law of medicine is this: 'whatever you do should cause no harm'.

(Rebillot 1996, p.2)

The resolution of this conundrum, therefore, is to help the animateur clarify their intent and to respect their point of view. However, one of the ways to aid their clarification and ability to take responsibility is to experiment with the transformation of language. Language is connected with the way we conceptualize; culture is connected to language, as is our habit of thinking.

By suggesting the animateur experiments with their language this may lead to the owning of feelings and the taking of responsibility rather than the blaming of others – whether it be significant people in their lives, institutions or primary family figures. The following transformations of language can be useful:

1. Make 'I' statements.

2. 'I can't' becomes 'I won't'. The first is the place of the victim, the door is closed, the latter takes responsibility.

3. Change 'but' to 'and' – 'but' can be an undermining statement.

4. 'I should' or 'have to' to 'I choose'.

5. 'I feel guilty' to 'I resent'. Guilt is anger turned away from an outside object back to oneself – turn it round by identifying the other.

The other forms of frustrating the defence system is to remind the animateur of all their resources. For example, the aspect that sabotages will be only one aspect of the psyche – see Roth's 'Ego Character's' (1989) or Hillman's (1975) archetypal 'Gods'. The resistance may have an archaic root in an emotionally 'younger self' who is not as strong as the 'adult self'. The adult self may be able to tolerate what the younger self was unable to; there may also be other internal characters who can help. For example, there is an aspect of the psyche I call the Wise Person (Hillman calls this aspect 'The Watcher' see Hillman and Ventura 1992), a part that is neither 'hero' nor 'demon', and may be able to offer a constructive *visionary* alternative. This Wise Person may also offer some 'instrument of power' to help the hero when the going gets tough. It may also be that during the action of a ritual, particularly during a delicate process of transformation, the psyche becomes particularly identified with the persona of resistance. 'Put a child in a prison and first they will get angry, then they become resigned. So, many people have to go through that level of resignation before reconnecting with the rage and then the energy.' (Rebillot 1988, Owning the Shadow). At such times the therapist may attempt to help the client 'reverse their retroflection'.

Retroflection is a term from Gestalt Therapy that Rebillot defines as :

Holding back is a very natural process that is called retroflection in gestalt theory. It is a very simple survival process that allows us to hold back something that wants to come out. Retroflection is a problem when it has become habitual, for example, when the desire to reach out is continually held back. At first the holding back is a conscious decision

acted out in the body. The body is a magnificent equilibrating machine; it constantly attempts to do what the mind asks it to do. The body takes over the job. Energy that desires to release itself and is held back in the system too long becomes poisonous. When the retroflected desire to reach out is held back too long, it becomes self-critical and self-destructive.

(Rebillot 1993, pp.93–94)

It may therefore be necessary to structure an activity which frustrates the defence of 'retroflection' and works to express this energy outwards rather than holding on to it and feeling for example, guilty, when guilt is resentment towards someone, turned against the self and felt as depression.

When we begin to work with retroflected energy, we may also begin to work with what Jung called the shadow, those parts of us that we disown, because they do not fit in with our Ego Ideal and Self-image. When these feelings begin to emerge they can surface at the age that the psyche repressed them:

If we provide an opportunity to give the disowned parts expression... Not only are the unacknowledged parts coming out of denial at the age they were put there, they are coming out angry at not having been allowed expression for so long. So not only are they going to make us feel a little childish and clumsy, there's probably rage locked in to the system too. Part of the nature of owning our shadows is giving that rage a chance to release so that the pure energy that exists beyond it – even though it's childish in some ways – can return at a certain level of its own purity.

(Rebillot 1988, p.2)

If you are facilitating a structure where you are encouraging your animateur to release retroflected energy, it is important, as Rebillot states, to be clear what you 'intend' to do, then the animateur can agree to it or choose not to participate in the experiment.

These are some of the techniques the dramatherapist can use to frustrate the part of the psyche which wants to hold on to the negative *status quo*. But the golden rule is, if the animateur chooses to say 'no' or 'stop', then it is vital that the dramatherapist acknowledges this and does not try to inspire, push, confront, challenge such a defence. It is equally important not to be critical towards the animateur for choosing to hold back, otherwise the therapist is

punishing the animateur for not doing the work the therapist would like them to do.

Conclusion

When I began this chapter there was an awareness of wanting to bring together a number of different ideas that had surfaced while teaching the Theatre of Self-Expression at The Institute of Dramatherapy at Roehampton. What I did not predict was the extent that I would deepen my own understanding of working with archetypes, ritual process and myth.

The essence of my thesis is that the animateur first needs a process where they can feel safe with the group and therapist as well as with the dramatic tools the group uses. This will involve learning theatre skills, identifying their parallel dramatic story, and the client demonstrating to the group, through the ritual enactment of their chosen scene, how wounded their lives are and the wish to have this acknowledged by the group and dramatherapist. Any attempt at reconstruction or working through issues until this has taken place may be met by resistance. By enacting their 'play' the animateur shows their painful burden. Only then can the animateur begin the third stage of healing, to ritually dramatize the confrontation between their own resistance, with a hero character which faces their own internal saboteur. Fourth, as a resolution to the hero/saboteur confrontation, the animateur can move deeper into their psychic world, here identifying issues which have to be addressed and worked through. Finally, comes the process of initiation, where attention is given to returning to everyday life, manifesting and maintaining a new point of view in the everyday world. Here the animateur incarnates a positive figure through the act of theatre to draw out healthy archetypal forces within themselves.

I hope my own learning can be shared by the reader and that new avenues and possibilities, connections and contrasting ideas will surface in your mind. I tell students before graduation from The Institute of Dramatherapy at Roehampton that I hope the training has offered a meaningful education. This can take place in two paradoxical ways. First, because what has been taught has inspired them because it makes sense and will stimulate further exploration. Second, their response to what has been taught has inspired disagreement and a contrasting perspective has been identified. My hope is that the reader has a similarly productive meeting with the ideas set out in this chapter and that the possibilities of 'initiation through ritual theatre' will inspire your next step.

References

Brook, P. (1968) *The Empty Space.* London: Macgibbon and Kee.

Campbell, J. (1949) *The Hero with a Thousand Faces.* London: Paladin Grafton Books.

Grotowski, J. (1995) 'From the theatre company to art as vehicle.' In T. Richards (ed) *At Work with Grotowski on Physical Actions.* London: Routledge.

Halprin, A. (1995) 'Five decades of transformational dance.' In R. Kaplan (ed) *Moving Toward Life.* London: Wesleyan University Press.

Hillman, J. (1972) *The Myth of Analysis: Three Essays in Archetypal Psychology.* Cranston, IL: Northwestern University Press.

Hillman, J. (1975) *Re-Visioning Psychology.* New York: Harper Perennial.

Hillman, J. (1983a) *Inter Views.* Woodstock, CT: Spring Publications.

Hillman, J. (1983b) *Archetypal Psychology: A Brief Account.* Woodstock, CT: Spring Publications.

Hillman, J. and Ventura, M. (1992) *We've Had a Hundred Years of Psychotherapy and the World's Getting Worse.* San Francisco: Harper Collins.

Kaplan, R. (ed) (1995) *Anna Halprin: Moving Towards Life.* New England, Hanover: Wesley University Press.

Kolankiewicz, L. (1979) *On the Road to Active Culture* (trans. Taborski). Wroclaw: Laboratory Theatre.

Kumiega, J. (1987) *The Theatre of Grotowski.* London: Methuen.

Landy, R. (1993) *Persona and Performance: The Meaning of Role in Dramatherapy, and Everyday Life.* London: Jessica Kingsley Publishers.

Mitchell, S. (1992) 'Therapeutic Theatre: a para-theatrical model of dramatherapy.' In S. Jennings (ed) *Dramatherapy Theory and Practice 2.* London: Routledge.

Mitchell, S. (1996) 'The ritual of individual dramatherapy.' In *Dramatherapy: Clinical Studies.* London: Jessica Kingsley Publishers.

Mitchell, S. (1998) 'The Theatre of Self-Expression: Seven approaches to an interactional ritual theatre form.' *The Journal of the British Association for Dramatherapists 20,* 1.

Rebillot, P. (1987) 'Walking the path of the hero.' In *Human Potential.* London: Charles Associates.

Rebillot, P. (1988) *Newsletter.* San Francisco, CA: Rebillot.

Rebillot, P. (1993) *The Call to Adventure: Bringing the Hero's Journey to Daily Life.* San Francisco, CA: Harper.

Rebillot, P. (1996) *Newsletter.* San Francisco, CA: Rebillot.

Rebillot, P. and Kay, M. (1979) 'A trilogy of transformation.' *Pilgrimage 17,* 1, p.68.

Roose-Evans, J. (1994) *Passages of the Soul: Rediscovering the Importance of Rituals in Everyday Life.* Shaftesbury: Element.

Roth, G. (1989) *Maps to Ecstasy: Teachings of an Urban Shaman.* San Rafael, CA: New World Library.

Stevens, A. (1982) *Archetype: A Natural History of the Self.* London: Routledge.

Turner, V. (1982) *From Ritual to Theatre: The Human Seriousness of Play.* New York: PAJ Publications.

Van Gennep, A. (1909) *The Rites of Passage.* London: Routledge.

The Theatre Process in Dramatherapy

Brenda Meldrum

Introduction

Working as a performer and a director and latterly as founder of The Prompt Corner Youth Theatre in South East London, convinced me of the power of theatre to transform the individual, both in the transitory sense of taking a 'part' in the play for the duration of the production, but also profoundly, through building an identity where positive and negative aspects of the self are rehearsed, shared and tolerated within a social group.

Theatre is both creative and structured; the actor is given permission to show anger, sadness, joy and love through roles and characters and above all to play with others in a social group motivated by the same sense of purpose, within the structure of the text and the theatre process of audition, rehearsal, performance and ending. Theatre is a metaphor of the therapeutic process which too concerns itself with creativity within boundaries, expression of feelings, exploration of process and negotiation of endings.

In my theatre work I was deeply influenced in particular by the work of Peter Brook (1987) on whom I tried to model myself as an empathic director. Peter Brook's work is a-theoretical – it is a method of practice which enables the actor use the dark and light of his own personality in the construction of character through rehearsal.

The theory of Stanislavski (1993), on the other hand, is a 'system', guiding the actor into role through exercises whose intention is to find the motivations of each character within the context of the narrative.

I found Brecht's (1964) 'alienation' theory of dramatic distance particularly helpful. My psychology training in role theory and my interest in the constructions, the images, the masks and the personae of identity fitted in well with Brecht's demands that actors do not try to *become* the characters in the play, but that they help the audience recognize that it is watching real people playing parts.

Boal's Theatre of the Oppressed (1992) reminds us that we are both actors and spectators – thus *spectactors*; were we simply observers of the play, we would have no power to alter our conditions of oppression.

Brook, Stanislavski, Brecht and Boal use play and exercises to help actors find themselves in the characters; each of these directors invites the individual to explore the self through the masks she plays in her different roles and to allow herself to be vulnerable and open to change. Above all, she is invited to explore layers of identity in the company of others.

Our sense of self comes from interaction with others. Theatre and dramatherapy are both group processes and since most human problems arise within the setting of a social group (which is mirrored in the unfolding drama on the stage), it follows that such problems may be solved in a group setting. The drama is embedded in conflict, searching for resolution and is a proper metaphor for the therapeutic group. We need to find shared meanings to enable us to forge co-operative processes so that human hostilities, aggression and violence towards the self and others can be explored and reduced (Slavson 1959). Group pressure can sanction, prohibit, control, accept and reject; groups are powerful and they need empathic direction.

In different kinds of therapeutic group, be they analytic, family therapy, Rogerian, encounter or focus we are encouraged to explore the group process through dialogue. However, playing a group member is only one role within a portfolio of possibilities; the person is a child of parents (for sure), a family person (however we define families); one is likely to be a friend, a work colleague, and to play a role as a member of a range of other groups. While many of our conflicts, anxieties and joyful memories arise within the family setting, the concept that in the talking therapeutic group we act out our family dynamics, is an interesting idea but open to investigation. 'Group work can reach parts that other modes of therapeutic work may not. It creates an atmosphere that is conducive to getting in touch with relevant feelings and issues and sharing them in a group of peers' (Dwivedi, 1993, p.10).

Humans are creatures of *action*; emotions and feelings are expressed in behaviour as well as in dialogue; we have an *active* relationship with family

and other individuals and it is from our *behaviour* that others imply our personalities and our states of mind. Dramatherapy as a therapeutic group activity uses action and behaviour, as well as dialogue, in the drama forms. The theatre model of dramatherapy, however, uses the theatre process itself as the therapeutic medium, giving the group the opportunity to play out conflict, misery and joy within the framework of the text of the piece.

In this chapter, I shall be using, as a case study, analysis of a dramatherapy group whose work was based on a particular text: Caryl Churchill's *The Skriker* (1994).

I shall briefly discuss the theatre model of dramatherapy; I will talk about the setting up of the group and the process of exploration through text, but, for ethical reasons, I shall not at any time talk about the process of individuals within the group.

I shall be discussing the *themes* which arose through working on the text during the period of the group, such as the importance of play, the group dynamics, the meaning of chaos, transformation, madness and the management of endings.

Issues will be explored, such as the composition of groups, the choice of text, the structuring of sessions and the setting of boundaries, using the character as individuals and as a group, voice work and the balance between 'sharing' and talking and expression through movement, sound and scenes from the playtext.

The theatre model of dramatherapy

The theatre, unlike film or television, is a direct experience where people encounter each other in a special place at a given time. Actors and audience are united in a joint experience; the actors take different roles in the narrative of the play, while the audience suspend their disbelief and accept that they are watching a make believe story in an imaginary time. A theatre model of dramatherapy therefore has the following ingredients: a set space, an agreed period of time, and a common goal (Meldrum 1994).

In the theatre, the audience and the actors are separate; however, in the dramatherapy group actors and audience are *spectactors*, in Boal's terms. The group members are both players and witnesses while the therapist is in the role of facilitative director, helping the group members do what he or she needs to do to find the character and play the part in interaction with the other members. The therapist helps the group members take responsibility for themselves through the theatrical metaphors within the narrative, using

the text as a boundary. The core of the theatre model is that the contract with the group and the running of the sessions is akin to the structure of a theatrical production. The sessions are similar to rehearsals where the structure is designed to allow the members to use their physicality and to develop the characters' motivations, while exploring their emotional and intellectual lives within the context of the text.

The theatre model of dramatherapy uses the concept of *aesthetic* or *dramatic distance*. The exploration of motivations, emotions and conflict through a character in a play, paradoxically gives the person a greater freedom to examine their own issues within the drama.

In the dramatherapy session, we invite the client to enter dramatic reality, a strange place where she can transform herself; we encourage clients to release their feelings, insights and emotions in the drama and we invite them to look at these thoughts and feelings in a distanced way as, returning to everyday reality, they reflect upon their responses while they were engaged in the drama. The client may then choose to change and transform their concepts and emotions and these changes create the opportunity to transform her own life and environment.

Using a Brechtian model of aesthetic distance is formally to acknowledge that the actor is still an actor on the stage performing a character within a story to an audience. By contrast, in Stanislavski's method or system, the actor digs deep into their emotional memory to play the character in as true and honest a role as possible to bring the reality of the part to the audience. While Brecht recognized that the actor must be true to the character, he taught that it is not the actor's task to fool the audience into believing that he *is* the character he is playing; on the contrary, he must make the audience aware that he is an actor playing the part of the character, albeit in as truthful a way as he can. Dramatherapy, like theatre, takes place both within 'real' time and 'dramatic' time and in a 'real' place and in a theatrical space.

Thus, a theatre model of dramatherapy makes a special contract with the group to work using text; within the dramatic distance of theatre, the group members explore their own motivations and feelings through the characters, using the theories of Boal, Brecht and Stanislavski.

Themes for dramatherapy within the text of *The Skriker*

I chose the text of *The Skriker* as a suitable vehicle for a dramatherapy group after I had seen a production in the Cottesloe Theatre in the spring of 1994. The drama held several themes which I thought would make powerful issues

for exploration within a group context, using the text and work on the characters within the theatre model of dramatherapy as powerful boundaries for the work. The following are some of the powerful themes within the drama which I thought would be useful to explore.

1. The ambiguity of the central character

I chose this play as an appropriate text for dramatherapy because it concerns a deeply ambiguous figure who is a mixture of mythical creature (embedded in English culture, versed in ancient tales), who is able to change forms and gender to suit its purpose. Thus, because the protagonist of the drama has no definition in terms of male/female it is a good vehicle for a mixed group; myths, parables and ancient stories are the meat and drink of the dramatherapy group and the ambiguous nature of the Skriker makes it an ideal container of projections.

Churchill calls the Skriker a shapeshifter and death portent, ancient and damaged: a creature from a sort of underworld peopled by Bogles, Kelpies and Brownies. It is hundreds of years old – older than history and timeless. The Skriker wants to take revenge on the world for being hated and for being forgotten. It is one of many spirits whose environment is being destroyed and worse still, who are no longer believed in. Its underworld is filled with strange sprites, more strange and mischievous than dire and devilish. This is not a world of mechanical monsters, but of ancient fairies. The underworld is a place of outward magic and glamour, masking foetid rot and decay.

The environment of the world is damaged and as a consequence, the Skriker speaks an obscure language – a damaged language (Cousin 1996). She articulates in a speech full of alliteration and association and despite its apparent chaos, the language is lyrical. She starts a sentence and a word sparks off another meaning, followed by another, followed by a word with a similar sound, so that while the original idea is not lost it is sometimes masked in chaos.

The Skriker seeks as her/his revenge figure a good young woman with a child. S/he goes into the world searching out the most vulnerable; her/his weapons are seduction, magic and guile and if s/he manages to entice a young woman to love her/him through various guises then s/he can possess her/him and the child.

The play begins with the Skriker addressing the audience:

Heard her boast beast a roast beef eater, daughter could spin span spick and spun the lowest form of wheat straw into gold, raw into roar, golden lion and lyonesse under the sea, dungeonesse under the castle for bad mad sad adders and takers away. Never marry a king size well beloved.

The Skriker spins tales and the first tale she uses as a metaphor for her revenge is the English folk tale, *Tom Tit Tot*, better known as The Brothers' Grimm: *Tale of Rumplestiltskin*. In the tale of Rumplestiltskin, the mother boasts (to the Skriker) that her daughter can spin wheat straw into gold; the king marries the daughter, 'never marry a king size well beloved' says the Skriker. Here the Skriker warns the girl never to marry a king, which leads her thoughts to a king-size bed, which leads to a quotation from *The Song of Solomon*. The king imprisons the daughter in a room packed with straw and demands that she turn it into gold. As she: 'weeps, seeps deeps her pretty puffy cream cake hole in the heart operation' along comes 'a little blackjack thingalingo with a long long tale awinding. Mayday she cries'. The girl weeps so much that her pretty face with its creamy complexion becomes all puffy like a cream cake, with open mouth (cake-hole) which makes the Skriker associate with a hole in the heart operation. The girl cries: 'Mayday', the international code for 'Help!', and the Skriker helps her spin the wheat into gold. The girl must guess its name, or the Skriker will take her away.

The play is the story of the Skriker's pursuit of Josie and Lily.

2. *The exploration of chaos and reality*

Chaos is a potent theme in all therapeutic work. People come to therapy often because their thoughts and feelings are in a chaotic state and it is sometimes hard for the therapist to help clients sort through their confusion. There is a danger of the therapist being drawn into the whirlpool of the client's emotions and becoming engulfed. Dramatherapy, within the boundary set by the text, can allow the group members to enter the chaos, the underworld, and explore this dangerous space and emerge wiser from the experience. In the group process the individual is in the company of others and it is the task of the facilitator to assist the group enter the chaos and emerge into reality.

3. *The theme of madness*

The theme of madness/badness is a potent mixture, a confusion, which worries society. During their training, dramatherapists (like other arts

therapies trainees) are required to go on clinical placements. I remember well in my training doing a placement in a forensic psychiatry unit and, for the first time, working with people who were labelled both 'mad' and 'bad'. There is a fear of madness in society and the therapists who work with people with mental health problems will be touched by such fears, so working on them in a dramatherapy group might, I surmised be helpful.

4. The use of character

The central character of the Skriker itself with its 'shapeshifting' nature and its ability to take on different seductive roles in pursuit of the two young women is a powerful figure for group work. The group members can take on the different aspects of the figure of the Skriker to form an image of the Skriker itself. The Image Theatre of Boal lends itself to this exploration of group work.

Josie is 'imprisoned' in a mental hospital after killing her baby; visiting her is Lily her friend who is pregnant. The Skriker assumes different shapes and roles in order to entice first Josie, then Lily to love it. The Skriker takes the shapes of damaged and needy people, such as a destitute street woman, who asks for a hug and a kiss and a lonely child who seeks a cuddle. The Skriker knows these shapes will encourage a reciprocity of response from the two vulnerable and lonely young women. The 'mad' (psychotic?) 'unkind' Josie recognizes the evil designs of the Skriker, but the 'good, kind' Lily tries to prevent the Skriker from doing harm by sacrificing herself and is finally lost. The two girls are, perhaps, two aspects of the same person, a powerful theme for dramatherapy.

The motivations of the characters of Josie and Lily can be explored in the sessions using Stanislavski's system and Brecht's 'alienation' technique.

The setting up of the group

Why and how was the group set up?

In September 1994 I decided to set aside time to work with the same group of people, as far as is possible, over a long period (two years), using play texts as part of a theatre model of dramatherapy. The impetus came from the dramatherapy training organisations' requirement that trainees should be in long-term group dramatherapy. The group was advertised in the British Association for Dramatherapist's *Newsletter,* at the training colleges and in the *Guardian* newspaper. I interviewed ten people (eight women and two men)

and selected eight: seven women and one man. To each person I explained the nature of the group, the therapeutic process and the contract.

In the event, the group was a mixture of trainee dramatherapists and people who were not in training, but who were interested in dramatherapy, or in the theatre. There was an initial contract of six sessions during which members had sufficient time to assess whether they wished to make a longer-term commitment.

The duration of the group

The group met for six two-hour sessions between November and December 1994.

The aims of the group

The aims of the group were general: 'Personal development within the group process, using theatre and drama structures with the intention of personal exploration and potential change and transformation.'

At the first session, members were asked to write and/or draw their personal expectations for the group, which they developed into a group expectation, and in the final session, members revisited these structures; however, these were very general.

If I were to repeat the process now, I would suggest that members set both general and specific targets for themselves individually and for the group, which we could revisit in terms of outcome at the end of the six sessions. My experience since 1994 is that setting targets and examining outcomes can be an integral part of the therapeutic process because individuals and groups can then more clearly visualise and examine personal change and development within the group.

The structure of the sessions

The sessions began and ended with simple rituals. Before the group members arrived, I set out a circle of cushions; if a member were absent, the cushion remained as a reminder of the person. In the opening circle I placed an egg-shaped carving made of seasoned and oiled wood which was a pleasure to hold. When a person wished to speak she or he picked up the egg and while s/he was speaking, she was not interrupted. The egg was returned to the centre of the circle. Members spoke about whatever was in their minds that they wanted to share with the group.

At the end of the session, we returned to the circle; a scented candle in a wooden holder was passed around the circle twice. If a member wished to say anything s/he retained the candle while speaking, then passed it on. Members spoke of their feelings and reactions to the work.

After the opening ritual and in the tradition of the theatre, rehearsal begins with preparing the body through movement, followed by a game which addresses the theme of the session, developing into an aspect of the text, de-roling and into the ending ritual.

The themes from *The Skriker* and their use within the sessions

1. The ambiguity of the central character and the exploration of chaos

In Caryl Churchill's play, the Skriker emerges into the 'real' world accompanied by ancient spirits: a *Bogy* – an object of terror, a creature called *Rawheadandbloodybones* – a monster who terrifies children, a *Bogle* – a phantom causing fright, a *Kelpie* – a Lowland Scottish fabled spirit, who usually appears in the shape of a horse and is reputed to haunt lakes and rivers and to take delight in the drowning of travellers, a *Changeling* – a substitute fairy child, a *Brownie* – a benevolent goblin who does household work when the family sleeps, the *Spriggan* – a grotesquely ugly creature, ten feet tall, *Johnny Squarefoot* – a giant riding on a piglike man, throwing stones and *The Passerby* – a person who, bewitched by fairy music, never stops dancing. In the drama, these spirits watch the unfolding story, silently dancing their own unfathomable narrative, as the conflicts between the Skriker, Jose and Lily are played out.

The structure I am about to describe took place in the second session. The group had contracted to work on the text of *The Skriker*, within the boundaries of the theatre model of dramatherapy over a period of six weekly sessions with the aim of exploring potential change and transformation within the group process. As facilitator, I was concerned that the group addressed these objectives early in this short-term contract. The Skriker as a character embodies transformation; s/he comes from an underworld peopled by goblins – frightening manifestations of the human psyche – many of whom are defined by their function which is or was to frighten children. If in such a short space of time as six weeks, we were to engage in the difficult process of self-examination and change, we should grasp the nettle and go in at the deep end! Actors (a profession renowned for the vulnerability of its members) often rehearse a production such as this for six to eight weeks

without benefit of supervision or therapy. Furthermore, in short-term group dramatherapy, it is, I believe, important that the group process starts early in the contract; actors in the theatre have a prescribed rehearsal time before performance to internalize their roles and form an ensemble within the context of the narrative and text. The contract for the session was to work on the Skriker and the Chaos of her Underworld.

I planned the session around finding a group image of the character of the Skriker as a gestalt of the goblins found in the underworld. Our Skriker was to be made up of all the ancient fairies and hobgoblins in the group; this gestalt allows the Skriker to transform her/himself. We established an area of the room as the 'stage', then, with pieces of fabric, props and furniture, the group built the underworld. Each person then chose the character of a goblin whose name was written on a card, with a description of its function: such as

The Changeling: a person especially a child put in exchange for another.
A waverer; a turncoat; a substitute and hence a fairy child; a half-wit.

We used as text an excerpt of the Skriker's opening speech, part of which I have quoted above.

We found the physicality in the words, speaking in unison moving to the *meaning* each member placed on the words. This exercise gives the words a dynamic quality which cannot be found if one sits around and simply 'talks' the lines, tussling and worrying at the meaning of the piece of text as a whole. Then each person took a phrase which she or he felt represented her/his character and memorised it, suiting her/his actions to the role s/he had chosen as s/he rehearsed the lines.

In preparation for entering the underworld, each group member chose a talisman for the journey from a jar of shells, marbles and dried flowers. My instructions were that the talisman represented the real self, which the member will return to after entering the underworld. Each small article is a metaphor – a representation of the self. (It transpired that each member of the group kept the small article in their pockets or in their purses to bring to the group at every session.)

In the role of their goblin characters, the members journeyed to the underworld through music and the movement of their bodies. In the space they had constructed as the underworld they became a group image – a gestalt of hobgoblins – of *The Skriker* itself. Through voice and image they welcomed the Skriker. And then, holding the talisman, they left the space of

the underworld, dismantled the stage and returned to themselves, into the 'real' space.

I have a sense, as I write, that these descriptions seem unreal and fantastic, and perhaps, in this 'cool' age – *precious*. I can only say, as a person trained as an empirical psychologist, that working with drama can transform shells into talismans, fabric into the underworld and pieces of seemingly incomprehensible text into meaning.

This was indeed a very important session. Members entered the underworld as their characters and emerged with real insights, for example, the Changeling was transformed and childlike; the Brownie allowed itself to play; Rawheadandbloodybones kept its head close to the floor and was in touch with its restricted self; the Passerby who never stops dancing felt how isolating it is when you never stop to communicate with others, and so on. Entering the underworld was a powerful experience and highlighted the importance of making sure that the set is cleared and the members, like actors, adequately de-role. Even so, the experience of going into the underworld remained with the group and brought to the surface a sharing of a fear of madness, one of the major themes in the play.

2. The theme of madness

The theory behind the Image Theatre of Augusto Boal suggests that:

1. nothing needs to be the way it is

2. that we can change our circumstances; that we *can* change ourselves

3. that we can change, not by 'magicing' ourselves out of our oppressed situation, but – on the contrary – by seeing it the way it is

4. when we see things the way they are, we can identify what it is that is making us unhappy and we can then *act* to help ourselves

5. that people who work with words are more powerful than people without words – but *everyone* can work with images.

Madness is a powerful theme in the text and the first scene between the two young women takes place in Josie's room in a mental hospital, where she was living after killing her own baby. Her friend Lily, pregnant herself, comes to visit her. Madness was also a powerful theme for the group who, after going into the underworld in the drama, shared experiences of madness in family and in their work. Members expressed fears that the psychoses were in some way inherited; they felt regret and guilt that in the past they may have been

impatient and brusque in response to a family member suffering from acute depression and they wondered whether they would be able to cope with the distress of working clinically with clients with mental health problems.

It was important to address the theme in a careful way through scaffolding the approach to the work. Boal's Image Theatre, which builds from an individual's personal image of madness into a group image and then into the characters within the text, seemed the best approach.

The text chosen was the scene in the mental hospital (1994, pp.5–10). While the scene progresses, the Kelpie, as part of the Skriker, haunts the scene, listening to the young women's conversation. Lily wants to look after Josie, so that they are together when her baby is born. She tells Josie she's going to run away to London. In reply, Josie says: 'I won't hurt your baby' and then proceeds to tell Lily about this old, old person whom at first she thought was a patient and now she knows is not. This old woman wants her to wish the baby back, but Josie won't because she senses the old woman will make the baby 'horrible'.[1]

As soon as Lily leaves, the Skriker in the form of a dowdy old patient bursts in: 'I heard that', she says. 'You don't want me' – and she begs Josie to keep her. Josie tries to persuade the Skriker to go to Lily instead; she says: 'She's stronger; she's more fun. I'm ill and you're ill'. To bribe the sick young woman, the Skriker offers to grant her a wish, which at first Josie wisely refuses. And then, because the old woman is so persistent and Josie wants to get rid of her she wishes: 'I wish you would have her instead of me'. The Skriker turns away. 'Wait', says Josie, 'I don't mind you any more'. The Skriker turns and looks with indifference at Josie: 'No, I'm not after you'. And as she leaves, Josie, realising that she has lost something that she finds both fascinating and repellent, calls after her: 'You won't hurt her? What do you want from her?'

Through Josie's wish, both young women are now in the power of the damaged Skriker. We built the scaffolding of the theme by adapting some of Boal's (1992) Image Theatre games, through the chair image game, the image circle, image pairs and ending in a group images of madness. We adapted Boal's oppression scale to make a madness scale. In this game, we had a scale of 1 (almost catatonic) to 10 (absolutely manic), with 5 the mid-point of

1 Like a Changeling. Ancient Fairies used to capture a human child and put a fairy child in its place. This is a powerful myth which recurs throughout British and Irish literature.

'normal' mental health. The group members move around the room and the leader calls '5'. Everyone walks around 'normally'; then the leader calls another number, say, '3'; everyone moves according to her own interpretation of the level of acute depression '3' on the scale might represent; the leader then calls '5' and so the game progresses, with members moving from depression, and back to normal, to euphoria and back to normal. It is very important always to return to the mid-point when playing this game.

In this way, the group expressed their perceptions of madness and sanity in their bodies. Then one person made her own image of madness which was added on to by another member until finally a group image of madness was constructed. In slow motion, over a count of three, we broke the image up.

My notes say: 'I was very struck by the fear and terror and distraught nature of their images. The group has a real fear of madness'. To break the spell, as it were, we made a very close circle to give each other support, before going to the text.

I had already divided the scene into Stanislavski-style 'units' of subject and meaning (Stanislavski 1993). For each unit, I invited two readers to take the roles of Lily and Josie respectively and the other group members to choose (internally) which of the three characters in the scene to play: the Skriker, Lily or Josie. As two members read the dialogue, the rest of the group made images of what they perceived to be happening, silently and in character. The image makers then presented the readers with a group image of each piece of text.

It was very powerful work and the group members expressed that each felt very emotional throughout the process. Through the images, the movement and the text, they had come into contact with the 'madness' in themselves. It was interesting that both from listening to the reading and watching the images, I, as the observer, could see no distinctions between the characters as far as their 'madness' was concerned; that is to say that the image of Lily did not stand out.

But there was a tangible reduction in the fear and tension manifested at the start of the work which the group attributed to facing their terrors and working with their fears through the action and the text. They found it very helpful that in Image Theatre there is no need to explain or interpret the image.

3. Getting into character

(A) STANISLAVSKI'S 'SYSTEM'

The actor takes on a role contained in the narrative of the story. The emotional life and the motivations of the character are explored in the text and the actor, through the processes of rehearsal brings her or his own self to the emotional life of the role. In dramatherapy we work with the client's motivations, desires and goals. We think about their unconscious processes, which in drama we call the *sub-texts* and we consider the client's character and emotional life.

Stanislavski (1993) said: 'Action is the base of emotion'. In his rehearsal 'system', Stanislavski uses three major processes: preparation, character and text. As Director, he insisted that the body should be prepared for the work of finding the character through working on the text. He asked his acting group to take the text and to break it down into units of meaning which can be worked on separately by the characters, who rehearse different motivations, using the written words but also through improvisation.

In the next session, we took the same text of the scene in the mental hospital with the aim of using the roles of Josie, Lily and the Skriker actively to explore motivations, sub-texts, emotions and character. The group members, by bringing themselves to the roles and through dramatic distance, encountered their own emotional lives.

After a physical warm-up, based on comparing activity with no purpose and activity in order to achieve an end, the group was invited to relax the body and to make an imaginary image of the outside of the mental hospital where Josie was staying. They were asked to imagine themselves as invisible, looking at the building from far off and gradually walking towards it. They were to perceive the environment – the time of day, the temperature, the driveway, the gardens until they reached the doorway. They pictured the door, and turning the handle, they walked into the lobby and imagined how it was – the reception desk, busy people in uniform, others waiting. They then walked upstairs, along corridors until they reached Josie's room. They opened the door and looked at her, imaging what she was wearing, what she was doing: they put her in position. Then, as though they were spirits entering Josie's body, they physicalized their images, performing the actions that they saw her doing in their minds' eye.

As they rehearsed Josie's movements, the group thought about what was going on in Josie's mind: what did she want; what specific thing did she want at that moment. The want gets stronger and stronger as she keeps on doing

the same things; at last she had what she wanted; and then the group was told that it was all a mirage: what she had so desired had been taken away. Through this exercise the group used their bodies, rehearsing the same movements over and over again, and yet were able to access a powerful desire within the character. No one was asked what it was that 'their' Josie desired.

The second exercise concerned Lily. Lily is pregnant and she's coming to see Josie in the mental hospital; as Lily the group started walking and finding the physicality of the pregnant Lily. As they walked they were asked to choose an incident from Lily's past. As Lily, they sat and thought about this incident; I tapped each person on the shoulder, one by one. Each person then went into a stream of consciousness as Lily.

Returning to the 'units' of text, I divided the group into three smaller groups ($2 \times 2 \times 3$ – one member was absent). Each group were given two units of text; their task was to decide who should play Lily, and who Josie, to read it aloud, to make a set within the room, to decide on a title of the unit and to improvise the small part of the scene, using their own words to tell what is on their minds at that moment.

After the improvisation, they returned to the texts. The characters decided on an immediate objective and played the unit with these objectives in mind. The objective was specific and linked with physical action.

For example, at the start of the scene, Josie says: 'I've a pain in my shoulder. I never used to have that did I? It's one of the things they give me here'. Lily says: 'I don't remember'. [Pause] 'Shall I rub it?' The actor playing Josie chooses an immediate objective of getting Lily to massage her shoulder and with her right arm across her body, she rubs her left shoulder, leaning towards Lily, rocking slightly, her tone of voice breathy and soft. The actor playing Lily chooses her immediate objective: to get out of the room as soon as she can because seeing Josie makes her terribly anxious. So, she sees Josie's need to be touched as a threat, hence the denial of any memory of Josie's ailments and the pause before she (reluctantly) asks: 'Shall I rub it'. When Josie leans towards her, she moves her body back.

Now, if the actor had decided that Lily's immediate objective was to persuade Josie to get better and come and live with her in London, because she knew she would be lonely, then her actions would have been different: she might have got up and started massaging Josie's shoulder, and the scene would have a very different meaning.

The group was invited to take their characters, to focus on what she wanted and to play the scenes in the units with those objectives in mind. There should be no intellectualizing, just energy. Acting is about the energy between people within the context of the space and the text. Each group showed their work to the other two groups, broke the sets, de-roled by physically jumping up and down and reflected on the work.

Thus, entering the characters of Lily and Josie through the imagination and movement, using Stanislavski's system was a powerful process. When we take on characters and roles, we use ourselves and if we play with full energy, we are using the role to explore ourselves. The group found that characters can have different motivations, yet they can use the same words. The emotional impact of a need dictates our actions; this reminds us that when we are playing a role in our 'real' lives, we sometimes repeat the same pattern of responses. And yet, even when we say the same words, we can alter the dynamic of interactions by changing our motivations.

(B) BRECHTIAN ALIENATION

This was the sixth and final session.

Central to Brecht's ideas concerning change is the concept of *Verfremdung* – often mistranslated as 'distancing' or 'alienation'. In fact *Verfremdung* means the making of familiar objects or ideas into something strange: making 'something ordinary, familiar, immediately accessible into something peculiar, striking and unexpected' (Roose Evans 1984, p.143).

Brecht argues that theatre, by presenting what is familiar in a different, transformed way, can provoke the spectator to change from a passive acceptance of what is happening to her or to him into a state of suspicious enquiry. Hence, the 'Alienation-Effect', which turns something familiar into something unexpected. In the dramatherapy session, using Brechtian distance, we make a formal acknowledgement that the group members are still the clients performing characters within a story in front of witnesses.

Like Stanislavski, Brecht had a system of exercises for rehearsal and like Stanislavski, he believed that actors must prepare their bodies for the work. So in our last session of working on *The Skriker*, the group worked on the end of the play, using techniques of Brechtian distance.

In the previous scene, Lily was visiting the Skriker, as an old woman apparently dying in hospital. Lily is so bewitched that she fools herself that doing what the spirit wants will stop the damaged Skriker doing more harm. She makes arrangements to leave her baby in the 'real world' and begs the

Skriker 'Even if it's a nightmare. I'll be back the same second. I'll make you safe. Take me with you'. The Skriker has won: immediately she leaps out of bed into her real self, full of power and energy. She says: 'Lily, my heartthrobber baron, my solo flighty, now I've some blood in my all in veins, now I've some light in my lifeline nightline nightlight a candle to light you to bedlam, here comes a…'. And she lights a candle and gives it to Lily to light her way into the underworld. But the Skriker has tricked her. Lily hoped to save the world from the demonic actions of the Skriker by giving it what it wanted – herself – and when she returns to the real world she has become a spirit who meets an old woman who is her granddaughter. The old woman holds the hand of a damaged girl who 'bellows wordless rage at Lily' (p.52). The Skriker says: 'Lily had bit off more than she could choose and she was dustbin'. And yet, the old woman, Lily's granddaughter offers her some food, which Lily is taking as the play ends and the Passerby stops dancing.

Clearly, it was important to use some powerful distancing mechanisms for the group to protect themselves from this apocalyptic vision and a Brechtian model seemed to be the best way. The members chose a card giving each person a character: the Passerby who never stops dancing, the old woman, the damaged child, Lily, a Reporter who gives the stage directions and the Skriker.

The group warmed up in pairs taking turns to be active and passive. We played the 'yes' game where a member suggests an action, for example, 'hide under the table', and everyone shouts 'yes' and obeys. And then we played with the text.

The group went through the text as though it were a rehearsed reading. In their characters, they rehearsed the scene by going into character and 'acting' the text and then coming out of character and immediately commenting on the action. The Reporter described what each character was doing. And then they played the scene to me as the Leader/Director and witness of the drama.

The session ended with each person holding a lighted candle in a ceremony to say farewell to *The Skriker*. The members said goodbye to the Skriker (and to the group) with each person saying what they would like to retain of *The Skriker* and what they would give up. Some found that they no longer feared going mad themselves, others felt that exploring the chameleon-like quality of the Skriker had helped them find insights into the destructive roles they played and others welcomed the opportunity to play different roles. All said that they had worked with their fears and to some extent, through working with this particular text, had overcome them.

The fact that the group ended so positively was due to the power of the drama and the commitment of group members to the work.

Conclusion

The model underlying the theatre process within dramatherapy is to use dramatic distance as the therapeutic medium. Dramatherapy, using the theatre model, can productively adapt the theories of Brook, Stanislavski and Brecht to explore even very difficult texts like Caryl Churchill's *The Skriker* to help the group find insights into emotional difficulties, face fears and work with potentially destructive patterns of behaviour.

This chapter has sketched the progress of a short-term focused group over only six sessions. The text formed a boundary for the exploration of difficult themes and the character work gave the individual the opportunity to play with extreme emotions in the knowledge that we were *only* playing. This text allowed the group to enter a chaotic underworld and emerge with dignity. Because the sessions were bounded by an opening and closing ritual, members allowed themselves the opportunity to work with the drama wholeheartedly. As the leader of this group I can only wonder at the creativity and the hard work of each of the members who embraced the challenges and found a resolution.

We ended our work together with an adaptation of an ancient poem from an anonymous Medieval Irish writer:

> I arise today
> Through the strength of the heavens:
> Light of sun,
> Radiance of moon,
> Splendour of fire
> Speed of lightning,
> Swiftness of wind
> Depth of sea,
> Stability of earth,
> Firmness of rock
> And the power of drama.

References

Boal, A. (1992) *Games for Actors and Non-Actors*. Trans. A. Jackson. London: Routledge.

Brecht, B. (1964) *Brecht on Theatre: The Development of an Aesthetic*. Edited and Trans. J. Willett. London: Methuen.

Brook, P. (1987) *The Shifting Point*. London: Methuen.

Churchill, C. (1994) *The Skriker*. London: Nick Hern Books.

Cousin, G. (1996) *Women in Dramatic Place and Time: Contemporary Female Characters on Stage*. London: Routledge.

Dwivedi, C.N. (1993) *Group Work with Children and Adolescents: A Handbook*. London: Jessica Kingsley Publishers.

Hargreaves, D.H. (1972) *Interpersonal Relations and Identity*. London: Routledge.

Meldrum, B. (1994) 'A role model of dramatherapy and its application with individuals and groups'. In S. Jennings *et al. The Handbook of Dramatherapy*. London: Routledge.

Roose-Evans, J. (1984) *Experimental Theatre*. London, Routledge.

Slavson, S.R. (1959) *The Era of Group Psychotherapy*. In M. Schiffer (ed) (1979) *Dynamics of Group Psychotherapy*. New York: Jason Aronson, pp.47–72.

Stanislavski, C. (1993) *An Actor Prepares*. Reading: Methuen.

The World within the Playroom

Chris Daniel

The playroom is a blank canvas ready for a child to create and communicate, to bring the place alive with their imagination as a means of exploring their fears, wishes and desires. Sharing their story in some way as a means of experimenting and reframing their experiences. They are not alone but have a guide who can be trusted, who accepts and believes and will endeavour to understand their struggles. A guide who speaks many languages, who is familiar with the terrain and the obstacles. Someone who will share the struggle, be alongside and go on ahead to prepare the way. Always maintaining safety and staying when the journey is painful.

The background

The essential elements of play therapy are the presence of a therapist and a safe space. The toys and equipment provided by the therapist are merely tools to aid communication; a child will find a way to play out their story regardless of the accoutrements presented. Nevertheless it is important that the therapist endeavours to provide a varied and balanced range of toys and equipment and to prepare the room for therapeutic play. Such a room may be solely used for play therapy, it may have other shared uses or it might be an accessible venue which the therapist transforms by creating a play space.

It was Margaret Lowenfeld who in 1925 set out to find a natural means of communication through which children could communicate their difficulties and problems. It was through her observations of children's play that she developed the World Technique. She recognized the symbolic significance of children's creations using various small objects to make a 'world' in the sand. Apparently it was the children themselves who adopted the use of this

term. The model of play therapy that Lowenfeld developed was to allow children free reign of a number of rooms designated for play. They were accompanied by a therapist who was randomly allocated on each visit. The emphasis for Lowenfeld was the child's relationship with the room and the objects rather than the therapist.

Virginia Axline was writing about non-directive sessions in the 1940s. She used a playroom but also recognized the significance of the relationship with the therapist. Her illuminating account of play therapy sessions with a six-year-old boy was published in 1964 *Dibs in Search of Self,* a source of inspiration to many aspiring therapists. It illustrates the impact of the provision of regular sessions in a playroom equipped for therapeutic play and outlines a model which has laid the foundations for therapy practice today. Describing the play space Axline comments:

> There was nothing about the room or the materials in it that would tend to restrain the activities of a child. Nothing seemed to be either too fragile or too good to touch or knock about. The room provided space and some materials that might lend themselves to the emergence of personalities of the children who might spend time there. The ingredients of experience would make the room uniquely different for each child. Here a child might search the silence for old sounds, shout out his discoveries of a self momentarily captured, and so escape from the prison of his uncertainties, anxieties, and fears. He brings into this room the impact of all the shapes and sounds and colours and movements, and rebuilds his world, reduced to a size he can handle.

(Axline 1964, p.22)

The aim of any playroom must be to emulate such an environment. There are no prescribed routes through therapy and each child must make their own individual journey along a unique route. As a play therapist it is vital to be flexible and able to respond to different circumstances. To facilitate regular sessions it may be necessary to find an accessible venue which may mean using a room not specially equipped for therapeutic play. In which case a model such as that suggested by Ann Cattanach (1992) may be appropriate .

In her book *Play Therapy with Abused Children,* Cattanach (1992) describes a portable approach suitable for visiting children in different places. Here the safe place is denoted by a mat which is placed on the floor to denote the playing space. Toys are held in bags which the child is free to open and explore. Instantly the room is transformed into a therapeutic playing space

and the therapist is able to provide boundaries and the tools necessary to the play. Effectively this model takes the playroom to the child and depends on the same theoretical basis. It can be used in various settings including family homes, community centres, and schools. Cattanach (1992) also outlines the importance of providing a range of media to represent the paradigm of play. A concept proposed by Sue Jennings (1990). She suggests that play develops from early, explorative play which is often messy, wet, and stimulates the five senses, known as embodiment play. This progresses to projective play when the child begins to explore the environment, using external objects, and finally to role play or enactment, imitating situations real and imaginary through drama.

Sometimes a playroom is shared with other professionals who have a different agenda for its use. Janet West (1992) acknowledges that rooms which have a shared purpose are often limited in the way that equipment can be arranged. This necessitates the creative use of storage to maintain a consistent provision of both toys and the environment. Using Axline's basic principles set out in 1947, West describes how different children have used sessions which have occurred in playrooms.

Elizabeth Newsom (1992) offers a different model and combines the world technique developed by Lowenfeld and the opportunity for dramatic play. First, children are offered the chance to make a world using a sand tray and a range of small objects. Second, the child and therapist move to an adjacent room which is equipped for dramatic play, the child leading the play. However, this model is slightly more restricting and does not allow as much freedom for the child to experience the breadth of play according to the paradigm of embodiment, projective and role play.

In my own work as a play therapist working first in London and latterly in the north west of England I have found that I have used a variety of models depending where I have needed to provide sessions. I have been interested in the various ways that therapists and other play workers have arranged and equipped their rooms and have borne this experience in mind when preparing my own. Drawing on the writing of Lowenfeld and Axline and the approaches of Cattanach, West and Newsom, it has been an exciting and interesting project. In some ways it is still developing in response to new inspiration and requests from children. But essentially the room has been prepared with all it needs to offer a sanctuary to children, for creative exploration, interactive play and transformation. Limited by the constraints

of space and money, the means of overcoming these hurdles have contributed to the dynamism of the environment.

The beginnings

Children are referred for play therapy sessions for a variety of reasons. Generally something has occurred which is out of the ordinary; the child is in need of some extra support and the opportunity to explore the issues and their affect with someone not involved in their day to day life. Some of the reasons for referral are family breakdown, bereavement, an experience of neglect, physical, emotional or sexual abuse. Not every child however, who experiences a trauma is in need of therapy. Children who are struggling to cope exhibit unusual behaviours, they may be withdrawn, having nightmares, or very difficult to manage or understand. Hence a referral is made to a service such as: child and adolescent mental health, child guidance, social services, or one of the many charities which offer help, e.g. Barnardos, NSPCC, The Children's Society. Increasingly such services are able to offer play therapy with a qualified and registered play therapist who can facilitate the child to communicate their distress through the familiar language of play. Such therapy can be offered in the community, using portable equipment or at a base using an established play therapy room.

The reason for referral may seem obvious, however the issue for the child may be something quite different. Jane, aged eight years, who lived with her mother who was a diabetic, was referred for a particularly difficult bereavement. Her father who had not been living at the family home for some time had committed suicide. One year later she was still very withdrawn and concerns were raised that she had not expressed her feelings at the tragic loss. The expectation from the referrer was that she would come to therapy to 'talk' about the loss and the circumstances of her father's death and be 'counselled' by the therapist. However when exploring her feelings through the medium of play what became apparent was that Jane's main concern was her relationship with her mother. Through the play she explored ambivalent and inconsistent maternal relationships and enacted scenarios whereby an ailing mother was taken to hospital leaving the daughter to be taken in to foster care. Jane was able to air her fear of being abandoned by her mother who could not be relied upon to take her essential medicine regularly. While Jane was affected by the loss of her father it seemed that the reason for cutting herself off from her feelings was her fear of losing her mother. It seemed that previously her father had given her a sense of

being parented which had freed her to take on a supportive role with her mother. The loss of her father had highlighted and perhaps magnified her mixed feelings about her maternal relationship. Through the play she mourned the loss of a maternal parent who looked after her needs.

Sometimes the child's concern is not to talk through the distressing events that they have experienced, but rather to express their fears about what affects them. Jane used the open agenda of the sessions to explore the issues most important to her, the freedom of the playroom gave her the language she needed to express her distress and mixed emotions not only at the loss of her father but also her own vulnerability.

The assessment

There is no blueprint of presenting symptoms which will mean that a play therapy approach will be appropriate, certainly they may indicate that therapy may be helpful. In the same way that each child will use the playroom in a unique way, so the means of assessment should be tailored to the individual needs of the client. Two factors which are essential are the child's willingness to attend and the support of the family. Children must want to come to the playroom and be ready to explore some of the difficult things which have happened in their life. Parents and carers must be willing to accept the potential change in their child and be prepared to commit to bringing them regularly to the clinic.

An occasion where it initially seemed that both these factors were present was with David, aged eight years, and his mother. He had previously suffered severe neglect, his self-esteem was understandably low and he had additional physical difficulties which identified him as being different. His mother seemed keen to help address his individual needs and an agreement was made whereby he would be brought for regular weekly sessions in the playroom for a number of weeks and his mother would receive support for herself. In fact she managed to bring him on the first occasion, on the second he arrived on time saying the rest of the family was not yet awake: he had got up, dressed and brought himself. He was an incredibly resourceful young boy and had learned at an early age to look after himself and be independent. It was unfortunate that his family were not able to meet his needs at this time. Responding to the commitment he had shown I felt that it was important to continue the therapy at a more accessible venue for him. I subsequently arranged sessions for him in his school, not always an ideal environment for therapy. However for David it was a vital opportunity to work with someone,

to be heard and responded to. In this case it was not possible to change the circumstances in which he was growing and developing but the sessions were a useful outlet and source of growth for him; sometimes we can only open windows for children not doors.

The initial visit

It may be helpful as part of an assessment to arrange an initial visit to the playroom. This not only introduces the child to the therapist and the room but can be a useful means of checking the parent's commitment and the child's potential for using the therapy. Seeing the playroom and discussing the value of regular sessions with the therapist helps make the proposition of weekly visits more real for the parent. It can be useful to observe the child's initial response to the room and the toys within it as a means of gauging the potential value of sessions.

Nicholas, aged nine, was referred to the child guidance service due to disruptive behaviour and nightmares after witnessing and being involved in extremely violent scenes between his parents. Following an initial assessment by a child psychiatrist, in which Nicholas was understandably reluctant to talk about his experiences, it was felt that individual sessions allowing non-verbal expression would be beneficial for him to explore the traumatic events in which he had been involved. I met Nicholas and his mother to discuss the possibility of sessions and as part of the visit to the clinic I introduced them to the playroom. While his mother and I talked about the implications of regular sessions, Nicholas swiftly introduced himself to the puppets. He enacted scenes reminiscent of seaside Punch and Judy shows while the adults were seemingly otherwise engaged. In parallel with my discussions with his parent Nicholas was telling his story, communicating in a language familiar to him that allowed free expression not limited by words or conditional on someone replying. From both my observations of his play within the room and discussions with his mother I could see the potential for play therapy to help him communicate and hopefully to influence his disturbed sleep and behaviour.

In fact it took months of relationship building before Nicholas reached a point where he could engage me in a dialogue with the same puppets within therapy and enact the brutality of the scenes he had stored within his memory. First Nicholas explored early play experiences of an embodiment nature using sand and water, followed by projective play making models and world play, thus he established boundaries and trust, and developed his

self-esteem. It was only when he felt strong and confident enough that he was able to explore the traumatic events and their affect on his ability to make and maintain relationships. Using the puppets was indeed a significant event in his therapy but only equal to his exploration of other play which was necessary as a foundation.

When a child enters into therapy the playroom becomes a significant place. While they are there it is as if it belongs to them, it becomes their domain. It is important that a wide variety of materials and play items are available, thus providing choice, allowing spontaneity and presenting a consistent environment. The selection of toys and equipment items do not need to be specialist 'therapy toys' but should reflect the whole spectrum of play. It is the unique combination, organization and presentation which makes the room special and adds that therapeutic ingredient.

The playroom

Come with me now into the playroom. The door sign is not turned to 'Do not disturb' so it's safe to enter. The door opens with a key, a significant ritual indicating that the contents are protected and preserved for the one who enters. The key is denoted by a fob: an unfortunate camel whose vulnerable legs have been broken in its day to day use — perhaps the first symbol of the special agenda of this place. The door opens to reveal what seems at first glance to be an ordinary room equipped for play; all manner of familiar things; sand, water, art materials, crayons, pencils, dolls, cars. The toys representing the familiar alphabet of the child waiting for them to string together a word, a sentence, a story.

The room is prepared for a session. The child's personal box, a sturdy cardboard container holding the artwork, models and stories the child has created in previous sessions awaits them. The room, tidy in a casual way shows no evidence of other children having played there today and yet it is apparent that the room is well used. A space has been created for them.

There is something magical about the playroom. Large enough to provide a fair bit of space, small enough to feel cosy and boundaried; like the Tardis in *Dr Who* it manages to be as big as you need it to be. Though the contents are necessarily limited by the confines of dimensions and financial restraints, it manages to have everything you need to play. It is tidy in an untidy way, allowing the child to be free while providing secure boundaries.

A single glance encompasses the room. There is an impression of order which reassures rather than bombards the senses. A few discrete art postcards

hanging at child's eye level, signal the creative nature of the room. A carpeted area, covered in a rug, scattered with cushions indicates that it is acceptable to stop in this room, to rest, to be. Equally a tiled area suggests that it is permissible to be messy, to create, to do. Separating the two areas is a bookcase, housing not only books, but a few games, jigsaws, and a variety of stationery. Interesting small boxes sit atop along with an inviting selection of pens, crayons and brushes.

A home corner provides the framework of another room, is it a shop, a castle, a police station? Puppets, dolls and soft toys lie inert on a cot and bed, waiting for life to be breathed into them. A selection of five sided wooden boxes are stacked and look like an empty cupboard, or could they be a dolls house or a garage? A low table holds a container of dry sand, beneath are drawers which when opened reveal various small objects; people, animals, vehicles, furniture, stones, fir cones, acorns, etc. Another table shows evidence of being used for painting and what's this underneath? More sand, a great container of wet sand. A large cupboard holds the promise of more to come. Looking up the window looks out over a green sward of turf and behind a railway line, a builders yard and sky.

The room

The room itself is not different or remarkable in any way, just a standard clinic room. Large enough to move about in and small enough to feel safe. The aim is to offer the child a world in which to explore their external and internal worlds. The walls are neutral and though children are free to put up their pictures while they are there, none remain after the sessions ends. Therefore there is no pressure to compare, to be good enough or to be reminded of other children that attend. The garish clown mosaic that greeted me when I first arrived at the playroom has long since been taken down. What a sad symbol for a child therapy room, a painted smile masking the real face behind, too uncomfortably true of many of the children that are likely to use the room. The few postcards that decorate the room are each carefully chosen to stimulate and encourage the child's creativity, to provide a balance of mood, colour and culture. Artists such as Matisse, Picasso and Kandinsky reflect the accessibility of art and encourage those who are held back by inhibition to pick up a paintbrush and create. I am often asked if I have painted them myself!

The comfy area

A small rag rug, with a few fringed cushions add a colourful, welcoming touch. The cushions are helpful to soften the impact of the hard floor when kneeling in preference to using a chair at the table. Occasionally a child will choose a book from the limited selection of myths and fairy tales and opt to sit in the comfy area, to read or to be read to. This often seems to happen before a break when children naturally prepare themselves for the separation. Sometimes the area is used within dramatic play to signify a different place. On one occasion a child lay down to rest as part of the enactment and slipped into sleep for ten minutes, leaving me to wonder what to do, since the play therapy manual did not cover this eventuality!

The bookcase

Central to the room is a bookcase which serves to roughly separate the wet and dry play areas. It is an important vantage point, at a first glance it offers the safety of books and paper which are familiar and known. Given a second look it offers a wide range of play materials and suggests the promise of more. A variety of pens and crayons invite artwork. Paint brushes and tools for clay or dough suggest the availability of other media. Small boxes entice the child to explore. Hand cream and handkerchiefs look after more practical needs. The shelves house not only books but a few jigsaws, which reflect different developmental stages. These more safe and familiar items can be an important source of comfort at difficult times. A therapist in training was once aghast to discover that I even allowed jigsaws in the playroom! However I have found them to be a useful tool, not only in representing a port in a storm, but by undertaking an 'easy' jigsaw a child may achieve success and may serve as a reminder of an earlier age. The bookcase is more than just a divider, it represents the playroom in miniature, it suggests the range of media available and is an invitation to play.

The telephone

A play telephone sits on top of the bookcase, it acts as a useful bridge into dramatic play, or can be a means of inviting the therapist into role. A real telephone rests beneath. This telephone will not ring during the session, but it serves as a potential link to the outside world. Telephones are a potent symbol, a child who regularly came for therapy apparently had a small item

that he had made at home stuck on his bedroom wall. When asked what it was he explained that it was a telephone to connect him to 'Chris Daniel'.

Most children ignore the telephone but for some it is a source of some conflict that an accessible item is 'out of bounds' and not available for play. Within the permissive environment, it is a useful reminder of the perimeter of the boundaries. On the one occasion that I did relax the boundary I invited disaster! I had just returned from two weeks unplanned sick leave. The telephone was 'needed' to play 'offices' properly. Perhaps suffering from some guilt for my unplanned absence I conceded and allowed it in the play. At the child's request I fetched something from the other side of the room and when I returned the telephone was apparently 'ringing' and I had to answer it. As I lifted the receiver I was shocked to find that the cord was cut clean through! On this occasion I felt that the use of the telephone was symbolic, it belonged to the adult world and was something I had previously protected. I understood that cutting the wire represented the anger and frustration that the child had hesitated to express at the separation experienced due to my unforeseen absence.

It is not often that a child will purposely damage a toy and if possible I will prevent it and provide an alternative that can be crushed or torn such as an old box or newspaper. Similarly I would prevent a child from being at risk or hurting themselves. It is important to value items in the playroom, reflecting the principle that children should also be valued.

Precious objects

A small, varied collection of boxes, wooden, cane, cloth and brass, hold various unusual and 'precious' things. While it is generally understood that items in the playroom should be fairly robust and able to withstand fairly rough treatment the presence of fragile items add another dimension. Children treat them with respect and do not need to be reminded to take care. It has been an important means of representing a different part of the child and allows them to express a different part of themselves. This is another opportunity to value something in the same way that they too should be valued. Both boys and girls love the paste jewels and refer to them as 'diamonds'. Even the unlikely basket of buttons has become a great source of creativity, representing family members in a sculpt, portraying magic jewels and beans in dramatic play, and replacing the cash till (which has twice been accidentally broken by adult visitors to the playroom!) as a source of coins.

The wet play area

There is nothing unusual about this area, it is able to survive a multitude of creative activities, where water, paint, clay, glue, glitter and other messy, sticky things are in abundance! Neither spotless nor dirty it signals that mess within limits is quite acceptable. I remember visiting a playroom where lumps of old clay were stuck to the table, and the residue of paint and glue meant the surface was no longer smooth enough to lay down a sheet of paper. I am not a naturally tidy person but I was struck by the chaos of the scene, it was as if the other children who had played here were still present. Children who visit the playroom often bring their own sense of chaos, it is important that the environment is sufficiently ordered enough to welcome them and help them explore their own confusion unhindered by the influence of others. It is a delicate balance to achieve a room that invites exploration and allows mess and one that engenders safety and security.

The sand

Beneath the table top is a large receptacle of moist sand. Children often 'discover' this themselves with great glee! Sand is a great source of embodiment play and it is important to have a choice of both wet and dry. When wet it can be moulded, patted, scratched. Dry, it has different qualities and can be poured, sifted and smoothed. In either state it has important sensory qualities and allows the child to explore mastering their environment. Without direction children will choose to create a 'world' in the sand, as described by Lowenfeld (1979), thus graduating to projective play. A wide range of small objects, including figures, vehicles and natural items are available from a set of drawers in close proximity.

It is remarkable the many different ways that children will use the sand. Martin began by moulding it, being in charge of the medium and master of the area within the sand tray. Burying his hands in the moist sand, he gradually moved them making cracks on the surface. Adding trees and swings he created a landscape. Martin experimented and developed a story, inviting me to play a part. His fist was buried within the sand, gradually it moved and cracked the surface, a baby worm was born. His finger searched the terrain, the worm looking for its mother, crying to be fed. It was a lonely, distressing time and though the worm did meet others, they often were cruel or teased him. The worm was not able to be a baby for long as other worms would be born who needed looking after. The story evolved over a number of

weeks. Until one day two worms were born who were a Mum and Dad! Able to look after the worm and keep it safe from the others who taunted it.

The story effectively parallelled Martin's own life experience. He had been mistreated as an infant by his natural parents. From an early age Martin did his best to look after other children born into the family. Some time later he was taken into care and was subsequently adopted. Seeing parents born to the worm in the womb of the sand was very moving and signified a new era for Martin when he could begin to move on from the difficult things he had experienced.

The home corner

Describing this area as a home corner is a misnomer. Like most of the items provided in the room the aim is to facilitate play rather than direct it. Consequently it is set out in a way which lends itself to being a variety of habitat. A purpose built three sided frame encloses an area which is equipped for role play. The venue is limited only by the imagination and easily becomes a puppet theatre, a nest, or a jail. I am constantly surprised by the different ways the space and equipment is used, a plastic apple can be a hand-grenade, a blanket becomes a tent, a tray is really a shield.

The sense of being enclosed by the frame is important, it is one place in the room where the child can easily sit alone, relatively unseen by the therapist. It can also be an area of great activity, for example setting up home and enacting Mums and Dads. For one boy who had been sadly neglected and had moved between foster placements it became an important focus for him to make a home and experiment in role. He explored many characters who looked after babies in different ways, some ambivalent or neglectful, others tending to their needs in a way that he himself had not always been cared for.

A small cot and bed are home to a variety of dolls, family and animal puppets and other soft toys, which I realise are mainly monsters! Used equally by both genders, they are a great source of play and are loved, nurtured, cajoled, punished and sometimes roughly treated. Children are free to explore the wealth of their experience, good and bad. Sometimes their play reflects real events but more often I am aware that the play symbolizes something from within.

A young girl who had been rejected by her mother was withdrawn and not very independent. She regularly took on the role of Wendy from the story of Peter Pan, taking control, feeding and nurturing the lost boys. She

set out the many saucers and plates and laid out a feast. I understood that she was experimenting with a different aspect of herself, one that was confident, able to meet needs which was quite unlike the persona she adopted in reality. Another boy who was adopted and had been recently unsettled by a burglary at home, explored his fear using the puppets and dolls. He enacted a baby being disturbed by a burglar who hid each night in the garden shed. By facing his fear he was able to become less fearful. In their own way each child was confronting a different aspect of their experience and a different aspect of themselves.

The treasure chest

A useful prop in dramatic play the treasure chest also holds a hoard of interesting things. Short lengths of sari fabric, and a whole sari can be hoisted up, attached to the blackboard and linked to each other by knots and bulldog clips to create a magical tent, or a dark hiding place. Useful also for dressing up, the different colours can suggest a variety of characters. Children love the texture of the material which is rich and silky. Girls particularly enjoy swathing themselves in the cloth, they refer to as 'silk' and parading around adorned with jewels and necklaces. Equally the cloth can suggest the disguise of an evil baddie or the cape of a hero. Other fabric offers a variety of texture, the lycra is a particular favourite and can be stretched and pulled without doing any harm.

Also in the chest is a selection of percussion instruments, such as tambour, cymbals and maracas. This provides another means of expressing emotion and can add another dimension to enactments. To a girl who found it difficult to communicate verbally, the instruments became an important means of expression. It was through becoming familiar with them that she was able to explore emotions that she had stored deep within. Staccato taps on the bongos were gradually increased to a wave of sound, a roar of thunder. In conjunction with other supportive work and the openness of her family to hear her, she was able to realize that she could express her anger and frustration and not be overwhelmed by it.

The percussion can be effectively used to encourage listening and responding. Another girl who was bound by words used the instruments to great effect, scripting a story and using the instruments to narrate it. Liberated from the spoken word she was able to tap into feelings which her words had previously hidden.

The refreshments

I always provide children with a drink, after all playing is thirsty work. It is rare that I provide biscuits. The role of the therapist is not to provide nurture but to facilitate children to use the nurturing relationships they have outside the therapy. Parents should be relied on to meet the physical needs of the child. However I can remember a small boy who requested biscuits and for whom I regularly provided them. He was brought to the sessions by a variety of carers or sometimes by the taxi driver who picked him up from school. It seemed that no one consistently met his needs. Following the family breakdown I was concerned that the sessions and my relationship with him were one of the few consistent things in his life. But we weathered the storm together and finally a new family was found for him that could offer the things his life had sadly lacked.

I have an idea that it would be good to provide a basket of fruit, being a more healthy alternative to sugary biscuits and perhaps flowers to add to the room, but my budget hasn't quite stretched that far! I have introduced one or two plants, but whether it is the heat or the draught I am never too successful with meeting their needs!

The cupboard

The cupboard holds a host of goodies. The shelves at child level house the paints, clay, plasticine, a variety of paper and material for creative work. There are also aprons and old shirts to protect clothes and particularly school uniforms. A large container of boxes for model making and playing in the shop can be pulled out to reveal a large space, big enough for a child to hide or to retreat to. Even though the playroom is not quite large enough to play a convincing game of hide and seek, children invent their own way to recreate the experience of hiding and being found. The adrenaline still runs, the heart beats faster and louder, pounding in the ears, the sense of fear and expectation rises as the giant stomps around the castle looking for Jack, who is actually hiding in the bottom section of the white cupboard. And that was only my experience of being Jack when the child had chosen to be the giant!

Things above child's eye level are accessible only to the therapist, a function for convenience to keep very sharp scissors out of reach and other items which are part of my secret store, which I bring out as required. This area symbolically represents other areas in the child's life which should not be accessible to them.

The junk

I can remember myself as a child playing at my grandparents' house, with what seemed at the time as a gigantic cardboard box, procured from the local grocery shop. It seemed like a great treat and with the addition of a simple piece of string was instantly transformed into a car, boat or coach and horses. It kept me occupied for ages. In the same way in the playroom the intricate Lego castle and the Duplo ship are often passed over for the most unlikely or unexpected of items. I hesitate to call my collection of empty boxes, containers and interesting things 'junk' as they are often the most valuable and prized objects.

The ambience

I hope that the general air of the playroom is warm and inviting, cosy without encouraging complacency. Not only do I tidy the room between clients but I open the window wide and air it. Sometimes it is in need of more desperate measures due to the occasional 'small eruption of gastro-intestinal air' as Bill Bryson (1995) so politely puts it. I have threatened to write a paper on the subject recognising that the phenomenon is related to the issue of holding on and letting go, which is after all the bread and butter of the playroom. The toilet is in close proximity for more serious letting go. But when the session time is so important, precious minutes spent visiting the toilet are often deferred to the last possible moment! Fortunately there have been no 'accidents'. A colleague has described to me how she too always needed to evacuate her bowels following her personal therapy sessions, it seems this is not uncommon and perhaps warrants further study!

The bin

Not to be underestimated the bin is another vessel for holding waste. Children may discard an item which seems precious and sometimes I will retrieve it later and keep it in case it is referred to later. Other times it can be cathartic to destroy something and throw it away. I am careful to empty the bin regularly to avoid one child's waste influencing another child.

The items of little consequence

Sometimes it is the least likely items that become of great significance to a child in therapy. A ragged three inch doll which I admit I had almost thrown

out became of great significance to a girl whose self-esteem was low. Over the period of the sessions she nurtured the doll and made new clothes for her, giving her a new lease of life. How often are the children we see in therapy 'overlooked' when all they need is some care and attention?

It is vital that the items in the playroom are available consistently and in roughly the same place. This is to facilitate children to bring their own conflicts rather than deal with conflicts that the room engenders. A small boy adopted a tiny plastic monkey which he would carry around the playroom with him. One day he looked in the drawer and when he couldn't find it, was very upset. After searching we found it in a different place. I communicated to him that I was sorry that it wasn't in the same place. I had felt responsible for letting him down but it was important to see it in perspective, the room and the therapist need only be good enough.

The one way screen

An inherited feature of the playroom is the one way screen. From within the room it looks like a large mirror and has a curtain which can be drawn across. I always explain how it is used in a way the child will understand. I outline that I have a supervisor who sometimes comes to watch me play. In the same way that Newsom (1992) describes her use of this facility, I always give children the freedom to draw the curtain. The screen is generally ignored by the children, occasionally it is useful as a mirror to see oneself dressed up or the curtain is drawn to signify 'evening' within the game.

The facility to observe sessions is very useful. It means that my therapy work can be discretely observed by my supervisor who is then able to offer insight into their play and my response. It also provides a safety net so that my sessions with children can be witnessed by another professional. I am grateful for the security this affords both the child and myself.

The clock

Though not all children have learned to tell the time when they commence therapy, they generally quickly learn! A session of 45 or 60 minutes passes quite quickly and it becomes important to manage your time well if you want to do everything you need to!

Jemima had experienced a significant bereavement and additionally had a mild learning disability. On commencing the sessions she had little concept of time or interest in learning to tell it. She enjoyed the freedom of creative

expression and initially explored and enacted fairy tales of her choice. Sometimes it was difficult to understand to what extent she was able to separate fantasy and reality; how much of this was her reluctance to operate in the real world and how much was a result of her learning difficulty? Her concept of time and time telling was similarly obscure; again it was difficult to ascertain how much was limited by ability or by choice.

It is my role as therapist to take responsibility for the time and ending the session, I will generally give a gentle reminder as to the approach of the end. This gives the child enough warning to sufficiently resolve their play and wind down. Jemima soon learned that the session was limited and to be able to do everything she wished she needed to manage her time well. She began by frequently asking for time checks and gradually learned to appreciate the configuration of the clock hands at the beginning and end of the session. She began to realize that sometimes her carers brought her late, resulting in her missing part of the session and so she would give them a good telling off!

When playing she began to glance at the clock and observe the progress of the movement of the hands tracking the extent of her sojourn in the playroom. During a session in which my supervisor was observing through the one-way screen Jemima turned around from playing in the sand, as I thought to view the clock behind her. Unbeknown to me she not only focused on the time but stuck out her tongue and pulled a face at the offending timepiece which signalled the end of the session! Not only had her reality become boundaried by time but she had also got in touch with her feelings! She was ready to take on the awareness and responsibility of time telling and discover the pleasure and power that managing one's time can bring.

The box

Each child who visits the playroom is given a container in which to store any artwork, stories and models made in the sessions. The box itself can become a significant feature and symbolizes a safe place for the child. Occasionally children will decorate it or write on the exterior warning of the consequences of unauthorized entry. For children whose privacy has been betrayed in the past it can be a particularly important symbol. It is also an important contract between the therapist and child, that anything created will be held until the termination of sessions when children decide as to the fate of their creations, some are taken home, others kept in my safe keeping or destroyed by the child.

This is an important boundary to establish early on in the sessions. It suggests that the work within the playroom is significant and that symbolically the therapist is able to hold the issues that the child explores. Sometimes it seems a tough principle when a child is desperate to show a creation to someone outside of the session. At the end of a session when he had spent some time creating a model in clay, Terry who was twelve years old asked if he could take it home to show his family. I gently reminded him of the boundary that anything created stays in the playroom until the completion of sessions. A discussion ensued as to the unfairness of the rule, internally I too battled with the apparently irrational boundary. I stuck to what I had said and what had been agreed at the outset. Reluctantly Terry left the session empty handed and met his father in the waiting room. I couldn't help but overhear him express his excitement at the success of his creative activities that afternoon, the positive feedback he received met his desperate need to raise his self-esteem. Rather than present an object to his father he had expressed his feelings about his creation, he had engaged his parent in eye contact and dialogue. It was Terry not his model that received the praise.

I was reminded of the purpose of the holding of artwork; not only is it symbolic of the ability to hold the child and their emotional baggage, thus keeping a promise. But it also liberates the child to express their feelings about what they have made, there is no sense of having to create something to impress, they are free to create what they feel. They are also free to describe the process or the end product to a carer or friend, giving a chance for the expression of feelings, so that it is the child that receives attention and praise not the creation. These are such valuable opportunities for the building of self-esteem. For Terry model making became a regular feature of the sessions. Interestingly at the close of sessions he chose not to take any of his creations with him, preferring to leave them in my safe keeping. Though my responses to Terry were based on my training and informed by my reading of other therapist's interventions, his particular struggles and torment taught me a great deal about why therapists do what they do and still influences my work today.

The window

It is fortunate that the first floor view is fairly green, with a selection of newly planted shrubs. Hospital residences and the rear of a builders' yard separate the grounds from the railway. When the possibility of moving the playroom was discussed I was concerned that a ground floor room looking on to the car

park with people regularly walking past would affect the tranquillity of the room. Though generally unnoticed by the children the peace is regularly broken by trains passing by! One young boy who was aware of the locomotives and would time them, began to anticipate their arrival and would peer out of the window to watch them. I felt that he was using this to avoid the substance of the session. In fact it became apparent through his reticence to immerse himself in the session that he was not secure enough to engage with the creative material and explore his inner world. The trains represented the external world which in his experience was not as reliable or secure as the timetable. Another child preparing to end his therapy suddenly became aware of the trains and asked if the railway had just been built!

The therapist

A playroom can not be therapeutic unless there is a therapist. A solid grounding in play and a clear theoretical foundation are vital to working effectively. The creative therapies are a growing profession and fortunately there are increasing opportunities for professionals to train in play therapy in Great Britain. Trainees rediscover the power of play as a means of communication, they learn how to respond to and interpret the language of play.

It is important to be familiar with the medium of play and to be confident with working in the open agenda of a playroom. It can seem daunting to work in a room which is well equipped and potentially quite stimulating. The therapist needs to feel comfortable in the room and be familiar with the contents. Supported by supervision the therapist is not alone, working without supervision would be like a diver working without an aqua-lung. It is hazardous territory we explore, it is important that we are suitably trained and equipped.

The first session

It never ceases to amaze me that following a brief introduction, children will develop a relationship with the therapist and engage in therapeutic play; play which explores meaningful events and facilitates resolution and therefore change. There is no need for a lengthy explanation of the purpose of the visits to the playroom, a brief and candid introduction suffices and generally when children are ready for further information they will request it. At minimum I will mention who has suggested that sessions will be helpful and briefly

outline the reasons why, giving an opportunity for the child to present their understanding of why they come to the playroom. Unfortunately many children feel that they need to come because they are 'very naughty'. While it is essential to reframe this for the benefit of their self-esteem they must also reach a point where they believe themselves to be basically 'good', often this is the work of the play therapy.

Children are referred for a wide range of reasons such as following traumatic life experiences such as bereavement, separation, neglect or abuse. These events damage the child's self-esteem: children may feel in some way responsible for life events that have affected them. It is vital that coming to the playroom does not reinforce this but liberates the child to explore new or hidden sides of themselves. This is achieved by giving the child appropriate reinforcement, in the form of positive regard and encouragement by demonstrating an interest in their activity. This is managed without the therapist declaring their own feelings about the child's creative work but rather by reflecting back the child's feelings of achievement. The first stage of therapy is often to reinforce the child's ego which is often battered and bruised; this serves as a foundation for the therapeutic work ahead.

The stages of therapy

In the early stages of therapy when familiarity, boundaries and trust are being established, it is common that children will use a particular play medium which then changes to another to explore the main theme of their difficulty. This is illustrated by Nicholas, mentioned previously, who used sand and water before graduating to working with puppets. It is a misconception that children need to talk about what has happened to them, certainly they need to communicate about it but in a means comfortable and familiar to them. Verbal articulation can be well used by adults who can adeptly avoid, deflect and defend from spontaneous expression. When facilitating children it is imperative to use their natural means of communication and not to inflict on them a method more familiar to the therapist. Also if a distressing event or trauma happened at a certain age it may be beneficial for the child to have at their disposal a means of expression pertinent to that age. For example, Thomas engaged in a safe and age appropriate game of 'shop' in the beginning of therapy when trust and boundaries were being established. During the middle phase he regressed to early embodiment play exploring basic sensations and mastery of movement through paint and clay. As the

ending of therapy approached he used projective play using small figures and animals, again reverting to age appropriate play.

Thomas had been labelled as having mild learning difficulties, he managed within mainstream school but struggled not only with educational tasks but with relationships both with adults and his peers. He had been removed from his natural parents who had been charged with severe neglect two years previously. It was understandable that his new carers would encounter some difficulties with his behaviour since he had spent his early years tied in a car seat and given little attention or freedom to explore and develop. The manifestation of his difficult behaviour in his new home was his inability to manage his anger. He would have what was described as a temper tantrum, kicking, hitting and smearing his faeces on the wall.

Thomas' early sessions were spent playing an uneventful game of shop. I tried to introduce small conflicts by representing difficult customers for him to deal with. It was not until the last session before a holiday break that Thomas himself introduced an element of disharmony and revealed a glimpse of the pain behind the mask. Multiple explosions took place in the shop destroying the *status quo* as we knew it. Just when you thought it was safe another explosion took place leaving the shop in total disarray. This was the close of the first phase. Thomas' outpourings were perhaps not as overwhelming as he feared and at the next session after the break he was able to use paint and clay to explore his anger and frustration in a safe and non-threatening way.

Eventually at home he no longer smeared or kicked out but was able to express his anger and disappointments in an acceptable way. Thus he was able to come to terms with his fears and manage his behaviour both at home and school. As this middle section of his therapy came to a close, Thomas adopted a third medium of small toys and used them to explore closure and endings as a preparation to the end of the block of sessions. All within a nine month gestation period, Thomas was, if there can be one, a classic play therapy client using the three aspects of the paradigm of play, enactment, embodiment and projected play as beginning, middle and ending.

The journey

Jennifer had been in a particularly violent relationship with her ex-husband. She was anxious about her eldest daughter, Vicky whose behaviour she was finding increasingly difficult to manage, particularly as it reminded her of her ex-partner's temper and brutality. Vicky had witnessed extreme situations of

violence, including seeing her father attempting to murder her mother. She had sometimes become involved and had attempted to intervene and help. The aim of the therapy was to allow Vicky to express her feelings in a safe way and to explore her different roles. She had sometimes been a valued friend to her mother and had been untimely pulled into the adult world. Understandably Jennifer's own self-esteem had taken a beating and she was offered some additional support to help her take control at home and be more assertive in her parenting.

Vicky was particularly amenable to engaging in the therapy and used the time productively. In her initial sessions she would transform the room into a school, using the blackboard and other items as props. She became a domineering school teacher and experimented with the discipline and boundaries that a schoolroom offered. It seemed that she was exploring the power dynamic between adults and children. She would constantly take control within the play and while this is desirable and necessary in the playroom, her manner of doing this was aggressive and effectively masked her vulnerability. She also pushed the boundaries of the session and would try to insist that the session time be extended. It was a struggle to contain her but it was essential that she felt contained by the parameters.

Gradually in the sessions Vicky used artwork to explore her more vulnerable side, moving from taking control to taking risks. She became more confident and was liberated to be more spontaneous. Significantly she worked on a picture of a dark and frightening monster, she requested my help and we painted together.

Vicky returned to dramatic play and began to create and enact stories about giants. Thus she entered the world of her imagination, working instinctively rather than in the controlled way she had previously. She desperately needed to control the giant within her and to understand the giant that had so terrified and mistreated her. Bearing similarities to the tale of Jack and the Beanstalk she first took on the role of the giant. Omnipotently stomping around the room, she terrified the poor mortal who tried to escape her wrath. She also played the role of Jack, bravely defending herself and tricking the monster that pursued her. In one story I was cast as her attendant and she allowed me to help her overcome the giant. We achieved this by me giving her a 'piggy back' so that together we could be tall. It seemed a significant session and mirrored the time when we had worked on the artwork.

At the close of the session she requested that I give her another piggy back to the waiting room where her mother was sitting. I was cautious about continuing the play outside the boundary of the playroom and was also wary about allowing her to push the boundaries. However on this occasion I trusted my intuition (a valuable play therapy tool) and consented, not instantly but with some discussion with Vicky of the boundaries. It was a very significant event as I deposited Vicky from my shoulders into the waiting lap of her mother. Vicky had been transformed from a child who took control because she felt out of control, to a child who wanted to be just a child. This was an illustration of other developments in their relationship, facilitated by changes in both of them.

The end

And they all lived happily ever after! Well, not quite but certainly therapists endeavour to facilitate resolutions within the therapy. Hopefully at the completion of sessions the child is stronger and able to cope with the struggles they will face in life, perhaps freeing them from the effect of experiences that previously hindered them.

Working in the playroom is working with paradox. Keeping it tidy in an untidy way, holding the chaos and maintaining order, securing boundaries and allowing the child to be free. The paradox of ending is that it too is a new beginning.

References

Axline, V.M. (1947/1989) *Play Therapy*. Edinburgh: Churchill Livingstone.

Axline, V.M. (1964) *Dibs. In Search of Self*. London: Penguin.

Bryson, B. (1995) *Notes from a Small Island*. London: Doubleday.

Cattanach, A. (1992) *Play Therapy with Abused Children*. London: Jessica Kingsley Publishers.

Jennings, S. (1990) *Dramatherapy with Families, Groups and Individuals. Waiting in the Wings*. London: Routledge.

Lowenfeld, M. (1979) *Understanding Children's Sandplay – Lowenfeld's World Technique*. Cambridge: Margaret Lowenfield Trust.

Newson, E. (1992) 'The Barefoot Playtherapist: Adapting skills for a time of need.' In D.A. Lane and A. Miller (eds) *Child and Adolescent Therapy: a Handbook*. Buckingham: Open University Press.

West, J. (1992) *Child-Centred Play Therapy*. London: Edward Arnold.

Co-construction in Play Therapy

Ann Cattanach

Dear Anne,

 Thank you for coming to see me and making me better with all of the things in my head going round and round. Thank you for playing and making up stories with me, that have things ~~that are~~ bad in and people who hurt ~~people~~ people. Thank you for talking to me about my daddy who hurt me.

Jamie dictated this letter to his foster sister to give to me. He did the drawing and Kerry did the writing. He said he wanted to thank me and it was important that I had the letter as well as all the stories he had made with me.

 I was interested in his construction of the meaning of play therapy for him. The way he described the sessions in his letter mirrored the way he structured our time together as we played.

First, he expressed the confusion some children feel when they have been hurt by adults. Jamie's confusion extended to his foster family who organized their lives in a different way from his birth family. Would they want him hurt too or were they really different?

He liked the structure and the rules of play with me because there was certainty there and he knew what to do. He was in charge of what he said but he knew that I would keep to the rules of play which we had discussed when we first met.

Second, he expressed the sense of freedom he experienced in the playing space where he could make up stories about 'bad' things and people. He had permission to structure his hurt and pain into a story over which he had artistic control so that he could decide what happened to his characters.

Finally Jamie found the safety to be able to say that his daddy had hurt him and how frightening that was.

He wanted an adult to hear him speak about the cruelty and fear and help him make sense of his past.

He had no control over his father's past behaviour and he wanted to make a narrative about that part of his life, which gave a satisfactory explanation for himself and others in his social world.

This chapter explores the process of play therapy as a social construction in which the therapist and child establish a relationship together and mediate this relationship through play. The purpose of the play and the relationship is to help the child make sense of their world through the narratives and stories which emerge as the relationship and the play develop. Some children explore their pain throughout with imaginative narratives and stories of heroes and monsters while other children like Jamie also want to make a narration of their personal experience as well.

I will describe one session with a boy called Daniel in some detail to show how a relationship is structured in time, place and a particular social environment. Finally, I will describe through stories, narratives and talk, what some children have said to me about their understanding of our time together.

Play therapy as a social construction

Burr (1995) states that social construction theory suggests that all ways of understanding are historically and culturally relative, specific to particular cultures and periods of history, products of that culture and history dependent on particular social and economic arrangements prevailing in that

culture at that time. Knowledge is sustained by social processes. Our knowledge of the world is constructed between people. Shared versions of knowledge are constructed in the course of everyday lives together. We make use of words in conversations to perform actions in a moral universe.

Much of the sorting of stories and narratives in play therapy is about actions in a moral universe. The 'goodies' and the 'baddies', what is a monster and are all monsters bad? We play around with versions of understanding until we find a satisfactory meaning together which encompasses the consequences in our particular culture and time. So Paul aged eight told this story:

> There was once a horrible monster
> His name was Skeleton
> He had no body, just a face and everything
> He was sad and lonely.
> One day he met another monster called Joe
> They liked each other and became friends
> The way they were with each other was to be kind and not hit each other.

I said that I was puzzled that they were called monsters. What had they done to deserve that title? Paul said that:

> People liked them even though they were monsters.
> They didn't have mums and dads. They were born without them.

I asked how they managed that. Paul said:

> They come from outer space in America.
> So they didn't know who their parents were
> And this made them sad.

We began a discussion about the meaning of monsters and the meaning of superheroes. Paul was sad and ashamed that he did not live with his parents and to him they seemed lost in outer space. To have no parents was a humiliation and must mean that you are 'bad' so therefore a 'monster' – even though you are kind and people liked you.

These conversations are important to children to define who they are and sort out some of their confusions about their world. It is the role of the therapist to help them sort out confusion and work through the cognitive distortions which children might have about their family and themselves. If we simply reflect back what children are saying then it is difficult for them to reach a satisfactory understanding of their situation. Of course the therapist

does not 'tell' them her understanding but through questions, talk about meaning, the child and therapist negotiate together.

Malone (1997) states that each person's life is lived as a series of conversations. It is in the flowing reciprocal exchange of conversation that the self becomes real. Without such talk the self would be inconceivable because it would lack the symbolic medium necessary for self-presentation.

Paul is sorting ideas about his origins, being friends, being awful, being a monster, but also being kind. These are moral dilemmas and need to be heard. In the therapeutic space and through the relationship with the therapist he can define himself and present himself.

Goffman (1959) states that the self is immanently social, an interactional achievement, a performed character, a dramatic effect, and we craft our behaviour so that it makes sense to others. In this frame, conversations and selves are both interactional accomplishments requiring trust, dependency and co-ordination. The presentation of self in a social event is the principal way for others to know who we are.

Lax (1992) states that in therapy the interaction itself is where the text exists and where new narratives of life emerge. This unfolding text happens between people. Clients unfold the story of their lives in conjunction with a specific therapist, therefore the therapist is always co-author of the story. So the resulting text is neither the client's nor the therapist's story but a co-construction of the two.

Play therapy is a social event with its own social rules and processes. It is also an interaction, which is semiotic because it should be understood as an assemblage of signs. All talk must be self-referential so child and therapist interpret utterances as signs, which stand for a larger self. The child makes assumptions about the life of the therapist from their own self references so Paul considers me as superhero or monster and himself as monster as these are his categories of people at this time.

Constructing the intervention: Play therapy as a cultural routine

The way the therapist negotiates the beginning of a play therapy intervention is crucial to the co-working of the interaction. If the structure is clear, the meeting becomes another cultural routine, which gives the child a sense of belonging. A place where the child has a role and responsibilities.

Corsaro (1997) describes a cultural routine as a place where the child has the security and shared understanding of belonging to a social group. Because the routine is predictable this provides a framework within which a

wide range of sociocultural knowledge can be produced, displayed and interpreted. These routines serve as anchors, which enable the child, deal with ambiguities, the unexpected and the problematic while remaining within the confines of everyday life.

Participation in cultural routines begin early with, for example, simple participation in the game of peek-a-boo. Initially the child learns a set of predictable rules which make up the game, then they learn that embellishment of the rules is possible as the play routine develops.

Initially in these routines, the games often proceed on an 'as if' assumption which means that the adult assumes that the child is capable of social interaction until the child gradually learns to be socially competent and can fully participate in these social routines.

If we explore play therapy as a cultural routine then the structure of the play must be well described to the child. The rules and boundaries are vital to the safety of the relationship and to clarify the roles and responsibility for both therapist and child. The child needs to feel safe with the therapist but must also feel confident that the therapist can enter the child's play world and help make sense of the confusion and misunderstandings which might be creating difficulties for the child. In this way the therapist does not interpret play from some esoteric source of knowledge, but together with the child mediate some satisfactory meaning, which is congruent with the child's social world.

As the routines are learnt and experienced then the child expands the meanings of the play and stories and learns more complex social communication. The mediating materials are the play, story-making with toys and objects and stories the therapist tells or reads which extends the child's individual experience to a cultural generality.

The cultural routines are also established and reinforced through the narratives spoken between the therapist and child during their time together. Children enjoy their mastery over the space, structure and the time spent with the therapist and are very strict that all the routine is maintained. It is often while setting up the area for play that the child will tell an imaginary story or narrate a family or school situation. Sometimes these narratives explore different cultural messages from the storytelling and play, especially when the child's relationships with family members are ambivalent.

David Le Vay (1998) described a child who was meticulous with his story-making, even demanding that David wrote the story down in a particular kind of writing. The story was contained, with a happy ending and

this was what he wanted his mother to read. However, at the same time the child was making a chaotic imaginary narrative about monsters who were not to be trusted.

> Looking at both Daniel's story and the narrative text, it struck me that they each provided a very different representation of how Daniel viewed the world and indeed how he perceived his own place within that world. The story of the Dinosaur and the Super Train could be seen to present an idealised, projective fantasy of how Daniel would like his life to be in that he creates a picture of a loving, nurturing mother and of a child Holly Rex, who is herself both likeable and loveable.
>
> In contrast to this vision, the narrative text provides an alternative description of how Daniel experiences himself, his mother and the immediate world around him, with its dominant themes of fear, danger and protection. It is as if the underlying but pervasive theme of duality that runs through Daniel's narrative identity has been graphically and symbolically represented within the stark contrast between the story and the narrative, one a desperate fantasy of love and nurture and the other a grim portrayal of fear and confusion.

It is always important for the therapist to think about the relationship with the child as a total event with all aspects of the meeting having an important function in the relationship.

The first meeting

The introduction to play therapy as a routine is important for it is through this explanation that the child can participate and feel safe.

Initially the child and therapist meet with the child's carers and everyone is asked to say why they think we are meeting. Many children are not told why they are there so it is important to share what everybody knows. Some children think that they will be given medicine or an injection or get 'told off' so it is important to clear up any misunderstandings. The therapist needs to say how the child was referred and by whom so that it is not a magic intervention but a process of communicating between adults concerned for the care of the child. When the reasons for meeting are made clear then there should be some discussion about whether it is appropriate to offer play therapy to the child. This requires an explanation of what happens in play therapy and why it might be helpful at this time. So the explanation would include a discussion with the child. Perhaps we might like to play together

because I hear from your social worker, mummy and daddy, teacher, or whoever referred, that some sad, scary, things have happened and perhaps we can sort this out to help you feel more comfortable. We talk about how the child is feeling, perhaps bad dreams, fear of monsters, being bullied, being sad, scared, lonely, whatever the child wishes to say to the therapist at this rather formal first meeting.

The therapist then describes what happens if we play together. We could play together with the toys and other things and as we play with the toys we can make up stories together. These stories will be special between us. They don't have to be about what happened to you, but I bet that some of the same things will have happened to people in your stories as have happened to you. Children seem to accept the rules of imaginative play with much less disbelief than adults do. They are more comfortable with make-believe because they understand the rules of play more clearly than the rules that adults have about what children are permitted to say about their experiences. For example, a child might describe an aspect of sexual abuse and the adult responds with horror and anger which inhibits the child from further discussion because the child feels responsible for the adult's distress. If we make up a story about aspects of abuse, then both child and therapist can express horror or anger through the externalization of the story.

After discussion of how we play, comes talk about the routine of a session. Clarity about this is essential for the security of the child. The rules are about whom is responsible for what. The therapist will bring the toys and will be responsible for bringing the same toys each time and keeping them safe meanwhile. We will play together in a special place and we define the playing space together. If we are in a playroom it may be one half of the room that we choose for the playing area and the other half the 'not-playing' area. It is important to have these two spaces to construct imaginative play as special with its own particular space. In this routine we explain the difference between the play world and the not-playing world. The play world is an extra special 'as if' world where we can make imaginary stories or be imaginary characters.

I still use my play mat to differentiate the play world and many children insist on carrying the mat and laying it down at each meeting to emphasize their control over their own imaginary world. Many children want to set out the place and the space because it is perhaps one environment over which they can gain mastery. The child is expected to play and make stories. That is their responsibility.

Both child and adult are responsible for rules of behaviour. No hitting and hurting, respect for body boundaries, respect for each other. The structure is very important for the child so they know what is expected and feeling safe they can develop their play in the space, through time, with toys and objects.

The routine offers safety and like all routines, the structure can be challenged by the child. The favourite challenge is about time. 'I want it to go on longer' for some children and others use time as self-punishment and stop early even when the desire is to go on.

I warned John that he had five minutes left to play and he got angry. He said he wanted all the toys put out again and I said we hadn't got the time for that. He turned his back on me and sulked before storming off. His mother asked him if he had enjoyed his session and he said that it was very nice and he had played with the sand. He knew that although he stormed off, he was accepted and would be accepted next time we met. He was satisfied with the meeting and he knew I would accept his decision to end abruptly.

Jason only allows himself five minutes of play before stopping, but stays around looking longingly at the toys but refusing to play. It took many sessions before he was able to manage to stay and make a relationship. The rules and structure were very important for him and enabled him to cope with his anxiety. It can at times be a fearful journey to play but also to remember the fear and the terror of past experiences. There is pain for child and therapist.

Conrad describes such a journey in *Heart of Darkness*.

Going up that river was like travelling back to the earliest beginnings of the world, when vegetation rioted on the earth and the big trees were kings. An empty stream, a great silence, an impenetrable forest. The air was warm, thick, heavy, sluggish. There was no joy in the brilliance of sunshine. The long stretches of the waterway ran on, deserted, into the gloom of overshadowed distances. On silvery sandbanks hippos and alligators sunned themselves side by side. The broadening waters flowed through a mob of wooded islands; you lost your way on that river as you would in a desert, and butted all day long against shoals, trying to find the channel, till you thought yourself bewitched and cut off for ever from everything you had known once – somewhere – far away – in another existence perhaps. There were moments when one's past came back to one, as it will sometimes when you have not a moment to spare to yourself; but it came in the space of an unrestful and noisy dream, remembered with wonder amongst the overwhelming realities of this

strange world of plants, and water, and silence. And this stillness of life did not in the least resemble a peace. It was the stillness of an implacable force brooding over an inscrutable intention. It looked at you with a vengeful aspect. We penetrated deeper and deeper into the heart of darkness. It was very quiet there.

The desire to control and challenge the therapist is also hard to resist and when the rules are clear then the challenge is also clear. The child will often take the imaginary play out of the playing area or play at the very margins of the spaces, never quite breaking the rules but showing a desire so to do. There is a delight in this game because it requires bodily skill to control being on the mat but by a hair's breadth. These tactics need to be acknowledged with reminders of the routine and reasons for the boundaries. The therapist as victim is not helpful to the child so rules must be kept, but these challenges are mostly full of fun and the response should likewise be humorous and accepting of the child's need to rule. The toys and objects are very important and used by the child to mediate their world. The toys they like are often those most disapproved of by adults.

Kline (1993) notes that marketers see children as highly informed consumers. Market researchers have also discovered that the appeal of certain toys is the fact that children realize that adults will not like such products and see them as schmaltzy or disgusting or gross.

Slime, which makes rude noises, is a particular favourite with children and brings horror or envy to the faces of carers. The Bart Simpson family dolls bring disapproval if the adults don't like the series. In fact toy products from any TV series are often disapproved of by adults.

Children use these toys not to repeat the TV programme but use aspects of their character to express other narratives congruent with the child's experience. It is through these small rebellions that children gain a little control over their lives and can challenge the power of adults.

Narratives and stories

It is through the narratives and stories that the child and therapist locate common themes important to the child in ordering their experiences. In play therapy we explore formal storytelling and more informal narratives. The difference between a narrative and a story in this context is that a narrative is embedded in a conversation or communication between people and is not necessarily experienced as a story by the listener or speaker, while a story is

communicated intentionally. A narrative is sequenced in time and conveys a meaning. It can be an imagined event or an everyday event, which is described, but the communication between narrator and audience is not formalized as in storytelling. Bruner (1996) called the narrative a construal of reality. He considered these narratives as essential to life in a culture. He defined nine universals of narrative realities.

1. *A structure of committed time.* The notion of time in a narrative is through the unfolding of crucial events in a story with a basic structure of a beginning, a middle and an end.

2. *Generic particularity.* Narratives deal with particulars and these stories are construed in genres. These genres exit in the text, in its plot and way of telling.

In therapy with children who have experienced fear and terror, horror stories are a particular genre used as a way of telling in informal narratives and story-making. So Jane narrated the monster story.

> There was a new monster in the back of the car.
> It is leaving a trail of slime behind.
> The monsters live in Never Never Land.
> They splat everywhere to make lots and lots of monsters.
> The little monster wants to grow so it goes back along the trail making a big monster.
> The big monster eats everything in sight.
> He gets the biggest arms in the world, the universe and then goes to the moon where it belongs.
> Then it farted.
> And if you ever hear noise in the night it's the monster.
> He is farting and he eats everything in the night.
> And he turns green or any colour he wants.
> People who know the monster are scared at night in case he eat them.
> He just opens his mouth and they just become hypnotised and go in.
> The boss of the monster was a monster and very strict.
> If you disobeyed her she would eat you up and swallow you up for dinner.
> The End.

3. *Actions have reasons.* What people do in stories is motivated by beliefs, desires, theories, values or other 'intentional states'. So there is a logic to the actions of the monsters in Jane's story based on her notions of adult cruelty. And perhaps a message to the therapist about how frightening she seems to be and strict as well!

4. *Hermeneutic composition.* No story has one unique construal. Its meanings are multiple and we try to establish an understanding of the whole text through exploration of parts of the text and their relationship to the whole

5. *Implied canonicity.* Part of our interest in a narrative is the way the story can make the ordinary strange so that we consider afresh what was taken for granted. So in Jane's story the boss of the monster is a woman so we readjust to consider this.

6. *Ambiguity of reference.* What a narrative is about is always open to question. Is Jane's story just a horror story and if so why does the monster fart and make us laugh. Is the monster adult or child?

7. *The centrality of trouble.* Stories worth telling are born in trouble. There must be some event of danger, disaster worth telling. However, this is not a once for all disaster. It expresses a time and circumstances so what might be considered a trauma at one time would not always be so. The tragic Victorian single mother thrown out in the snow is bound by time and history.

8. *Inherent negotiability.* We all tell our stories and accept others' versions of the same story. Six witnesses of the same event will have different narratives.

9. *The historical extensibility of narrative.* Through life we create a continuous story for ourselves, an autobiography. We seem to make this narrative by highlighting pivotal points in time when the new replaces the old. We connect our autobiography to the history of our culture, which mirrors these moments of change as a narration of our history.

These constructs can be helpful when considering the stories of children. When child and therapist communicate together the therapist mediates the social and cultural world, which the child inhabits by asking questions about the narratives and stories exchanged in the therapeutic space. The child can test out ideas, construct an autobiography, construct a relationship with the therapist and best of all, play.

Meeting with Daniel

Daniel lives with a family who hope to adopt him but sometimes he feels like a cuckoo in the nest, a bird who flew in to destroy certainty. The parents had already adopted another boy now aged ten and the time before Daniel came to live with them is narrated as a kind of paradise. His new mother just finds it difficult to love him but his father enjoys his company so the family are splitting. The adults acknowledge their feelings and the ambivalence of loving/hating, which is also a family narrative. The parents are exploring their relationship in couple therapy.

Daniel is by disposition a joyful and optimistic child and copes by ducking and diving his way through the complexities of family. He expresses much of his anger at school with the other children.

Our meetings have a structure. I walk along the road to Daniel's house and he and his father see me coming and go down the garden to meet me to help me with the toys. It is a very steep path from the road up to the front door. Sometimes, if it is fine dad and Daniel wait for me sitting on the garden wall. We puff our way up the garden to the front door. A hard journey to get there. I feel my age. Dad helps Daniel and carries my toys.

It seems like a construction of Daniel's place in this family. A hard journey to get to the front door but dad is giving support otherwise it would be an impossible journey to make on your own. I comment on this struggle to the front door to the parents who acknowledge the same perception.

I think of that journey in retrospect and I am reminded of the castle of the giant in Jack and the Beanstalk or St Michael's Mount in the days of Jack the Giant Killer when the Mount was inhabited by a 'huge and monstrous Giant'.

> In those Days the Mount of *Cornwall* was kept by a huge and monstrous Giant, eighteen foot in height, and about three yards in compass, of a fierce and grim countenance the terror of all the neighbouring town and villages; his habitation was a cave in the midst of all the Mount. Never would he suffer any living creature to inhabit near him.

Did Daniel feel he would be eaten up when he entered this house? I think he had the optimism of Jack and he said that he enjoyed adventure. It became a game to enter the castle and become the hero.

Fonagay *et al.* (1994) states that it is reflective-self function that provides protection against the terrifying threat of fusion, passive submission and loss of identity, so frequently observed in the severely maltreated child. Reflective-self functioning and the understanding of the nature of mental

states are closely linked to the capacity for pretence, when feelings, thoughts and objects may be played with and when pretend worlds may be created and inhabited.

So today the castle belongs to Daniel and his dad. At the front door Daniel and dad take off their shoes and I carefully wipe my feet. Daniel is in control because he knows the rules about shoes and he can keep that rule. He looks at my feet, questions why I won't take off my shoes. I tell him that visitors don't have to take off their shoes but they wipe their feet instead. Daniel asks to carry the play mat and he leads the way to the playroom at the back of the house where we meet together. It is next to the kitchen where the two dogs sit and watch us play. He leads and is confident.

This is our third meeting. Daniel is familiar with the routine and confident that this time is special to him and our relationship respected and approved of by all the family. Theirs is a genuine struggle and they want to love each other.

Waiting to start is difficult. Daniel wants to leap into the toy bags and he finds the polite adult conversation a distraction but he can wait because he gets a drink and then dad leaves us and we can settle down together.

We set our drinks on the table and get down to the serious business of play. Daniel places the play mat carefully on the floor next to the sofa facing the fireplace. He wants to control the space and place for play. We sit down together. We discuss my difficulties of settling down on the mat at my great age. He is sympathetic.

Daniel takes out all the bags of toys from my trolley. He checks the bags to see what is new and what is the same as before. He asks if I have the new police car. I say that so far I can't find a small police car. We talk about the difficulty of buying toy cars where the car doors open. We discuss price and good toy shops, the excitement of a trip to buy toys, how he spent his pocket money last Saturday. As we sort out the toys it is also the time we talk together to catch up on family news.

Daniel says he has been better at school and not pinched any of the children and today he has listened to the teacher and done his work. He brought his work home to show mum and dad, and his pictures too. Mum pinned his pictures on the wall. We admire them together. They are pictures of animals.

Daniel becomes impatient and bored by this conversation so we start to play. He grabs all the slime out of the bag, takes each pot of slime and empties it to make a big pile. He takes a plastic head that goes with the slime and

pushes slime inside until it is squeezed out of the mouth and eyes of the toy head.

He tells me this story as he plays.

Once there was a naughty boy called Mr Evans.
I asked what his first name was and said it was rather strange to call a boy Mr Evans.
Daniel said he would have to think of a name and this was difficult. He paused then continued his story:
His first name was John.
He was very silly because he stuck his tongue out and his eyes popped out as well.
The grown ups shouted at him and swore at him.
He got taken away by the police and never came out again.

I asked why the police had taken the boy away. I said that it was a good job this was a pretend story because the police couldn't really take John away. We talked a little about some grown-ups who scare children by telling them that the police or monsters will come and take children away. We decided that this was a bad thing to do because the children got mixed up and didn't understand. We both had a drink together then Daniel took another monster toy and told me this story.

There was another monster called Mr Dino and he ate a slimy worm.
He was sick all over the place and his mum really shouted at him.
'Naughty' she screamed and he ended up in jail.
He came out after a long, long time but he couldn't live with his mum.
I asked what happened to him and how did he manage?

Daniel continued:

Nothing happened to him because he lived on his own and he had some food and a new mum and dad.
They shouted at him when he was naughty.
They didn't do nice things and he got taken back to his old family.
That was a better family.
He was a very naughty monster at school.
He hit the other children and pinched them.
He was cross because nobody loved him at school.

We talked about families and children who have lived with more than one family. How difficult it is to move to another family and the trouble with mothers who shout a lot. He said that all mothers seem to shout.

Perhaps the impact of the new environment is not acknowledged when children move to new homes. Most children say how much they miss their old homes and how difficult it can be to learn how to be tidy and clean when the old home was messy and nobody bothered. Children miss the mess.

Daniel grabbed the toy box and sorted out a group of small dogs. He set them up together with some trees and fences. He narrated as follows:

Once there was a boy called Daniel who had a dog farm.
He took the dogs into his home and they barked because they heard people coming round.
Daniel was kind to the dogs.
He didn't hurt them.
He stroked them in the right direction.
He gave them food and water, toys to play with like balls and other dogs' toys. He bathed them when they rolled in poo.
He gave them chocolate bars.

He was learning the routines in his new home and proud of knowing how to care for the dogs.

The stories come flooding out as he picks up new toys and objects. He often ended a story with the police arriving to take people away or shoot them.

Bart Simpson gets shooted by the police.
Bart Simpson is getting shooted by the police because he is under arrest.
Why is he getting arrested?
Because he is naughty.
Why? What did he do?
Because he hurted the baby.
(Daniel arranged some soldiers with the other objects.)
The soldiers are asleep and they are annoying the police.
Everybody in Bart Simpson's family is getting shooted by the police.
They woke the soldiers up so they are getting shot.
They can't cry because they are dead.

What does it mean to be dead?
When you are dead you have to go to Devon.
You got buried.
The car is between them.
The soldiers didn't care that they had killed the family.
They were very naughty not to care.

Daniel continued talking as he finished the story

> Have you seen Cinderella?
> I don't like the horrible bits but I like the sad bits and the happy bits.
> *What are the horrible bits?*
> The horrible bits were scary but I liked the horrible bits too.
> Where is Rose?
> (Rosie is the puppet dog. Daniel gets her out of her bag. He works the puppet.)
> Come and watch me Rosie.
> Rosie sit by Ann.
> Do you like the soldiers Rosie?
> (Rosie nods.)
> What shall we do with her?
> *Just let her play with them.*
> (Rosie picks up the soldiers.
> Daniel plays with the Simpson family dolls. He puts Rosie next to me.)
> The dad went to pick the baby with his pickaxe.
> *Why did he do that?*
> Because the baby is very naughty.
> (Daniel lifts Rosie who licks Ann.)
> *Your dog is licking me.*
> She wants to lick me because she likes me.
> Mummy won't mind.

Daniel began to talk about his birth mother.

> I slept on the sofa with my old mummy.
> My sisters slept outside in the rain.
> We had no bed, no sheets.
> I don't mind about her.
> I don't care about her.

Daniel began to look at my story book. He was very interested in the way I wrote down his stories. He looked at my writing, admired my book and we counted the pages I had written today, which contained his stories. He asked me if I showed them to my daddy when I got home. I told him that the stories were private between him and me and that I kept them in my book so we could remember them if we wished.

It was interesting the way he connected bringing home his good work from school and his mother hanging it on the wall, with me going home to do the same with my daddy hanging up the story he had written. The sense

that my life mirrored his life. He had commented on my great age at the beginning of our meeting but still assumed that I had a daddy who had to approve of my work. Daniel began to talk about his birth family and his adoptive family. He again commented that all mothers shouted. All his friends at school had mummies who shouted.

He told me about his birth mother and how they lived in one room and it was dirty and not very comfortable and sometimes when his mum was asleep he switched on the television and watched.

We sat in companionable silence. I said it was time to end now, so we put away the toys. Daniel talked about the two dogs that sat in the kitchen during our sessions, watching from their safe place. Daniel asked for a fairy story like Cinderella. I told him *Jack the Giant Killer.*

Jack the Giant Killer

Once upon a time – a very good time it was – when pigs were swine and dogs ate lime, and monkeys chewed tobacco, when houses were thatched with pancakes, streets paved with plum puddings, and roasted pigs ran up and down the street with knives and forks in their backs, crying 'come and eat me' that was a good time for travellers.

Then it was that I went off over hills, dales and lofty mountains, far farther than I can tell you tonight, tomorrow night, or any other night in this new year. The cocks never crew, the winds never blew, and the devil never sounded his bugle horn to this day yet.

Then I came to a giant castle; a lady came out of the door with a large nose as long as my arm. She said to me she says, 'What do you want at here? If you don't be off my door I'll take you up for a pinch of snuff'. But Jack said, 'Will you?' and he drew his sword and cut off her head.

He went into the castle and hunted all over the place. He found a bag of money and two or three ladies hanging by the hair of their heads. He cut them down and divided the money between them, locked the doors and started off.

Then Jack came to another giant's castle, but there was a drop over the door. He slipped in as quickly as he could but nevertheless the drop struck him on the side of the head and killed him. And the old giant came out and buried him. But in the night, three little dogs, named Swift, Sure and Venture, came and dug him up. One scratched him out of the ground; one breathed health into his nostrils, and brought him to life, while the other got him out of the grave. Then Jack pulled on his cloak of darkness, shoes of swiftness and cap of knowledge. He went once more to the

giant's door and knocked When the giant came out of doors he could see nobody Jack being invisible. He at once drew his sword, and struck the giant's head off. He plundered the house, taking all the money he could find, and went into all the rooms. He found four ladies hung up by their hair, and again dividing the money between them, turned them out and locked the door.

Then he went off again over hill over dale.

Then Jack came to another giant's castle. He knocked at the door and an old lady came out and he told her he wanted to lodge for the night. She said that her husband was a giant and if he comes in the castle while you are here he will smell you and kill you. But never mind I'll put you in the oven. When the old woman was not looking Jack got out of the oven and went upstairs into a bedroom. He put a lump of wood in the bed and hid underneath. By and by the giant came in. He said

> Fee, fi, fum,
> I smell the blood of an Englishman
> Let him alive or let him be dead
> I'll have his flesh to eat for my bread.
> And his blood to drink for my drink

He then went down to supper and after eating he slept. When he woke up he said to his wife, 'Now is the time for me to find the man that is here.' He went upstairs with his club in his hand. He hit the log in the bed three times. Every time Jack groaned under the bed until the giant said, 'I think I've finished you now.' He went downstairs, talked to his wife for a while then he went to bed.

At breakfast next day he was very surprised to see Jack and said 'How do you feel this morning?' And Jack said 'All right, only in the night a mouse gave me a slap with his tail.'

Then they had breakfast. It was a pudding only there was poison in Jack's and instead of eating it he put it in a leather bag under his shirt. When they had eaten breakfast Jack said 'I can do something more than you'. The giant said 'Can you?' 'Yes' said Jack and pulling the knife out of his pocket he slit the leather bag and loosed all the pudding out on the ground. The giant trying to follow Jack's example pulled out a knife and wounding himself fell dead immediately.

Then Jack found two or three ladies hanging up cut them down took a bag of money that was lying on the table and then went out and locked the doors.

> Be bow bend it
> My tale's ended.
> If you don't like it
> You may mend it.

Daniel said that he thought this story was better than Cinderella because it was a story told by me and not a play in the theatre. The problem with the theatre was that you had to mind your manners and when they went to the pantomime he got into trouble for pinching a girl.

We had some quiet moments together as I put the toys away. We folded the mat, said goodbye to Rosie again. It was ended. Daniel called up the stairs to his father, 'You can come now. We've finished.'

Daniel went upstairs to play. Dad and I talked a little then I left. Daniel came to say good-bye. I skated down the drive. Dad took my toy bags. Daniel waved. The hard path up to the front door and the slippy path back to the main road. We all need help and support on that journey.

In this session Daniel moves from one story to another very quickly. He explores a variety of families, the place of children in families, how to nurture, who can children nurture, losing your family, being taken away, fear of the police, soldiers, those external forces that take you away, what happens when you die. Imaginary stories are interspersed with narratives about home, school, the past, my life connected to his life. It all tumbles out in a rush. He needs the rules of play, the clarity of structure to contain his experiences. We are at the beginning of our time together. We have time to repeat and reflect on these themes and subsequently did so again and again.

I feel the physical battle to reach the house, up the steep path to the front door. Daniel's joy and energy can be difficult to hold in the structure of the play but he stays contained and I just manage to follow him as he moves from narrative to narrative. Afterwards, I slip down the path to the main road thinking about Jack the Giant Killer. That's a breathless story too. I expect that is why Daniel likes it. I remember the beginning: 'Once upon a time and a very good time it was... That was a good time for travellers.' I leave the slippery slope for the main road but will climb the path again so we can travel on together.

Children's views of the meaning of play therapy

Jenny

Jenny is ten and comes to see me because she was sexually abused by her stepfather who is now in prison. She lives with her mother who has eight children and life is a bit like the old woman who lived in a shoe.

> There was an old woman who lived in a shoe
> She had so many children she didn't know what to do;
> She gave them some broth, without any bread,
> She whipped them all round, and sent them to bed.

Jenny says it's a bit like that except that mummy shouts a lot and doesn't hit. It is hard for Jenny to fight for her place in the family. Her best friend is her sister who is pleased that Jenny comes to see me and says she is lucky to be able to play. Jenny is finding her voice and has her special pleasures and fun. We paint and play and tell stories. She liked the story of The Lion and the Mouse.

The Lion and the Mouse

One day a lion, having nothing better to do, caught a mouse, and was about to pop the tiny creature into his mouth, when in its squeaky voice it pleaded with the lion for its life. 'Let me go O mighty King of Beasts' it cried, 'I am no meal for you.'

'How dare you speak to me' growled the lion.

'Because you are the King of Beasts' answered the mouse 'and so are bound to listen'.

'Suppose I choose to eat you just for fun' said the lion.

'That is surely beneath your dignity' answered the mouse.

'If you do eat me you will be just as hungry afterwards. Apart from that if you let me go alive the day may come when I shall be able to do you a good turn.' This idea so much amused the lion that laughing loudly he let the mouse run off. Some time after this, in the same part of the forest, the lion ran into a net spread in his path by hunters. At once he became tangled, and as he struggled and struggled he became more stuck in the net.

He became exhausted by his efforts to escape and finally lay still in fear and despair. He thought he might die because if his strength couldn't free him then he was doomed.

In the silence of his fear and despair he heard the voice of the mouse. 'Here I am, if you will be still and quiet I will soon set you free, for I have not forgotten my gratitude.'

And with that the mouse began to nibble through the cords of the net, and soon its sharp little teeth had cut so many that with one great pull the lion broke the rest and was free once more.

> Moral.
> Never despise a humble friend.
> Perhaps he'll save you in the end.

After six months' therapy with Jenny I asked her if she remembered why we were meeting together. Jenny said: 'Because I am nice'. I asked her why we play and she said:

> My sister says I'm lucky to play.
> She want to play.
> We play because I'm nice and you are nice.
> We play together and that's nice and my sister says it's nice.

Jenny laughed and I laughed at so many 'nice' things and people. So together we mediate memories of violence, fear, neglect; telling horror stories of the 'gorilla man' and the dreams he left behind. Like the mouse in the story, 'being nice' can save you from the wrath of the lion to negotiate your way through the snares of this life. So that's a strategy and we know it for what it is.

Alan

Alan is six and he is in foster care waiting to find out where he will live. He likes it where he is. He worries about his future. He likes to play. He wants me to listen to him. He saw his mum die of a heart attack. It was scary. He misses his mum. His dad did funny rude things. He likes to tell stories. Horror stories.

> There was once a giant called Mucky Guts
> and he picked up a police car
> and picked up a little baby
> and a person cried for it
> and he put the baby in the boot of the car
> and shakes it all about
> and the baby died.

then he took her out,
looked at it
and it was dead.
The End.

Those big people again. No chance, for a baby even if 'a person' cared.
I asked Alan to tell me story of why we meet together.

Once upon a time there was a lady called Ann
and a boy called Alan
and they met together and played together
to help Alan about his dad
because he couldn't look after him
and Alan felt horrible.

Alan wants us to play together until he has a new family and feels comfortable with them.

John

John and I have known each other for four years. He is eleven. He is in foster care and has moved from place to place for a variety of reasons not of his making. Twice he was about to be adopted but illness or other life events prevented this happening.

John is resilient. We constantly narrate his capacity to cope. He clearly remembers all the places and people who have looked after him. He says everyone has been kind to him. He longs for love of an idealized kind. He thinks he is unlovable. I asked him how he saw the relationship between us. He said he would draw a picture to explain. He said that the relationship was the monster and the therapist with the broken heart. I was shaken by this insight. He taught me more about myself than I wanted to know. We talked about these two people.

Could my broken heart be mended and what kind of monster was the monster and could the monster transform into the prince. Well not at the moment. I had to hold on to my broken heart because the world is a sad place and with the story of John's life I would be silly not to be broken hearted.

We searched for a fitting 'monster' for John and decided on the highland Bodach. He is a small and shaggy creature wrinkled and brown in appearance standing some twenty-five inches in height dressed in tattered brown clothes.

The Bodach 'adopts' a house which he then looks after. He has a very strong sense of responsibility and will come out at night to look after the house and the household animals. All he wants for this is a bowl of cream or best milk and a cake smeared with honey. If he gets too much kindness he will take offence and leave. Bodachs are unpredictable in their behaviour and if offended turn from helpful Bodachs into troublesome Boggarts. We thought this was a good match; the Bodach and the broken-hearted therapist. So that is where our narrative stands at this moment and we are comfortable with the story.

The man with the inexplicable life

This final story is for therapists. We make stories and narratives to explain ourselves to others and to ourselves. We adapt and amend for particular audiences. We change and negotiate meaning all the time. We listen to the stories other people tell about us and we amend our stories in the light of this information. This is a Sufi story called 'The Man with the Inexplicable Life'.

Once there was a man called Mojud. He worked in a small town as a small official and he hoped to become Inspector of Weights and Measures. One day as he was walking in the garden of an old building near his home, Khidr the guide to the Sufis appeared to him dressed in beautiful shimmering green.

Khidr said 'Leave your work. Meet me at the riverside in three days time'. Then he disappeared.

Mojud left his work.

Everyone in the town heard of this and said that poor Mojud had gone mad. Many people wanted his job and they soon forgot him. On the day Mojud met Khidr who said to him 'Tear your clothes and throw yourself into the stream. Perhaps someone will save you.' Mojud did so, wondering whether he was mad.

Since he could swim he didn't drown but drifted and drifted down the stream.

A fisherman hauled him out of the stream saying: 'Foolish man. The current is strong what are you trying to do?' Mojud said 'I don't really know'. 'You are mad' said the fisherman 'but I will take you to my hut and we shall see what we can do for you.' When he discovered that Mojud could read and write he learned from him in exchange for food and Mojud helped the fisherman with his work. After a few months Khidr again appeared to Mojud and said 'Go now and leave the fisherman. You

will be provided for.' Mojud left the hut dressed in fisherman's clothes and walked until he came to a highway.

He saw a farmer on a donkey on his way to market. 'Do you want work' said the farmer 'because I want someone to help me bring back some purchases'.

Mojud followed him.

He worked for the farmer for nearly two years by which time he had learnt a great deal about agriculture but little else.

Then Khidr appeared to him again. 'Leave that work. Walk to the city of Mosul and use your saving to become a skin merchant'. Mojud obeyed and worked as a skin merchant for three years. He made a lot of money. He wanted to buy a house.

Then Khidr appeared and said. 'Give me your money, walk out of this town as far as Samarkand and work for a grocer there'. Mojud did so.

Presently he began to show signs of understanding. He healed the sick, served his fellow men in the shop and his knowledge of the mysteries became deeper and deeper. Many visited him and asked 'Under whom did you study?' 'It is difficult to say' said Mojud. His disciples asked 'How did you begin your career?' He said 'As an official.' 'And you gave it up to devote yourself to self mortification?' 'No, I just gave it up.' They did not understand him. People approached him to write the story of his life. 'What have you been in your life?' they asked. 'I jumped into a river, became a fisherman, then walked out of his reed hut in the middle of one night. After that I became a farmhand. While I was baling wool I changed and went to Mosul where I became a skin merchant. I saved some money there and gave it away. Then I walked to Samarkand where I worked for a grocer. And this is where I am now'. 'But this is inexplicable behaviour. It throws no light upon your strange gifts and wonderful examples' said his biographers. 'That is so' said Mojud. So the biographers constructed for Mojud a wonderful and exciting history; Because all saints must have their story and the story must be in accordance with the appetite of the listener not with the realities of the life. And nobody is allowed to speak to Khidr directly. That is why this story is not true. It is a representation of a life.

References

Bruner, J. (1996) *The Culture of Education.* Cambridge, MA: Harvard University Press.

Burr, V. (1995) *An Introduction to Social Constructionism.* London: Routledge.

Conrad, J. (1902, 1994) *The Heart of Darkness.* London: Penguin.

Corsaro, W. (1997) *The Sociology of Childhood.* Thousand Oaks, CA: Pine Forge Press.

Fonagay, P., Steele, M., Steele, H., Higgitt, A. and Target, M. (1994) 'The Emmanuel Miller Memorial Lecture 1992. The theory and practice of resilience'. *Journal of Child Psychology and Psychiatry 35*, 2, 231–257.

Goffman, E. (1959) *The Presentation of Self in Everyday Life*. New York: Doubleday.

Kline, S. (1993) *Out of the Garden; Toys, TV, and Children's Culture in the Age of Marketing.* New York: Verso.

Lax, W. (1992) 'Post-modern thinking in a clinical practice.' In K. Gergen and S. Mcnamee (eds) *Therapy as Social Construction*. London: Sage.

Le Vay, D. (1998) 'The Self is a Telling', MA thesis. London: Roehampton Institute.

Malone, M. (1997) *Worlds of Talk*. Cambridge: Polity Press.

Shaping Connections
Hands-on Art Therapy

Cathy Ward

Introduction

In art therapy it is the process that is so important and deserves our attention. In this chapter I am going to be showing the fundamental nature and function of *process* in the art therapy encounter. It is the trunk and roots of the art therapy 'tree', that allows the healing sap of change to flow: it is the change itself.

The chapter is solely concerned with the art therapy process.[1] In it I am going to look at several inter-connected themes to show their impact on this process. I will discuss these themes in relation both to my personal and my professional development. These themes are:

- the central role of the body
- the externalization of processes of change through transformation of media
- the influence of race and culture
- the birth of meaning

In this chapter, I have emphasized the importance of combining a personal with a professional awareness of the art therapy process. This is because our personal experiences as an artist, or as a client of particular approaches, shape the way we intervene therapeutically with others (see Jennings 1998). As Harriet Wadeson also says: 'The art therapy process begins with the art

[1] For people wanting a historical overview please see: Waller, D. (1991) *Becoming a Profession: The History of Art Therapy in Britain 1940–1982*. London: Routledge.

therapist… and who she is determines the nature of the therapeutic interaction' (1995, p.7).

Art has had a major role in my own developmental process from early childhood. It gave me a personal language and a form of self-expression that I valued greatly. After school I changed dramatically from an academic career to studying fine art and then clay sculpture at post-graduate level. But it was my sense of finding a voice for my creative self through art that dominated my study and practice.

It was not until after I had worked as a community artist for a year, with an art therapist as supervisor, that I decided to train as an art therapist. Since then I have worked mainly in social services with a varied client group, most recently with families. I was a part-time art therapy lecturer for many years at the City University. In addition, as a manager, I have used art therapy methods in consultancy sessions with staff teams to team-build and to mobilize energies for planning service delivery.

My theoretical background is broad. The following are four of my main areas of interest. First, I take the view that it is the relationship with both the therapist and the art process itself that bring about change in art therapy. Second, I prefer an inclusive approach with the accommodation of difference at its core (see Campbell 1993). This is because traditionally therapy has been a white, middle-class, heterosexual and European construct. This has seriously limited its scope and relevance to those from different social or cultural backgrounds. Third, I have a growing interest in the impact of race and culture on my own practice and the art therapy process in general (Liebmann and Ward 1999). The implications of this new field for art therapy enquiry are only beginning to be recognized. A fourth influence is the spiritual dimension of therapy: a dimension which is intensifying in my own personal work (see Milgrom 1992).

Practically, I try to encourage a positive problem-solving approach, which fits well with service requirements for briefer, more task-focused methods. I have been very influenced by recent advances in family therapy. These improvements attempt to address the power imbalance between client and therapist by acknowledging the political, socio-economic and cultural contexts in which both client and therapist exist.

What this means is that my approach is down-to-earth, literally when clay is being used, and flexible. I emphasize building on the strengths of families and the 'unique outcomes' (White 1990) they can create in their own lives.

In the stories that follow, I will show the connection and differences between my own process and that of the people I have worked with, and the influence of one on another. To do so, I am going to trace and connect key process points from my own therapeutic use of art, with process points from the stories of the people I have worked with.

Hands-on stories

1. Hands-on analysis

My story starts with a memory. This was from an early analytic session with Donald Winnicott[2] when I was in my teens.

During a two hour session, there had been only intermittent speaking. I don't know when I noticed the hand; it was Winnicott's hand lying on the edge of the desk. Could I trust myself to come out of my closed cell/shell of doubt and fear? Could I touch his waiting hand? and what would I, or what would it do if I did? I took the risk: to lay my hand on top of his. I made a huge leap from isolation, mistrust and doubt to a slow but radical beginning of a relationship through the physical medium of his hand, and the physical medium of my hand: like starting life again; like starting life.

REFLECTIONS ON THE PROCESS

What this experience gave me was evidence of a holding and a relationship in a concrete form, that I think would have been almost impossible to recreate as powerfully in a verbal way. The physicality of this relationship was not imposed; but waited for me to respond. Theoreticians could analyse this through different symbol formations.[3] For me, the most important thing was a symbolic and actual finding of safety with another human being, and building trust through the creative channel of the body.

Our ability to relate often needs repairing; and the above example demonstrates how this can be done briefly, but significantly.

2 D.W. Winnicott (1896–1971), influential psychoanalyst and writer, was a great innovator within the psychoanalytic tradition.

3 For a classical Freudian perspective see: Freud, S. (1954) *The Origins of Psychoanalysis*. London: Imago. For papers on clinical psychoanalysis from a Kleinian position see: Klein. M., Heimann, P. and Money-Kyrle, R.E. (eds) (1955) *New Directions in Psychoanalysis*. London: Tavistock. For Winnicott's views on psychoanalysis: Winnicott, D.W. (1958) *Collected Papers: Through Paediatrics to Psycho-analysis*. London: Tavistock.

2. The baking of bread

One of the joys of being a member of an alternative community in the seventies was the personal access to a lively food co-operative. A member of the co-op ran the wholemeal bakery and delivered warm crusty loaves on his bicycle.

After having been part of this community for a while, I was able to witness the bread-making process. This took place on a large wooden table in one of the communal kitchens. I was surprised to see the leftovers from last night's vegetarian supper being added to the dough in the mixing bowl, and then even more surprised that the table did not get wiped before the dough was turned out on to it. The table was rarely cleaned and there were remnants of past meals and snacks on it. All of this got incorporated into the dough. I was told that this would add to the taste and quality of the bread. The transformation of this rich mix into mouthwatering hot 'doorsteps' was evidence enough that this was the case.

REFLECTIONS ON THE PROCESS

The learning from this story is about the pragmatic use of materials/ingredients. Our usual assumptions about what is clean or dirty no longer apply. Rubbish is put to new use; it is transformed through the process of cooking and digesting. This different way of making meaning reminds me of the art therapy process, which often deconstructs and then reconstructs our beliefs and actions. There is a similar transformation of materials into outcomes and understandings that nourish and sustain. This story demonstrates the inclusiveness of my approach to art, life and food and the fundamental processes of change and transformation that are all around us.

3. Clay, a significant other

Here I am. Clearing away the debris on my kitchen table; moving aside the bills and to-do lists and literally making some physical space and time to touch clay; to reconnect with it as with some long-lost love. Tears come at the thought. It was the first passion of my adolescence, and it is still with me today. This story is all about love.

At the table I settle myself with a tape recorder and the clay. I will use clay now, and voice my thoughts and record them as a running commentary, to try and capture and understand the process.

I squeeze it delicately. My being is given meaning from this simple gesture, of reaching to touch. I am here. I exist.

I touch the clay, remembering that once it was a new experience. Now it is like meeting with a familiar friend. And still the immediate intimacy, the immediate risk: of touching the mess of clay, the unknown.

This clay is too safe; clean from the bag, convenient, white, sanitized. The clay I remember and prefer is rich, dark, red, sometimes smelling of earth and mould and fecundity; sometimes gritty with a mixture of different clay bodies, bodies![4] I like the way, through its texture and colour, it can speak to me. I touch and influence it, but it touches and shapes me. There is give-and-take. Some clays fashion and respond to me as strongly as I to them. It is a relationship.

In my adolescence, at the time I began using clay, it was a life-line. Besides the relationship with clay and Winnicott, I wrongly believed I had no other.

Now, in this moment, I am shaping ears, animal ears, cow-like... now tiger-like! The clay is soft and willing. I am sculpting a jaw and eye-sockets and a strange concave brow. What is this creature? What is its pedigree or story or meaning?

Aah! Something begins to take shape. Something that takes me back, reconnecting with past themes. I see a skull. I don't know whether it is an animal skull; yes, like a series of those I made years ago. In fact I gave small glazed skulls , shaped rather like faeces, to Winnicott, and they lived on his bedside table for some years. I remove clay, as though peeling it away from the forms I want. This *is* a skull. It brings tears. I remember I have been reflecting on death recently but without making time to find out why.

I laugh: I am creating a heart-shaped skull. How can a skull be heart-shaped? I find myself thinking that I want my death to be heart-shaped.

Now as the form is clearer, do I want to use modelling tools? No, just my hands. I grasp the clay and it is a struggle; I have to pull and push it – fight with it and yet not really, but it does take effort. I am shaping the clay and using the clay and reapportioning it, into my shape, the shape I want. From the mess and the previous meaninglessness of the lump, I am making changes.

From the back it looks like a giant strawberry. I work on the back for a while. What will it look like when I turn it round?

4 A clay 'body' is the term used for the particular mixture of ingredients that determine a clay's physical characteristics before and after firing.

Turned round, it looks childish, squashed and misshapen. Can I live with that childishness? Can I confront the childishness of my trying to look at death?

I stop working on the clay, I have to think about this. I notice the rain outside. There is a stillness as I reflect, holding and turning over the ideas about death, like turning over the clay, looking at it from all sides. I feel a helplessness and stare at what I have made: a strawberry, heart-shaped skull, which gazes at me, incomplete, messy.

I renew contact, deepening the eye sockets. One wants to be larger than the other: asymmetric, imperfect – a characteristic I love. Now I'm tracing shapes that have accidentally arrived in the clay; exaggerating or going with them; playing with them in a strange shifting aesthetic; an interplay between the accident of the shape in the clay and my reshaping of it. I'm playing with the 'accidental' all the time. I am in a conversation with the clayness of the clay.

A lovely sphere is coming! A sphere has emerged out of the shapelessness, the sphere of the eye socket. I turn the clay over. It is drying. I must keep it damp.

What is this object? I turn it back over. It has no meaning. *It has no meaning.* I do not recognize or understand it. I do not want it, this thing I have created.

I decide I'll leave it and come back to it.

A tiredness creeps up on me – I feel spent, relaxed. I can curl up and sleep for a while. Without effort, I am back in touch with my own natural rhythms.

REFLECTIONS ON THE PROCESS

Clay is clearly a 'significant other' in my life, when I think about my continuing use of the medium. This story shows the intense relationship and interactions that I have with it. There are some obvious similarities and differences between this and the previous stories. The immediate connection that I see is touch: hand on hand, dough and clay. In each of the stories positive and nourishing experiences have been offered. In the second story, I was witness to a ritual (one of many) that changed my assumptions about food for ever. The other two stories are more associated with an atmosphere of acceptance and safety; in the first, through the analytic relationship, and in the third, the one-to-one with clay. Perhaps the major connection here was the sense that both the analyst and the clay were responsive and waiting to be used. At the end of his life, Winnicott said with some satisfaction that I 'had

Figure 5.1

Figure 5.2

Figure 5.3

Figure 5.4

really used him'. I had certainly gained a deep and liberating sense of my own being from him. Perhaps this was what gave me the confidence to make my mark and be 'myself' when working creatively with media.

In the therapist's voice

As I have said in my introduction to this chapter, I want to comment on some key themes that have shaped my personal use of art therapy as a healing tool and that have formed my therapeutic practice. These themes have emerged strongly from the commentary above and I now want to discuss and elaborate on them in more detail.

The central role of the body and its relationship to art media

The way that someone relates to a medium through their body and body language can become the mirror for their being. How the body is used is a powerful message to the therapist of an individual's state of mind. It can give significant information about how that person is approaching the challenge of meeting with this particular medium in this particular moment. The experience can have its own terror when the emptiness of the waiting page or untouched clay can numb and can dismay us all. It is like the moment of risk when we stand on the edge of any new experience or relationship. How we approach that risk is a powerful marker.

It was important to ask the question in my commentary 'Do I want to use tools in this work?' At the time, I wanted to carry on using my hands. In my personal and professional experience, tools can sometimes minimize the richness and the power of the experience. They can also be a safe stepping stone from which to build confidence in the more instinctual processes that hands-on contact with media can foster. Finger painting is a very different experience from using a brush, sponges or scrunched up paper to make marks. Tearing paper is not the same as cutting paper with a pair of scissors. At times it can be important to extend our bodies through the use of brushes. All these methods have their own place and can be chosen by the client or the therapist as appropriate.

The actual physical struggle and contact between the medium and the body is so important because it is through the struggle that creative solutions are often found. Through art therapy, the physical release of tension happens. This very special quality of externalizing through a tangible medium is at the heart of the approach. Wrestling with a three-dimensional medium, or with

paint using a paint brush or with the fingers is all part of healing and creating a balance between the whole body and mind. I would like to suggest that art therapy brings about a homeostasis because of the balance it encourages between physical, mental and spiritual, conscious and unconscious, processes.

CHOICE OF ART MEDIA

One of the joys for me is the flexibility and responsiveness of clay to my every touch; from the most tender or fragile to the most robust. Wedging clay, which is the energetic cutting and slamming down of clay on a hard surface to remove air bubbles, is pure therapy. I have set it as a task for people who need to 'let off steam' when its dual significance can be overtly or covertly enjoyed. Clay has a powerful three-dimensional voice in the art therapy conversation and has a major impact on what can be expressed. This is true of any medium: though some media have stronger or more distinctive 'voices' than others. If we listen to these particular voices, the work we produce has a special quality to it. For instance, pencils and rubbers, felt-tip pens or water-colour paints with fine brushes, can be used when the controlled, adult aspect of the work is important. In most cases, a choice from a broad range of media creates a context for people to find their way to a medium that reflects their particular state of mind. For the same reason, choice in terms of various sizes of paper, brushes and other equipment is crucial. The qualities and other attributes of the medium join forces with our own creative purposes to deliver a clearer healing message; and to mirror our sensory requirements more accurately. Media are like homeopathic essences: we choose them to meet our particular needs for healing.

Building connections

Building a relationship through a particular medium is a powerful and sensuous experience, not unlike the power and sensuality of a relationship between humans. The medium has its own qualities; it responds and reacts and has to be grappled with, in the same way as a human relationship does if it is to progress. This is one of art therapy's most potent qualities. The growing relationship with the medium is like the growing relationship with the therapist and promotes the entry into the widening sphere of the outside world. The significance of this playful rehearsal for living is similar to the connection between acting and reality that Jennings and Minde (1993)

describes: 'Through acting, we are empowered to act'. In art therapy, it is the dynamic engagement with media, within the boundaries of the therapeutic relationship, that prepares us for life. Winnicott also makes this his theme in *Playing and Reality* (1971).

For me, conversing with the unconscious through clay is about making sense of different shapes as they emerge; about allowing them to connect up with different recognitions, like a continuing Rorschach test.[5] This intercourse between the physical, sensual nature of the medium and the unconscious brings about the birth of meaning. On the tape that records my commentary while using clay, there are many involuntary noises: cries, 'aaahs', and laughs, that underline the sensory nature of the experience for me, like a physical intercourse or a birth. The recognition of meaning and insight is accompanied and expressed in a concrete way through the sounds, shapes, ideas and stories that emerge. In client work, the different physical, intellectual and spiritual ingredients of the experience are inseparable. These connections mean that there has to be a respectful and confidential relationship with images and three-dimensional work once they have been made. How and where images are kept and who can see them or touch them need to be carefully considered. Art therapy is an integrated experience; on so many different levels these ingredients interconnect and interact.

Shaping meaning

Playfulness and spontaneity are in a dynamic conversation with the medium as the 'other'. The play takes place on the margins of the unconscious. Although I do not usually adhere to the classic Freudian interpretation of symbols i.e. snakes as penises, mountains as breasts etc., I often reflect on the different meanings of particular images and stories that emerge through art therapy interactions. I use a Gestalt approach, animating images and asking them to become more explicit in their conversation with me; to speak their mind, and to offload their message. I am interested in the universal meanings as well as the personal ones; both add to the understanding of that particular image. These images generate information to use or not use as appropriate in the therapeutic interaction. I seem to remember that in later years Winnicott said that the greatest skill is in not speaking, or interpreting, in the analysis, but allowing the client to find their own way to their own meaning. This is very much in line with recent systemic and narrative approaches (White

5 A Rorschach test is a test using ink-blots to explore mental states and feelings.

1990; Hayward 1996) which explicitly put the power back with the client to positively shape their own insights and therapy.

The message from the unconscious through the image can be a prompt about something that requires attention like an internal email, that needs to be opened up and read.

In my conversation with the clay I was able to allow the skull to become a heart-shaped skull. I could then play with what that idea might mean, layering different, sometimes contradictory meanings about life, death and love, on top of each other. This provided many fruitful possibilities to be meditated upon.

Art therapy applications

The beauty of the medium is its accessibility and appropriateness with a wide range of client groups. It is particularly useful with survivors of trauma, who can use it to rebuild personal boundaries (see Murphy 1998); with people recovering from strokes, to restore concentration and co-ordination in the hands; and with people who are visually impaired, where the medium offers the scope for greater sensory articulation. To make sure that people are disabled as little as possible during art therapy sessions, it is particularly helpful to create a positive emphasis by offering a flexible and adaptable approach to use of the media. For instance group painting for people in wheelchairs can be particularly successful using brushes taped to the ends of garden canes, with large sheets of paper on the floor. People who have limited ability in their hands and arms can also enjoy using different consistencies of clay, paint and other media when they are given the opportunity to see which consistency or tool is most suitable or comfortable for them.

In the following accounts of work with families, I will illustrate some of the themes that I have discussed above. I will be looking at points of significant change and the processes that accompanied them. This will be in relation to the use of the body and of particular media and the impact of race and culture. I will also discuss the building of relationships and the learning and insights that occurred for both the families I worked with and myself.

Art therapy with families

When I began work at the family centre, I aimed to set up and run specific interventions with the focus on using art therapy techniques to meet the families' identified needs. However, I soon found that the most effective

work came out of a multi-disciplinary approach. As a result of this, I joined with colleagues in organizing co-worked programmes for families. In these I would offer art therapy for parents and young children as part of family parenting and play sessions. I found I was able to work with mothers and very young children using paint and other media. Here the hands-on approach really did bear fruit. Babies as young as a year can enjoy mark-making with fingers or simple brushes. A family painting on a single piece of paper provides an ideal arena for a non-verbal conversation. Parents can be shown that the aim is about enjoying colour and shape and playful interaction, not clever art. These creative interactions seem to have a positive impact on family relationships. However they also show up more dysfunctional aspects; for instance in a joint picture with a mother and her eighteen-month-old child. It was possible both to witness at the time (and afterwards captured on the paper) how the mother had been unable to share the 'space' of the paper with her child. She first pushed the child's playful mark-making to the very edge of the paper and then obliterated the child's contribution with her own marks and colours. This graphically reinforced concerns about this mother's own level of need and her inability to respond to those of her child.

To summarize some key features of family art therapy sessions:

- the images demonstrate the strengths and concerns in family interactions

- sessions can be organised in a range of ways: individual, whole family, parents, children etc.

- the approach encourages usually a positive, fun experience which consolidates the family unit in a creative way

- it helps build channels of communication and rehearse new ways of being together

- it provides permanent records on paper or in clay that can be compared with future and past work

- the image as a record of an interaction is also a form of 'mirror/observer' that can offer useful insights for family members

- families can be helped towards change by recognizing helpful/unhelpful patterns highlighted through these visual interactions.

Cultural connections

I mentioned earlier in this chapter that I have become increasingly interested in the impact and influence of race and culture on our practice as therapists. As a member of the Art Therapy, Race and Culture group (a sub-committee of the British Association of Art Therapists), I have been considering, along with other members, how positive racial and cultural identity are best sustained through the use of art therapy.

Working within a social services setting for most of my career, I have developed a broad equalities framework to my work. Within much of social services there is a recognition that differences in socio-economic power impede the process of social work or therapy, if they are not addressed on many levels. In the centres where I have worked, we have evolved a 'strength' model which builds on consolidating family resources. This is to confront racist practice and to prevent the pathologizing of people for their differences from a white 'norm'.

The aim is to integrate race and culture into every aspect of service planning and delivery; also to create a multicultural environment where consolidation of people's racial and cultural identities is part of the therapeutic process. To really take account of power imbalances and ensure as equitable a therapeutic process as possible, it is important to:

- recruit more Black practitioners, including those who speak relevant languages
- prioritize how buildings look to make them more welcoming and accessible to people from different backgrounds
- ensure practice rooms are appropriately decorated and equipped – again with the emphasis on creating a multicultural environment.

In order to understand the issues and my own identity better, I began to think about my assimilated Jewish upbringing, and its impact on my role as a therapist. I joined a Jewish art therapists' and Jewish family therapists' group to trace how our individual and collective stories have shaped our careers and lives. It soon emerged how often our cultural background had been a driving force behind our training as therapists and commitment to therapy.

Some important and painful themes have come to the fore. These themes touch on intergenerational trauma and discrimination and experiences of being a refugee. In my own case, the dilemmas of assimilation have given me an insight into the losses as well as the gains of a sense of belonging and identity in the process of acculturation (see Mathews 1998). I take these

Insights from my own and my colleagues' experience into my work with families. I believe what I am describing is the development of a 'cultural reflexivity' (Toledano 1996); an ability to explore where race and culture fit in the relationship and process between my clients and myself as therapist.

To introduce a series of four family stories I will describe some work with an African-Caribbean family. The other three families are white, British. This first story is an example of connecting up cultural identity, values and intergenerational stories, through the image-making and therapeutic process.

1. The reconstruction of family bonds

In this family, I worked with a mother, her daughter and son and later on also the grandmother. The daughter had begun sexually abusing other children after having been abused by a girl friend when they were both five years old. The young girl friend had previously been abused by an adult outside the family.

My understanding of sexually abusive behaviour in children has been greatly extended and enriched by Ann Cattanach's inspiring approach and writing in this complex area (Cattanach 1993, 1997). In her view, sexually abusive behaviour in children thrives on neglect and lack of care. The goal of the work was, therefore, to reinforce the family as the centre of a caring system. Both the mother (and intermittently the grandmother) needed to offer 24 hour monitoring of the child and firm but supportive confrontation of the abusive behaviour when it occurred. The school also offered supervisory back up.

Other key features of the work were about nurturing self-esteem and positivity and creating an environment at home and at school where feelings and anxieties could be shared openly. Art therapy was an approach that I used to support this consolidation of the family structure.

In individual play and art sessions the child, now seven years old, was able to use Black dolls, musical instruments and themes and ideas to express and strengthen herself and her African-Caribbean identity. Through images she created of her body, she explored her feelings about herself, and rehearsed a sense of self-value and protection. This involved developing respect for her own right to privacy and to not be abused; and alongside that, a respect for other children's rights to protection from herself.

In a family art therapy session it became clear how different perspectives from each family member (including the grandmother) created a spectrum of values, expectations and beliefs about their culture and their

needs. Their images and the stories that these told, spoke of transitions through colonial history in the West Indies, to the complex cultural transitions and changes brought about by living in Britain in the nineties.

What I began to recognize through the images was a theme of family fragmentation, which spanned at least four generations. These stories featured mostly mothers, i.e. the mother, grandmother and great grandmother leaving their children in the West Indies to go abroad for economic reasons. In each generation children had been left to survive, without adequate care, when the structure of their family had been broken. Children had not bonded or had bonds broken with their mothers, and mothers were left feeling unsure about being parents, split from their children. The dimension that the girl's mother and I wondered about and discussed together was the intergenerational one: that this pattern of fragmentation was possibly a legacy from slavery, persisting and being lived out in the present day. (The specific aim of slavery was to subvert familial bonding in order to assert the economics of ownership and production.)

The little girl's mother was able to turn this history of fragmentation around. With strength and dedication, she created a new story (see White 1990) of love, and repaired the emotional security, through much personal sacrifice, that her children needed.

REFLECTIONS ON THE PROCESS

By putting race and our differences and similarities very much on the agenda I think I may have been able to overcome some of the negative stories from the past about relationships between white and Black people. I hope 'my cultural reflexivity' and personal connection to my collective Jewish history may have helped me to engage and establish a rapport, that allowed this family's intergenerational and current struggle against fragmentation to be processed through art therapy.

Access to culturally appropriate toys, art and musical equipment and media reinforced the message to family members that their cultural identities were being given value and meaning. Similar efforts should be made with families from all backgrounds.

I describe the following family story from early in my career because of its simple and successful use of art media and therapeutic space.

2. The repair of a family landscape

A mother and a three-and-a-half-year-old child were seen by myself and a colleague when working as community artists. We offered four sessions to this family in the setting of a children and families consultation service. The difficulty identified was that the child was encropretic.[6] The mother had recently ended her marriage and started a new relationship. We were not given many other clinical details; however we were told that other programmes had been attempted without success.

We suggested the family create something together. (I usually explain that a playful approach using art materials will be useful in bringing the family together to resolve their difficulties. I then add that this artwork will not be 'judged'.) The little girl chose to work in plasticine, and her mother joined in the activity with her. A joint landscape emerged and was completed over the four sessions. It involved a country scene, fields, fences and toy farm animals. A couple of times the fences were broken and repaired, usually by the mother, and the animals that attempted to stray, encouraged by the child, were kept within the enclosed areas, again by the mother. The process was intermittently left and returned to. Individual pieces were made by either the child or the mother and then incorporated into the whole landscape. Another shared activity was the sorting out of the different coloured pieces of plasticine that were kept in a box, where previous clients had left them muddled together.

OUTCOME

Very soon after the first session the encropresis stopped. This progress was maintained on a six month follow-up.

REFLECTIONS ON THE PROCESS

What stands out for me was:

1. the child's choice of this particular three-dimensional medium

2. the imaginative process of the shared story-making with her mother

3. the time-limited sense of containment offered by the practitioners.

In relation to the use of media, it was interesting that the child chose plasticine, given its three-dimensional nature and given the very physical aspect of her encropresis. Clay and other sculptural media have been

6 Encropresis is the inability to control faeces.

compared to faeces and many children, given the opportunity, do play with excreta and all their other body substances.

To my mind, the medium was being used to consolidate concrete boundaries within an imaginative context that has analytically, and aesthetically been compared to the human body, i.e. a landscape. The child's control of media outside her body may have helped to control 'media' inside. The use of the physical medium to shape and construct, and to separate into clear colour distinctions, from the box of messy remainders, seems to add to the importance of grappling with real matter to create order in a tangible way. This, within the context of the jointly-made landscape, may have allowed an experience of inclusion and connection with her mother, a connection which may have been disrupted during the breakdown and remaking of the mother's partnerships. This renewed connection may have enabled the child to feel more contained and therefore contain herself more successfully. The theme of containment may have been echoed in the 'enclosed space' of the sessional work that my colleague and I were able to offer this mother and child.

3. The creation of space for growth

This mother and child were referred to the family centre where I worked. The mother had a long mental health history and there were fears that her relationship with her eight-year-old son was 'enmeshed' with no clear boundaries. There were also concerns that he was not making the expected educational progress for his age and ability. I was able to offer some time-limited family art therapy sessions, co-working with the woman's psychiatric social worker.

In the sessions, I encouraged mother and child to create separate images on subjects of their own choice. Both their first paintings were powerful, because of their visual confidence and their use of colour and size. However, the most striking outcome was the mother's reaction to her son's painting. She expressed shock that her son had been able to 'have ideas of his own'. It seems that until then she had not recognized that he had his own thoughts and feelings. This recognition remained a significant turning point in the therapy and was built upon in future sessions.

REFLECTIONS ON THE PROCESS

What stood out from this particular process was the effectiveness of the art therapy work to encourage more 'distance' between mother and child. This mother's dramatic insight was brought about by the concrete difference she

was able to see between herself and her son. This difference was demonstrated in the individual images completed in the family sessions. The images allowed both the mother and her son to learn about the importance of more appropriate boundaries. They showed the potential for art therapy to distance or connect family members and to provide more helpful boundaries.

4. Unravelling responsibility

A mother and child were referred to the family centre; the two-year old-boy was on the child protection register for physical abuse. His mother had injured him on his head and face. As part of a series of assessment sessions combining parenting and art therapy approaches, two early art therapy sessions stand out for the way in which they brought key issues to life, to be worked on later.

To help engage the young family in a warm-up exercise and an accessible process, I had suggested a family hand-painting. The mother became very involved in the activity, painting her palms with different colours and then placing them on the large sheet of paper she had chosen. Her young son darted anxiously about, on the margins of the activity, apparently fearful of joining in. Gradually her hand printing became more and more energetic and self absorbed, until she was slamming her hands against the paper on the floor. Throughout this, her son stood ignored at the edge of the paper, unwilling to try any other activity.

The next week the young woman said she did not want to use paint or any of the other art materials that were available. I had discovered some toilet rolls that were hidden at the back of a cupboard. She began unravelling these, sitting on the floor with the child. Soon a purposeful game developed and they began to tear and shred the soft paper. Presently they were surrounded by drifts of torn tissue pieces. Then they picked up handfuls of the pieces and started throwing them gently over each other like snow. This game was repeated with much delighted chuckling from the youngster.

Later his mother began unrolling the paper again. She began making a hat for him that involved winding the paper round his head. Her wrapping of the paper became more and more careful and loving. 'It's like bandage' the young woman suddenly said. She was 'bandaging' the injuries she had previously inflicted to his head. Her son was calm and still as this activity took place.

REFLECTIONS ON THE PROCESS

In the first session with this family, the use of the paint in a hands-on activity and the opportunity of therapeutic space seems to have allowed the

frustrations this young mother struggled with to come to the fore. In retrospect, this invitation to her spontaneity needed to have been thought through more. This was because of the way it brought the reality of her violence to the fore (though of course mediated through the medium of the paint on paper). This reflection helped me understand how more spontaneous hands-on techniques using paint and similar media may not always be appropriate where someone's impulse control is weak. This may have been the reason why the young woman was reluctant to use the art media the following week (i.e. because she had been so forcefully in touch with her anger and perhaps aware that her child had been left out). In contrast, the medium of the toilet tissue allowed for a safe expression of aggression that brought mother and child together through play. This playful rebuilding of their relationship around an impromptu healing ritual, showed the close overlap between art, drama and play therapy. The transformation, which did presage the beginning of this mother taking responsibility for her violence towards her son, relied on an interconnecting backdrop of different experiences. Her use of the paint, and then 'discovery' of the rolls of toilet paper, her ability to play and then to 'enact' reparation, were all features that helped bring about change.

Group stories: training and team building

I will now consider other types of group settings, in addition to family groups, where the art therapy process can be effective. In this section I am going to be describing sessions that were done while I was working:

1. as a part-time art therapy lecturer at the City University in London[7]

2. team-building with a staff group using art therapy.

7 The Art Therapy course at the City University, London. Initially, colleagues and I ran this course as an introductory one. Later it became a foundation course in art therapy. The open-ended structure allowed me an opportunity to experiment with art therapy group work processes and to develop a hands-on style, responsive to students' creative needs. In the course programme I made theoretical and methodological connections with a range of disciplines, including the other arts therapies. As my own professional practice developed within social services, and I embarked on some family therapy training, my teaching incorporated ideas from systems thinking and other theoretical bases. However, the main emphasis was on art therapy. Eventually, I co-ran the course with a Black colleague and friend. Together we seized this exciting opportunity to explore race and culture as part of the group work process.

Group work: Work or play?

As I began to build my confidence and understanding about art therapy and groups, I could see how, in a striking way, the art therapy process could make visible the life of the group (and the individuals and smaller groupings within it). My aim for the course was to use this visible process as a rich and playful environment for learning. In my role as art therapy tutor, I emphasized the individuals' and group's interactional experiences, rather than transferential material. I was often directive in style and my starting point was a range of topics for the group to explore and progress in their own way. This approach was in line with the educational nature of the group and my own professional orientation.

The course developed three key themes over the one-year programme: the individual, the group and the use of media. The context for the interactional learning was in individual, pair work, and both small and large group settings. The impact of the body on the art therapy process was also a central issue throughout the programme.

I am going to describe two workshops from this course to show the development of the process at various stages. I will try and highlight the changes that I observed.

1. Mandalas of gesture and movement

This workshop was held over the first day of the course that year. The aim was to introduce students to easily accessible art therapy methods and to build confidence in the group process. It had an overall theme of the self and 'centredness'. This was explored through a meditation, then movement with and without partners, and then exercises using art media. The art exercises followed the theme, with students experimenting with the idea of connecting with and leaving a centre as individuals, in pairs and in a large group. There was also an emphasis on experimenting with media: both the individual and pair work exercises encouraged finger-painting and working on different sizes of paper.

OUTCOMES FROM THE WORKSHOP

The images that resulted were extremely powerful. The movement exercises seemed to lead naturally on to a physical engagement with the medium of paint and fingers or brushes, often on large pieces of paper. In some, a strong gestural component came to the fore, with students using large hand and arm

movements to make marks that started from a central point. In others, mandala-like forms materialized in individual and pair work representations and in the final group image. (Mandalas are the centred images that occur spontaneously in artwork and also are used as meditational icons in the Hindu religion.) In the ensuing discussions students talked about the particular impact of each exercise and which they had found most interesting or rewarding. Although the approach was apparently directive, group members interpreted the exercises in very different ways. The exercises appeared to have brought the students together as a group in a dynamic and positive fashion.

REFLECTING ON THE PROCESS

From this workshop new students gathered a range of structured arts therapeutic experiences. The activities were 'anchored' in individual exercises spread over the day. This provided the safety from which it was possible to compare and contrast the creative learning in the pair work, small group and large group contexts. For instance, as students moved from the relative calm of their individual work to the pair work and large group exercises, they talked of how these could throw up interpersonal insights in a startling way. Patterns of communication and rules, taboos and etiquettes shaped by personality, gender or other cultural forces, appear to dictate how competitive/harmonious these interactions become. The image could be relied on to provide a snapshot of the encounter for all to see. From the level of talking and amusement that always follow it is obvious how safe, energizing and successful in bringing people together, these exercises are. In this way, the workshop offered an opportunity to explore creating images that consolidated both the individual and the group process through the use of a variety of media and image making.

2. The celebration of a group rite of passage

This workshop took place at the end of the second term, two-thirds of the way through the year's programme, when the student group had come together well and were preparing to have a holiday break from the course. The theme for the workshop was ritual as an aspect of group work. This theme is, by its nature, an important one as it harks back to the roots of art therapy and arts therapies in general. Rites of passage in prehistoric times and more recently, were designed to help communities

and individuals manage change. They involved the use of art, music, dance and drama in similar ways to arts therapies.

In the morning session, students had been asked to reflect on a significant event in their lives they would like to recognize (such as an ending and beginning that had gone unmarked). They were asked to represent this event individually in a painting or three-dimensional form and celebrate it in some way. They had brought in materials, objects and music to enhance this.

In the afternoon, the group were asked to create a group sculpture and then to use it to participate in a celebratory ritual.

OUTCOMES FROM THE WORKSHOP

In the morning session, the group touched on some painful personal events they wanted to acknowledge; for instance recovering from a car accident, letting go of adolescent children and the parenting role, and a visit to a father who had not been seen for many years. There were also joyous ones, for instance a regular peaceful communing in the bath with lighted candles, a recent experience of regeneration and newness, and the private joy of contemplating the sea. The revisiting of these personal events and celebratory rituals took place in special areas around the room, that began to look rather like personal shrines; and were brought to life using an abundance of colourful two- and three-dimensional media.

In the afternoon students chose to use these personal shrines as starting points for the group sculpture. Students chatted and laughed together as they discussed what to do. Gradually hanging structures began to surround and enshrine people's personal spaces. Aspects of the morning's individual work became woven, literally, into the whole assemblage. Rolls of material and paper were suspended from lines of string across the room and huge tented forms emerged. Chairs and tables were incorporated, festooned with different coloured string and trails and curtains of coloured tissue paper and toilet tissue (again!) which created softly boundaried areas. An air of lively concentration developed as a group ritual was being enacted.

At last the activity came to a halt. Students decided they would take off their shoes to enter the tented areas. They sat, talking and smiling at each other, quietly taking in the atmosphere that had been created inside. I joined them, sitting half in and half outside, not wanting to intrude too much on their space. There was a strong sense of an inner sanctum that the group had created for itself.

Figure 5.5

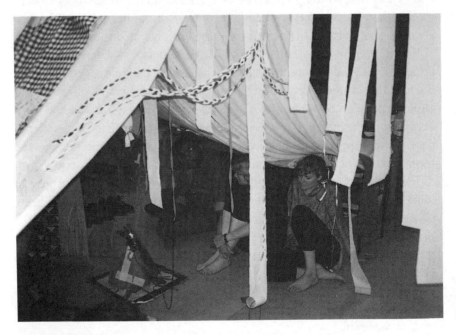

Figure 5.6

After a while, I asked people to comment on the experience and the results of their collective activity. No one seemed to be able to respond. The experience of jointly creating appeared to have been enough. They had done it together and wanted more time to absorb and enjoy the special environment side by side.

REFLECTIONS

I have chosen this example of the group process because the ritual element can become particularly evident in group paintings and sculptures. In my role as a hands-on art therapist/tutor I was able to create a facilitating environment that allowed the group to express itself in a powerful and visible way. The group took its own direction and had its own purpose prompted by my simple instruction. I witnessed the 'groupness' of the group, in the same way that I always enjoy the 'clayness' of clay, or the truth to its nature of any medium. The initial ingredients of group members, materials and their ideas from the morning, became transformed into something more: a celebration of the individuality of the group and its members in a unique shared creation. Their physical engagement with the process was shown in the way they used the room and the space that was available and adapted and transformed it. The media that they chose were crucial in this enlarged expressiveness; rolls of paper and lengths of material and string added the different textures and colours that made boundaries that were needed to transform the space on such a large scale. The whole physical experience of changing the space and working to shape different meanings together was partly inspired by the struggle with the materials and the nature of the materials themselves.

The group forged something collectively that at the time needed no discussion or reflection; there appeared to be a sense of completion as they ended the day and the term.

3. Team building: upheaval and stability

I am going to describe a team-building session in a children and families consultation centre. I had been asked to offer a three hour art therapy input as part of a two-day review of their service. The ten team members were new to arts therapeutic methods and thought that working non-verbally might add an additional dimension to their verbal exchanges. Every member of the team was present, including administrative staff, practitioners from various backgrounds and the team manager. I had not been informed that the team were, at the time,

going through a major upheaval, where changes of role and status would be taking place, without the full agreement of those involved. This fact only emerged during the workshop.

As an introduction, I described the main principles and methods of art therapy. After a 'conversation' in pairs that emphasized playful interaction and reflections on this, I asked people to work individually. I invited them simply to 'tear and create' something from the wide range of materials available. The emphasis was, as usual, on enjoying the process rather than focusing on the end product. I recommended that people did not use scissors. They were allowed access to glue and sticky tape, if necessary.

This exercise normally releases people's inhibitions and gets the creative 'juices' flowing. It resulted in some lively three-dimensional constructions. I then asked the team to use these as the basis for a group sculpture. The whole team joined in energetically and a lofty and complex structure emerged. Interestingly, the administrative staff took a key role in the process, offering practical and creative suggestions for holding the whole sculpture together. Despite this, the edifice wobbled precariously, with parts hanging dangerously over the edge.

It was at this point that there was a surprising realization in the team. As they began to discuss what the sculpture needed structurally to become more stable, they started discussing the actual structural upheavals that were confronting them as a team.

I suggested that they did not discuss these at the time, but continued to work together to stabilize their group sculpture. When they had done this, in the concluding part of the workshop, they talked openly for the first time. It seems they had not discussed, as a team, their views and feelings about what was going on before. They commented on the safety that they had established through the workshop, that had enabled them to consider and address these changes in a constructive way.

REFLECTIONS ON THE PROCESS

The main recognitions I took away from this session were that:

- the art work had replicated the work setting on a fundamental level, which had provided insight and direction for the team in a concrete form

- team roles and dynamics had become visible in the group's interactions; for instance, the importance of lower-status staff who 'held' the team together in a creative and supportive way

- team members had used their whole selves in the creative process; it was not simply an intellectual problem-solving technique.

As I conclude this chapter, I will return to my own relationship with clay that I have described as a much-loved 'significant other' in my life.

Transforming meaning: The alchemy of change

As a fine art student working in the old pottery department in Leeds Art College in the seventies, I was determined that I would never fire the clay sculptures I was making. It was the moment by moment process of playing with the medium and its responsiveness that I treasured. Firing the work in a kiln seemed conventional, boring. Looking back now, I think I feared the process of surrendering to something unknown.

The pottery tutor was frustrated by my stubbornness to recognize the ceramic potential of the medium. Eventually he 'stole' a couple of the dried clay skulls I had been making and fired them in the old gas kiln in a special stoneware firing. My shock at the transformation was enormous. The skulls looked as if they had aged a thousand years and felt like stone, rock or bone to the touch. Planned and accidental indentations and markings on the surface of the clay had become enriched, etched and burnished. The sculptures glowed with earthy colours like lichen. I had been given back something new: of me, but not me; a birth of a new understanding about the medium and my relationship with it. I sensed an alchemical process (Jung 1955) turning the base clay and the baseness of myself into something precious, long-lasting.

Once I had been exposed to the possibility of firing, I wanted to develop the new meanings in my relationship with clay more. I experimented with different sorts of firings and took fragile, transitory objects like leaves, lace and grass, soaked in liquid clay, and gave them permanency through the firing and glazing process.

I found I was able to hand over myself and 'my significant other' (embodied in my sculptures) to a death/birth transformation in the kiln that was 'bigger than both of us'. It transformed my relationship with clay into a new dimension.

This process provided a positive model of change for both myself and my relationships. It gave me the confidence to begin a new stage in my own development that represented a better engagement with the world and with other people.

In the family, group and my own stories, I hope I have shown that if process is the sap of the art therapy tree, then transformation is both the blossoming and the fruitful outcome.

Conclusion

The process of art therapy is deeply rooted in the body and in the body's connection, through the senses, to different media. While being held in the crucible of an open and accepting relationship by the therapist, a transformation can take place: a meeting with new meaning.

I have shown, through brief accounts, how my own hands-on experiences of life and therapy have led me to pass on the art therapy experience to others. I would like to suggest that in doing so these contacts become, for myself and other therapists, a new medium for hands-on experience. Here the medium is life and people and the relationship to both.

Hands-on art therapy has never been easy. It takes great courage to reach out playfully to connect with the strangeness of ourselves and of others and taste the freshness of that exchange; and to welcome in the new learning that is revealed.

References

Campbell, J. (1993) *Creative Art in Groupwork*. Oxfordshire: Winslow Press.

Cattanach, A. (1993) *Play Therapy with Abused Children*. London: Jessica Kingsley Publishers.

Cattanach, A. (1997) *Children's Stories in Play Therapy*. London: Jessica Kingsley Publishers.

Hayward, M. (1996) 'Is second order practice possible?' *Journal of Family Therapy 18*, 3. Oxford: Blackwell Publishers

Jennings, S. and Minde, Å. (1993) *Art Therapy and Drama Therapy: Masks of the Soul*. London: Jessica Kingsley Publishers.

Jennings, S. (1998) *The Introduction to Drama therapy: Theatre and Healing*. London: Jessica Kingsley Publishers.

Jung, C.G. (1955) *Mysterium Coniunctionis*. London: Routledge and Kegan Paul.

Lawrence, D.H. (1964a) 'Making pictures'. In M. Levy (ed) *Paintings of D.H. Lawrence*. London: Cory, Adams and Mackay.

Lawrence, D.H. (1964b) 'The song of a man who has come through'. In V. de Sola Pinto and W. Roberts (eds) *The Complete Poems of D.H. Lawrence*, 2. London: Heinemann.

Liebmann, M. and Ward, C. (1999) 'Art therapy and Jewish identity: Stories from Jewish art therapists.' In J. Campbell, M. Liebmann, F. Brooks, J. Jones and C. Ward (eds) *Art Therapy Race and Culture*. London: Jessica Kingsley Publishers.

Mathews, N. (1998) 'Finding myself in America: An Indian art therapist's experience of acculturation' In A.R. Hiscox and A.C. Calisch (eds) *Tapestry of Cultural Issues in Art Therapy*. London: Jessica Kingsley Publishers.

Milgrom, J. (1992) *Handmade Midrash: Workshops in Visual Theology*. Philadelphia: The Jewish Publication Society.

Murphy, J. (1998) 'Art therapy with sexually abused children and young people'. *Inscape* 3, 1.

Toledano, A. (1996) 'Issues arising from inter-cultural family therapy' *Journal of Family Therapy 18*, 3.

Wadeson, H. (1995) *The Dynamics of Art Psychotherapy*. New York: Wiley.

White, M. (1990) *Narrative Means to Therapeutic Ends*. New York: Norton.

Winnicott, D.W. (1971) *Playing and Reality*. London: Penguin.

Psychodynamic Music Therapy
Considerations in Training

Kay Sobey and John Woodcock

Introduction

Seen in a world context, music therapy in Great Britain is a comparatively cohesive profession with a strong professional body (Association of Professional Music Therapists) working co-operatively with those who administer and teach on qualifying programmes. An agreed core syllabus for training is precise enough to ensure adequately high standards but sufficiently flexible to embrace some strongly defined different philosophies of work. An important unifying element in music therapy practice in Great Britain is the interactive use of music, which is most commonly improvised. This is in contrast to those countries where the clinical use of pre- composed or recorded music is prevalent. Few contemporary definitions of music therapy in Great Britain fail to include the keyword 'relationship'. It may therefore be concluded that a further common principle would be that both music and the client–therapist relationship are regarded as essential therapeutic factors, implying less recourse to behavioural and medical models than in some other countries. However there are considerable differences in how these factors are thought about, where the emphasis is placed and which theories are employed to understand them.

The role of the music in the therapeutic process remains a subject of some debate. Brown (1994) writes in the *Journal of British Music Therapy* 'by working to free the person's musical limitations, resistances and defences and by building on the structure of his musical elements, components and structures within an improvisational relationship, we are simultaneously working on his cognitive, physical, neurological, and emotional being'

(p.19), while Priestley (1994) comments that it is 'the quality of the patient's life and being' which is the focus for change and 'the music may be the one factor that shows little or no change at all'. These views might be seen as occupying polarized positions within a spectrum and other views that lie between may be influenced as much by personal experience and preference as by training, or work setting. The emphasis in the training at Roehampton Institute, London is on the relationship and we would agree with John that 'The focus is on the relating which goes on whether there is playing or not. The clue to the meaning is not hidden somewhere in the music but in the shared experience of client and therapist' (1994, p.160). However we would argue that this does not detract from the value of the music which has a vital role to play in creating opportunities for shared experiences and increasing their significance.

It is hoped that this chapter may contribute to a greater understanding of how, at Roehampton Institute, a training course has evolved which has psycho-analytical thinking at its heart while offering a coherent rationale for the function of the music and the ways it is employed. Central to this is the consideration of the relationship and its analogies with and derivatives from mothering and parenting.

The first relationship

Underlying this is the assumption that the earliest experiences, particularly that of the first relationship which is usually between infant and mother, will inevitably continue to exercise their influence for better or worse throughout the life span. Whether or not words are part of the communicative repertoire of a particular client group, there is an assumption in all the arts therapies that alternative non-verbal mediums of expression will be offered. There is therefore every likelihood of connections being made, albeit at an unconscious level, with earliest pre-verbal emotional experiences which are part of all our individual histories. The emotive qualities inherent in musical sound and the shared use of these sounds within a therapeutic setting make it particularly likely that patterns of relating which took root in these experiences will surface quickly and strongly within the client therapist dyad, or indeed between members of groups. This will not be confined to more articulate clients: Aigen (1995), researching group music therapy with learning disabled adolescents was expecting to find that their language deficits and autistic features would confine the usefulness of the therapy to what could be achieved by involving them in musical activities and

structures. It became evident however that group processes as described by theorists such as Yalom were as central to the therapy as with any other client group (1975, p.338). Nigel Beail (1989) writing of his work as a psycho-therapist with people with severe learning disabilities writes that they seemed to experience 'easier communications between the conscious and the unconscious'. Parsons and Upton (1982) found transference relationships of particular intensity developing rapidly with learning disabled clients and suggested that this may be because many have rarely had the experience of someone just 'being with them and trying to understand their commun-ications'. Being with and understanding someone's communications, conscious and unconscious are arguably the primary aims of the therapist.

The role of a mother–infant observation

With this emphasis it is not surprising that students generally regard the process of undertaking a mother–infant observation as a valuable and formative one in their understanding of the therapeutic relationship. The rationale for including such an experience in their training derives from the work of Bick (1963) and the subsequent importance played by infant observations in the training of child psychotherapists. Courses such as those at the Tavistock which include observational studies have become increasingly popular with those who wish to apply psychodynamic understandings to their professional practice and creative arts therapists have been amongst those who have been able to make good use of this.

Undertaking an observation of this kind, albeit shortened to be accommodated within a one-year training, proves its worth continually as an irreplaceable and universally valued preparation for undertaking clinical work as a music therapist, first on placement and later in professional practice. However compressing the more usual two-year observation into this time span does alter a number of elements and imposes a sense of urgency into the ways it is used. The content of seminar discussion still derives directly from the experiences presented by the observers but seminar leaders are obliged to ensure that the particular psychoanalytical concepts which are thought to be most relevant to music therapy have been introduced in the time provided. Despite this the observation of a very young infant with its mother or primary caregiver can provide something fundamental to the therapist's role in addition to illustrating psychological theories, the establishment of a primary relationship and the importance of the non-verbal elements in earliest communications.

Learning to describe without interpreting (Segal 1985), keeping interpretative impulses at bay, or in the words of Bick (1963) herself 'how difficult it is to observe... to learn to watch and feel before jumping in with theories... to discard fixed notions about right and wrong handling,... the uniqueness of each couple, each baby develops at its own pace and relates to its mother in its own way' – all these instil a particular frame of mind thought to be an asset as a therapist. The difficulty of having no active role but allowing oneself to receive the full emotional impact of the often turbulent infantile feelings is often underestimated. Seminar discussion will help observers recognise when arousal of their own feelings derived from infancy has interfered with this impact, intensifying or dampening its effect on them. This can lead to a consideration of countertransference, experientially rather than just as abstract theory. As Segal (1985) points out, feeling responses are often thought of as clouding objectivity or distorting reality but here the usefulness of attending to them becomes apparent. Additionally there is value in learning not to act on difficult feelings in order to dispel them or make things more tolerable, but rather to hold on to and reflect on them together with the anxieties associated with not knowing the answer. This attitude is one Bion (1967) has drawn from Keats and described as 'negative capability' or 'living in the question'. It is a helpful attribute for therapists to cultivate (Segal 1985); Bick 1963; Harris 1987; Rustin 1989). It is particularly apt for those whose mode of communication is as abstract but as feelingful as music and whose clients will often be those who are unable to put their thoughts and reactions into words.

As students consider the establishment in an infant of an internal world, they also become more aware of their own and how it colours their perception of external reality. Even such a short observation will have introduced them to many aspects of 'object relations' theory such as projection, transference and defences against psychic pain. They will realise that these are not confined to infancy but continue to permeate our relationships through life; they will have been enabled to see the links between the mother/baby relationship and that of therapist/client even when that client is not a child. At any stage of life there is a tendency in moments of distress to revert to more infantile modes of coping and on the positive side Harris (1987) stresses that there is 'a drive towards development in every adult patient as in every baby'. She goes on to advise that this should be respected rather than met with 'premature, anxiety-ridden therapeutic zeal' (p.267).

The lessons learnt from undertaking an infant observation are useful to any therapist but there are aspects of working with music which make it particularly relevant. A non-verbal mode of relating is considered likely to rekindle feelings connected with earlier emotional experiences which were forged without words. Improvised music may resemble free association and arise from the unconscious 'as dreams do' (Steele 1991). It is used in therapy to forge an affective relationship and so places a responsibility on a music therapist to have some understanding of unconscious processes when considering the meaning of both musical and non-musical behaviour. Additionally the clients most frequently referred are those whose start in life is most likely to have been jeopardised by an innate vulnerability or disabling factor which has interfered with an aspect of development. Most often there will be a disorder of communication and this may have either originated in or been the cause of disruption and distortion of the primary relationships. It can only be useful to consider the likely impact of this on the establishment of an internal world and take it into account when trying to understand behaviours that are interfering with clients' current relationships.

The emotional experiences involved in this kind of observation bring to life theories concerning the far-ranging effects of events in earliest infancy. This is not unconnected to the practical use of the music since it induces a frame of mind which imbues every aspect of the training. The nature of the relationship will be seen to inform the nature of the music and vice versa. Further reflection reveals a common underlying 'grammar' behind the therapeutic relationship, the parenting relationship and client-centred clinical improvisation.

Clinical improvisation

This is taught, or rather explored, in practical small group sessions. New musical idioms and techniques are introduced and shared but it is the experiential aspect of these sessions that is most important. Students, through musical role play, can experiment with and discuss what it feels like to be on the receiving end, so to speak, of a variety of kinds of therapist activity.

Our most basic exercise is providing a simple accompaniment to a 'client's' steady walking pace: the brief being for the 'therapist' to avoid hurrying or slowing the pace and to simply accompany. It is often surprising how extraordinarily difficult this seems to be. The 'client' will often report feeling the 'therapist' to be intrusive and over-compelling. On the

'therapist's' part, there often seems to be an over-anxiousness to make their presence felt, leading to musical over-activity. It can take time for students in the role of therapist to feel confident that a very simple musical presence, avoiding duplication of the basic beat provided by the 'client's' walking pace, is experienced most readily by the 'client' as a true accompaniment.

This exercise is fundamental in illuminating a general tendency in therapists to be over-active. It seems all too easy for the client to experience their musical output as merely an adjunct to the therapist's solo. This is often exacerbated by the therapist's apparent anxiety to 'mirror' every nuance of the client's music. It is as if all the natural talent of the experienced musician, sense of phrase structure and form, has been lost in the attempt to say to the client 'I am listening'. There are lessons to be learned here for all therapists, but when we consider how particularly vulnerable, fragile and tentative our music therapy clients often are, the need to develop musical cogency is clear. Such cogency is however often difficult to achieve. There may be many reasons for this: it is certainly a response to anxiety, either due to inexperience or the material of the client – much in the way that one might talk too much when nervous. However we use words like 'reflecting', 'mirroring', 'interacting' so often and loosely that perhaps we come to believe that the therapist needs to be highly active, second by second.

Additionally in Western culture involvement in music (and most of the arts) is assumed to be a passive activity. Indeed the professionalisation of the musician is the necessary concomitant of the work of art as commodity. Of all the arts therapies, counselling and psychotherapy, music with its implied passivity of the client/listener and activity of the therapist/performer makes us particularly prone to this kind of mistake. This cultural 'baggage' and the Western classical musical training of most music therapists makes the task of using music as a medium or means of communion extremely difficult. At Roehampton we have found that students with alternative or atypical musical backgrounds often find it easiest to relate musically and naturally. It is worth considering that with verbal therapies, although many authors – e.g. Cox (1987) – have a great interest in literature and metaphor, training courses have no insistence for prospective trainees to have had an immersion in artistic literature. The currency of communication, language, is rightly assumed to be free from sole existence in the work of art.

In a sense the difficulty of our attempt to use music as a communicative medium is compounded because it is also an attempt to wrest music from an

assumed sole existence as 'art'. This is perhaps a philosophical conundrum that follows music therapists throughout their career.

The therapist's music

What informs the moment to moment decision as to what the therapist should play? The consequence of viewing the music as a medium for therapy is a change in the nature of the music itself. In a supervision group, while reviewing the audio recording of a session we were pondering the issue of what to play in the case of a currently silent non-verbal, learning-disabled man. The therapist had played music which although warm, empathic and apparently 'appropriate', left the supervision group members feeling uneasy. Earlier in the session the client had vocalised freely and idiosyncratically, and the therapist had responded with music centred on this non-tonal idiosyncrasy. This felt connected and meaningful. Now, however, it felt as if the client, despite the quality of his silence and the apparently correct empathic response of the therapist, was not being heard. It seemed that the problem lay in the therapists's use of music of limited tonal possibility (it was a Blues-influenced idiom). The question arose as to what now were the client's musical (and hence emotional and relational) options? Put simply, right or wrong notes become in a sense polarised and fixed. In an improvisational sense the future of the music is within certain parameters pre-ordained. The therapist had brought into the session too much of his own musical and cultural world and the client in a purely musical sense was left with no other options than to join this world, go actively against it or to remain passive and silent. The fact of the learning disability and lack of musical technique was seen to be irrelevant; as the group realised all of us, as musicians would be faced with the same limited options. In this particular case, the relationship at that moment did indeed seem to call for the therapist actively to express a warm nurturing presence and thus the music needed to represent these qualities while simultaneously being open to change and transformation. It needed to be free of the tonal cultural implications of the Blues. As a pianist, the supervisor could imagine clusters of major seconds moving in perfect or diminished fifths, but the therapist, being a percussionist, was in a technically much better position to imagine a warm, non-tonal sound world.

By looking at the above extreme of inactive client/active therapist we can more easily consider what needs to be taken into account when choosing how to play with a client's output. Alongside our clinical aims, there is a sense

in which, when we listen to the music of a session, we continue to employ our musical aesthetic sense. We can draw a parallel with the accompaniment of any musical focus, whether it be an actual accompaniment (to a song for example), or simply the relationship between parts. Put at its most simple, it is rare for any musical element such as the basic beat to be duplicated elsewhere. The standard jazz trio provides the perfect example in the sharing of musical elements: when the bass takes the melody the piano will literally keep out of the way of the pitch, relinquish the melody and be content with simple interpolation and harmonic and rhythmic commentary. Even direct imitation in, for example, an imitative turn-taking sequence in a Bach Concerto is used sparingly within the whole piece and probably never goes beyond three direct imitations before an elaboration or extension is employed. It is only when a composer deliberately sets out to create an effect or provide emphasis to an element of structure (such as in the final bars of the end of a concerto) that these 'rules' will be flouted. Therefore, regardless of the emotional content of the music which, given the fact that we tend to be dealing with 'difficult' feelings is likely to be unpleasant, perhaps discordant, there remains a sense in which we can hear our musical accompaniment to the client in terms of its musicality.

Non-verbal interactions in early development

During training practical exploration of improvisation will be developing concurrently with studies in child development; parallels to the musical activity of the therapist emerge when consideration is given to research into the care-giving activities of mothers.

Schaffer (1977) describes mothering 'techniques' along a continuum of what can be seen to be from passive to highly active. The first is what he calls 'phasing': basically this is the fact that the mother continually monitors the baby's state – she is always at some level alert to the baby's presence and aware of its activity and level of arousal. In the development of the mother/infant dyad the infant leads or at least sets the pace and the mother takes her cue from the infant – as Schaffer says the mother is phased by the baby. In the same way we speak of client-centredness and as therapists take our cue from and 'follow' the client. Thus the first task for the music therapist in accompanying the client is simply to be there attentively. This can be compared to the active listening which occurs in counselling or psychotherapy. It is only relatively late in the passivity/activity continuum of mothering techniques that intervention occurs. Indeed in sequences of

mothers and babies smiling at each other 'if the mother continued to bombard the infant with unphased stimulation, then (the baby) would become tense and fretful and eventually begin to cry instead of smile' (1977, pp.69–74). The parallel with musical over-activity is easy to draw. We can observe much from our own experience with our children and from our observations of mothers and infants. It is remarkable how as parents we are able to maintain quite complex activities such as conversation with another adult while simultaneously monitoring a child's state and intervening appropriately as and when necessary.

Let us look at Schaffer's techniques further; he goes on to distinguish 'adaptation, facilitation, elaboration, initiation and control' all of which assume the presence of phasing. Adaptation can be seen in the mother's adjustment of her behaviour to the arousal state and general developmental level of the child – tone of voice, speech content, speed and length of phrase for instance are re-adjusted very accurately to the child's needs. As adults we all do this instinctively and unconsciously, as musicians we may need to apply this more consciously when learning to use music interactively in the best interest of clients. Elaborations are comments on the child's sphere of attention, initiations are geared to the child's arousal state and control similarly. It is only when the child might be in immediate danger that the mother will disregard the child's lead.

These 'techniques' can readily be compared to and used to inform the musical and general behaviour of the therapist, and in so doing fulfil those previously identified tasks of 'being with and understanding the communications of the client'. Following the client does lead to a quite specialised form of musical behaviour in which the therapist's personal musical/emotional impulses are held in check. This is to a certain extent true for any musician even in the most free-form improvisation for the members of a group must co-exist. Indeed one of the most stimulating aspects of (non-therapeutic) musical improvisation is the interaction and 'negotiation' between the personalities involved. However, clinical improvisation demands an unusually high degree of discipline in keeping the output of the other central.

Drawing theories together: Affect attunement

We have drawn on Schaffer's mothering techniques for guidance in using improvised music as a communication and have used Bick's model of infant observation to think about the beginnings of emotional life from a

psychoanalytical point of view. Stern (1985) combines the two approaches and has provided a rich field of both information and inspiration to music therapists (amongst others: Bartram 1991; Pavlicevic 1990, 1997). His abundant use of musical metaphor further entices us to see how the concepts, particularly that of affect attunement, can be employed in thinking about our use of music to commune with clients. He asks 'How can you "get inside of" other people's subjective experience and then let them know that you have arrived there without using words?' (1985, p.138), just the question uppermost in our minds as we attempt to come alongside our clients musically. The mothers involved in his research echo the theme of this chapter – when asked why they behaved as they did most gave as their motive that they wished to 'be with' their child.

Stern (1985) identified a stage in development at which mothers in the presence of their babies unconsciously drop their more purely imitative behaviours and adopt ways which are more all-pervasive and subtle: he specifies these using the term affect attunement and saying that it denotes 'for the first time the capacity for psychic intimacy'. A determining factor is the growing ability, the seeds of which are innately present, to recognise the properties of 'intensity, time and shape' when these are matched cross modally – a quality of gesture for example being met by a vocalisation displaying the same quality. While by mirroring a sound or physical gesture we show we have noticed it, by this more sophisticated translation of its intrinsic components we are conveying we recognise the feeling behind the outward expression.

One of the values of this notion to the therapist in his/her mothering role is the ongoing, fluidity of 'attuning', for as Stern says it is 'embedded' in everything which is going on (p.157). Further it does not require our clients to be producing 'music': in reality we all know that there are many who do very little that is intentionally or obviously musical. However their physical appearance, gestures, movements may all display the amodal properties identified by Stern which provide us with opportunities for contact and connection. A student showed us a video of her work with a young child with cerebral palsy. His languid movements were sometimes loosely directed towards a string of bells and resulted in small ringing tones. At others he raised his head and circled it towards her. The singing tone of the piano flowed slowly in phrases of matching contour, rising and falling in small gradations. A sforzando marked the moment when his eyebrow raised as their gaze met and additional notes were added to the single melodic line

when his mouth widened in a smile. The pace was his, something requiring great sensitivity and attention to detail, the feelingful quality conveyed additionally by the shape and above all the variations of intensity. It is noteworthy that both Stern's original findings and recent music therapy research identified intensity as the element most often matched rather than the more obvious 'time' which can lead to an over- insistence on matching pulse or rhythm.

At other times our clients will be playing music spontaneously or with conscious intention to communicate. The concept of matching by metaphor or analogy rather than direct imitation can still be useful to retain even within the purely auditory mode i.e. intra-modally rather than cross-modally. The growth of intensity in a surge of loudness, for example, can be recast by an increase in dissonance, a rise in pitch or more disjunct movement rather than by simply mirroring the crescendo. Stern talks of the feelings which are being shared in this way as being more often 'vitality affects' or qualities of feeling (such as surging, bursting, fading) rather than categorical affects which denote a feeling specifically, labelling it joy or sadness for example (1985, p.156). It is interesting to compare this with how musicians and philosophers speak of 'meaning' in music, Langer (1967) for example saying that what is expressed in music is not emotion but 'mere feeling of vitality, energy or somnolence' which are amongst 'the countless inward actions and conditions which are felt in the living fabric of mental life' (p.84). Similarly Aaron Copland (1952) says that music cannot be directly translated into words but gives experiences of 'tension and release, density and transparency, a smooth or angry surface' together with its 'swellings and subsidings, thunders and whisperings'. It is arguable that these are exactly the vitality affects to which we endeavour to attune. The implied ambiguity of musical expression reminds us not to be too ready to attribute a simple category of emotion to a client's output, interpreting it in our minds (or more starkly in words) as obviously representing anger or sadness which may be imposing our subjective impression and will be coloured by personal experience or cultural influences.

The behaviour of the therapist

It is often said that in the psychodynamic approach to music therapy, it is the relationship between client and therapist which is the agent of change with the music as the medium for forming that relationship. We have now looked in some detail at what this might mean in using our improvised music to 'be

with' clients and offer them an additional way to communicate. What else informs the behaviour of the therapist?

Together with the parenting analogies, comparisons can be made with the therapeutic role in counselling and psychotherapy. Here a similar issue to the debate in music therapy on relationship versus music can be discerned with regard to the debate within the psychotherapies on relationship versus technique: 'Is the relationship in and of itself the mechanism through which client change occurs or is there an intervening variable between the relationship and client behaviour that is the basic mechanism of change?' (Gelso and Carter 1985) Roezen (1975) shows us that Freud himself was not unaware of the question; 'Freud remained highly rationalistic when it came to technique' yet he 'was too wise to be dogmatic about (it)' (p.134). 'It is still an open question how much Freud's results were due to his own personal capacities and how much to the technique he adopted' (p.154). Research points to the importance if not the primacy of the quality of therapist/client relationship in psychotherapies as diverse as behavioural and psychoanalytic – the conundrum of 'equivalence of outcome despite technical diversity' (Stiles and Shapiro 1986). The core process skills of the therapist – non-possessive warmth, accurate empathy and congruence – are considered necessary to positive therapeutic outcomes. These essentially nurturing qualities are most famously central to the humanistic school of client-centred psychotherapy (Rogers 1967). However Fiedler as far back as 1950 found that experienced therapists from differing theoretical backgrounds resembled each other more than they resembled less experienced practitioners from their own theoretical school in terms of what they actually did. The experienced therapists all possessed an ability to communicate with and understand the client (good rapport), a lack of concern regarding their own status and 'proper' emotional distance (i.e. a professional concern). Such abilities seem close to the qualities described by Rogers. Clarkson (1995) describes this equivalence between therapies as 'one of the best kept secrets in psychotherapy', implying an adherence to ideology and dogma rather than evidence on the part of theoretical schools. This may well be true of 'schools' of music therapy too and a study along the lines of Fiedler's would be extremely interesting. Further parallels can be drawn when we consider therapist qualities implicated in negative therapeutic outcome. These include authoritarianism, impatience and insistence on disclosure. We are reminded of the over-active music therapist and further of the over-intrusive perhaps anxious parent or mother whose own needs override the infants 'phasing'. At

the other end of the spectrum the overly *laissez-faire* therapist who allows the client to ramble, pursue tangents and who fails to integrate the client's material reminds us of the emotionally absent, drained or overwhelmed parent or mother and further of the music therapist who may also be emotionally absent or struggling with technique and trying too hard to 'be' a music therapist.

Mothering techniques and the identified therapeutic core process skills come from different and separate disciplines of developmental psychology and counselling psychology respectively; yet it seems clear, at least intuitively, that the qualities for the good therapist, what a good therapist does, are closely parallelled in what the good mother does. In turn these can be discerned in the therapist's musical behaviour. By looking at the therapist's behaviour from these three perspectives it becomes apparent that the question is not so much 'what does the therapist do?' as 'what is the therapist's quality of being-with?' – it is an attentive, empathic accompaniment.

The relationship: Concepts from psychotherapy

The therapist however brings to the relationship a set of boundaries: regularity of time and place, limits as to acting-out, but foremost the boundary of the therapist's role, which in turn is the maintenance of the mothering quality of being-with as discussed above. What is often the struggle to establish and maintain this role boundary is inextricably linked to the establishment or strengthening of the client's sense of self. Balint uses the term 'harmonious interpenetrating mix-up' to conjure up the nature of the early undifferentiated self. His vision of being-with is 'a quiet rightness that is easily over-looked in our everyday life and in the therapeutic setting. He sees the ground of our relatedness in the shimmering ambience we move within and through, distinct only when its absence jars us out of the well-being we take for granted' (Gomez 1997, p.111).

By focusing on the relationship in music therapy we are inevitably forced to consider transference and countertransference. Here the literature is vast and, although the development of the concepts within Freud's thinking and since is considered during training, we will here focus upon aspects of the concepts as uniquely manifested in music therapy.

One possible way of approaching these concepts has Balint in mind when we propose that as therapists we are attempting to offer the appropriate environment, or mothering quality of being-with, corresponding to a

particular client's needs. Perhaps we are attempting to provide what was missing or lacking at the time of the original trauma, failures of containment or failures of mothering or environmental provision. Transference may then be viewed as an inability to accept, or make use of, the mothering offered. The transference is the Winnicottian false-self or the maladaptive way of being arising from attempts to deal with trauma.

'Kim' was an intelligent but severely schizoid young woman. After a few weeks of desultory improvisation at the start of therapy, during which there seemed no hope of meaningful connection between us and it was impossible to find music that could in any way adequately be there for her, she finally and in some despair told me she felt all she wanted to do was 'just play middle C all the time'. At the time this felt like a metaphor for despair and hopelessness, but later it became more relevant to reframe this in terms of a desire to return to fundamentals.

Similarly many clients with a history of schizophrenia begin improvising by playing a basic beat or single note. This used to be viewed as defensive or indicative of the flatness of affect associated with the diagnosis, but we have come to accept it as a return to a figurative, prenatal heartbeat. A chronic schizophrenic, Rosie's playing has moved from an almost inaudible basic beat to a mezzo forte basic beat (over a year) with indications of development and separateness emerging as simple rhythm to the therapist's static but warm slow musical presence. Concurrent has been a growing ability to speak of her feelings in the first person as opposed to a kind of second-hand reporting how professionals and parents see her.

It is refreshing to turn to Sullivan's (1955) concept of 'parataxic distortion' which is 'one way that the personality displays before another some of its greatest problems. In other words parataxic distortion may actually be an obscure attempt to communicate something that really needs to be grasped by the therapist…' and later with the equivalent of countertransference (the psychiatrist) is trying to get some clues as to what this imago to whom the patient is reacting might be like. This idea of distortion is helpful in considering what we could call musical countertransference: a distortion, or a tendency towards distortion, of the therapist's musical personality. A highly talented student, gifted violinist and sophisticated musician, played an extract of her work with her young client – Tom. The student's line was remarkable for its repetitive, uncreative and frankly boring quality. In her initial observation and meeting with Tom, the student had described how 'everyone (in the classroom) including myself

receives a piece of plasticine. He takes his bit, works it to a random shape then suddenly takes my bit as well and sticks the two together'. This image of two lumps stuck together into one unidentifiable shape became a metaphor for thinking about the early stages of Tom's music therapy. He was brain damaged from birth and the plasticine and the repetitive 'stuck' music could imaginatively be seen to repeat an early mother/child relationship painfully stuck in repetitive patterns of behaviour, emotionally crippled as the handicap became more apparent with time. By becoming conscious of her musically sterile output and at the same time conscious of the pain involved in the acknowledgement of difference which would inevitably accompany a movement away from the one 'plasticine lump', the student was able to find a more spontaneous and creative musical presence. From here the therapy could move forward: Tom went on to show an understanding of the difference between and meaning of the words 'Tom, I and you' which he had previously muddled – a muddle which had been attributed to his learning difficulties.

Containment

An infant observation will have inevitably led to discussion of Bion's theory of containment (1962). It is arguable that in working with some of the most damaged and disturbed client populations, as music therapists are wont to do, containing is often the most useful function we have to offer. Bion writes of maternal reverie, a state of mind in which a mother's absorption in her baby enables her to receive the full force of the floods of feeling which he or she has not yet developed the capacity to manage for her/himself. The beginnings of life are sensation-dominated, and physical discomfort such as cold or hunger may swamp other feelings – the mind of a baby cannot yet use thinking to recall past good experiences and anticipate their return to make the pain tolerable. Physical and emotional discomfort are not then differentiated and may be felt not just as an absence of food and warmth, for example, but as the presence of something actively hostile, gnawing and devouring the core of the being. Feelings which become too much for the baby are split off and projected into the mother. The mothering, containing, role is to take in these incomprehensible unmanageable feelings and metabolise or digest them on the baby's behalf so that they are felt as less overwhelming. The unconscious process is an active one – the feelings are not just received by the mother but worked on, digested, ('filtered of their distress' Hermann) so that the infantile mind can accept them back and find

them manageable. Over time with sufficient experience of this the baby develops his own capacities for containment. This capacity is variable: dependent partly on innate differences of personality – some of us are borne more vulnerable and less able to tolerate frustrations – and partly on circumstances and the environment which may present us with more or less hardship or unpleasantness to endure. Also, of course, mothers have more or less capacity to contain both because of their own temperaments and external factors. All of us from time to time 'fall apart' or 'go to pieces' under difficult or stressful circumstances but those who are referred for music therapy are likely to have had more adverse circumstances and less chance than most to experience being sufficiently contained let alone able to contain themselves.

Commentators on Bion's theory use many metaphors which are helpful in thinking about the way a musical response could embody, or concretely represent, this maternal function. J. Klein (1993) writes 'do not retaliate, do not retreat ... retaliation punishes people for being themselves ... retreat in the face of dangerous feelings leaves them shapeless and unbounded when what they need is recognition, and meaningful, acceptable, limited expression' (p.374). The sounds produced by someone whose frame of mind is confused and perhaps fearful are likely to be shapeless and unbounded but musical forms give therapists the potential for the recognition of some elements – perhaps the power and intensity – while shaping and organising others so that the resulting music is expressive but in a limited, meaningful and acceptable way. Although responding with a calm sustained melody could indicate a therapist able to survive the onslaught it might be experienced as serene detachment and therefore 'retreat'. Music that was too similar, forceful but merging too closely could seem either like counter-attack (retaliation) or give the impression of a therapist who, in identifying with the client, has become victim to the emotional onslaught and might be swept away in the storm with them rather than helping withstand it. A balance has to be found enabling the music to receive, process and feed back the feelings so that at least some part of them can be integrated. Jos De Backer (1993) describes this process saying that there is a need to 'give form or shape to chaotic and frightening feelings' which he suggests may happen in the music but may also require words.

Chaotic and frightening feelings were very much present in a music therapist's work with Paul. The difficulties he presented will be familiar to many who work with those most damaged by a primary cognitive

impairment which has been exacerbated by a lifetime of emotional deprivation and institutionalisation. A middle-aged man who had been in residential care for most of his life, having had minimal contact with his mother in early childhood, he had suffered global delay in all areas of his development and never acquired words or established a form of recognisable communication. Isolated on a large ward of similarly profoundly learning-disabled men he vocalised continually using sounds that were grotesque and distressing. It is not surprising that staff, like overworked child-minders with a bawling unconsolable baby, cut-off from the frustration and despair in these sounds and reacted with numbness or irritation, arguably responses which might be experienced as retreat or retaliation. Music therapy sessions could provide a protected time and space where those sounds could receive a thoughtful response: attending to them and acting on them as if they were intentionally communicative. Papousek (1992) points out that communication functions 'more because of the recipient's readiness and capacity to decode and integrate the transmitted information' than on the communicator's intention. Thus, a therapist, like a mother, may treat as meaningful and significant, sounds which perhaps initially are spontaneous and unintentional. Becoming aware that these are being treated as communicative may lead to them being used as such; this can lead to an intention of being expressive and wishing to convey something to a receptive other.

The therapist was faced by a man who sat rocking, bellowing or emitting shrieks of hysterical, manic laughter. Instruments offered would be sniffed or licked before being forcibly rejected. He had no interest in their sound-making potential and no capacity to explore or play. Initially these heart-rending vocalisations provided a starting point: musical elements existed within them – pitch, dynamics, timbre and contour. Music therapists are familiar with latching on to such musical aspects, giving them coherence and expressiveness, developing a dialogue. There is a place for this with someone who is so unaware of the impact he may have or the possibilities open to him of more communicative use of sound. However we have discussed already the trap of becoming over-imitative, too caught up with 'interaction' for its own sake. Music must not be reduced to an echo or faithful 'parroting' of someone's vocal noises but retain its ability to commune feeling fully with the depths of emotion that lie behind the sounds in all their desperation. It is likely that he lacks not only the words but the mental apparatus to ponder, digest and make tolerable the confusion of

feelings. While 'resonating to the dissonances of others' (Casement 1985) the therapist in her musical response can convey the capacity to think the unthinkable. Along with tuning into his sounds with her own voice, the therapist in this case provided a solid bass on the piano, re-iterated chords as a kind of reassuring ostinato accompaniment. Gradually he modified his vocalisations, which remained anguished but became less primitive and chaotic, and eventually pulled himself to a standing position. He then walked to the large chimes on which he played forcefully but appropriately. One way of thinking about this is that 'containment' had taken place: he had internalised something of the therapist's attitude of acceptance of the force of his feelings along with an ability to survive the hostile attack (John 1994) which they implied. Perhaps the recurring harmonies had embodied the 'going-on-being' of which Winnicott (1965) writes which is felt to be threatened by primitive fears of annihilation something akin to what Bion (1967) calls 'nameless dread'. The music may have succeeded in incorporating all kinds of signs and signals – of pain, confusion, fragmentation – and reshaped them into more organised patterns which represented distress without being distressing. The therapist had managed the difficult balance between being too alike in her musical output – therefore perhaps conveying that she too was overwhelmed and vulnerable to disintegration, and remaining sweetly reassuring and calm as if unable to recognise the difficulties. Certainly something 'happened' which enabled 'play' to become a possibility. Sounds became no longer a purely physical response to sensation, nor a stereotypical habitual reaction but began to be the result of an appropriate use of a musical object employed to engage with another. If this did represent an experience of the 'containing process' then it was one which would need to happen repeatedly if he was to internalise it and possibly, even at this late stage develop some capacity to contain himself.

The concept of secondary handicap

Underlying the use of music to establish an affective relationship with severely disturbed clients is the belief that many of the behaviours found most challenging to the caring services and to their own well-being are not an inevitable consequence of their primary impairment or disabling condition. Rather they have been superimposed, as McCormack (1991) says 'all that is added by the responses to the meaning of that handicap by the individual, the family and the wider environment' (p.59). The work and writing of those who initiated the Mental Handicap Workshops at the

Tavistock have added to the validity of those who look to psychotherapy for ways of deepening their understanding of what is 'going on' in therapy sessions. Stokes (1987) and Sinason (1986) stress not only how much potential may be blocked by pathological defences but also that 'emotional intelligence' is not correlated with 'cognitive intelligence'. Because learning has been stunted and expressive language is either scanty or not used, it does not mean there is a lack of feelings or an inability to have any insight into them. In our earlier reference to Beail we quoted his belief in the usefulness of 'being with and trying to understand communications': by so doing our clients may become more aware that there are alternatives to maladaptive communications. Bicknell (1983) writes of 'symptom trapping', describing how difficult behaviours can be 'an expression of distress' but then lead to limitations in life-style which in turn cause more frustration and pain – 'a downward spiral of unhappiness'.

In coining the term 'secondary handicap' Sinason (1986) was drawing attention to ways of being which are adopted as an unconscious defence against the pain of facing up to the reality of being different or seen to be inadequate. This could be an exaggeration of the initial handicapping condition or a denial of it. Her definitions can be widened to include more than those with severe cognitive impairment since the same use could be made of any disability or illness, that is to protect a vulnerable area of the self from too much awareness. This concept provides therapists with hope for change – there is something more to the isolating, aggressive or self-harming behaviours than that they are the inevitable outcome of having a learning disability. Clearly there is a responsibility to take seriously the function of any defence and not to approach it as simply an obstacle to be forcibly removed. Nevertheless it is possible, with a secure enough relationship and sufficient external support for the therapy, to discover pain can be borne, unacceptable feelings accepted and the consequences of expressing them found to be not always disastrous. Thinking in this way gives a sense of purpose to work across a range of diagnoses and client groups. Music therapists often are referred those whose disabling conditions seem most intransigent, but they can retain their hope for change (which is a fundamental necessity) by assuming that the problems presented to or by the client are not wholly due to his impairment or illness. Bion describes psychosis as a fluctuating state and this influenced the thinking of Stokes and Sinason when first working with mental handicap; Sinason rightly reminds us that we all fluctuate in our mental functioning – how alert and capable we

are depending to a lesser or greater extent on our emotional state. These states of mind seem to be susceptible to music and in sessions a combination of involvement with music-making and the containing presence of the therapist do seem to induce unusual moments of clarity in those who present as confused and unreachable.

Words and music

The precise function of the music and the necessity or otherwise of putting things into words remains debatable. (Odell-Miller 1989, John 1992, Pavlicevic 1997 and others.) Winnicott (1965) stresses the value of the fundamentals of therapy over that of making 'clever interpretations'. By fundamentals he is referring to those qualities required at the start of our lives which are recreated in therapy by the reliability of the setting and the therapeutic attitude – back to our recurring theme of therapy as mothering or parenting. Anne Alvarez (1992) makes a point which has significance for music therapists: speaking of damaged or severely deprived children she describes the primary need as being for realising that someone can know how they feel and only at a much later stage being ready to think about why they feel it. It could be suggested that music, as we have been discussing, has an inherent potential for conveying the how but has obvious limitations in addressing the why which is likely to require words.

It sometimes seems as if those who question the relevance of psychoanalytical concepts to music therapy focus on word use as if this in itself defined such a theoretical stance. It is then easy to dismiss the thinking as irrelevant to those who have no access to verbal language. There may also be an assumption that using words in some way conflicts with a belief in the potential of the music. Some thoughts on this were expressed by contributors to the Stretto section of the *Journal of British Music Therapy* (Hoskyns *et al.* 1992) These misunderstanding doubtless arose because at one time so much that was written described casework with verbally articulate clients (Priestley 1975). In this chapter we have been trying to show how some understanding of unconscious processes can enhance all aspects of music therapy irrespective of the age or diagnosis of the client, or indeed whether the clients are seen for individual sessions or in groups.

Enhancing the therapists' understanding of the dynamics of the relationship in this way does not mean ignoring the particular needs of each client by treating them all alike. Nor should it lead to a disregard for the reality of the effects of neurological or organic impairment. Training will

include teaching about disabling conditions, their aetiology, and current approaches to treatment, education and service provision. These provide a context within which the therapy relationship can be considered.

Inevitably there are then modifications in the way music is used: more or less reliance on structure in some groupwork, more use of pre-composed music with some elderly clients, more directiveness with groups of young children but none of these preclude an internal consistency in applying psychodynamic insights into reflection on the session material. Indeed it is hard to envisage useful therapeutic work being done with non-verbal clients without attention at some level to counter-transference or reflecting on maladaptive behaviour as possibly arising from unconscious defences against psychic pain. Similarly ignorance of group dynamics and processes, and the universality with which these operate, would reduce much work in music therapy groups to mere recreation or an extension of social training. This does not mean working outside the limits of the profession for which we have been trained and students are made well aware of the boundaries within which they will be operating. Personal therapy and supervision enable music therapists to gain insight into what may be 'going on' in the therapy relationship and this in turn may help them make more useful musical interventions. Thinking aloud may be helpful, indicating a therapist who is able to consider and make sense of session events however painful they may be, but this does not imply making inappropriate interpretations of unconscious processes. It does however make therapists more aware of the impact of their words and music on clients, particularly those who have very limited means to give 'feedback' on the effect the therapy is producing in them.

It is hoped that, while many aspects of therapy process and musical techniques have been merely alluded to or skimmed over, that this chapter will go some way to dispelling some music therapy myths and will be a useful addition to earlier published work on a psychodynamic approach to music therapy. This seems particularly important since the theories discussed are those which are shared with many branches of the other arts therapy professions. We all value the unique qualities of our own art forms but we gain strength too from shared concepts, common language and likemindedness.

References

Aigen, K. (1995) 'Interpretational research'. In B.L. Wheeler (ed) *Music Therapy Research: Quantitative and Qualitative Perspectives.* Philadelphia: Barcelona Publishers.

Alvarez, A. (1992) *Live Company Psychoanalytic Psychotherapy with Autistic, Borderline, Deprived and Abused Children.* London: Routledge.

Balint, ? (1968) *The Basic Fault: Therapeutic Aspects of Regression.* London: Tavistock.

Bartram, P. (1991) 'Improvisation and play in the therapeutic engagement of a five-year old boy with physical and interpersonal problems'. In K. Bruscia (ed) *Case Studies in Music Therapy.* Philadelphia: Barcelona Publisher.

Beail, N. (1989) 'Understanding emotions.' In Brandon (ed) *Mutual Respect: Therapeutic Approaches to Working with People with Learning Difficulties.* Surbiton: Good Impressions Publishing Ltd.

Bick, E. (1963) 'Notes on infant observation in psychoanalytical training'. In Williams (ed) *Collected Papers of Martha Harris and Esther Bick.* Strathtay: Clunie Press, 1987.

Bicknell, J. (1983) 'The psychopathology of handicap'. *British Journal of Medical Psychology* 56, 167–78.

Bion, W.R. (1962) *Learning from Experience.* London: Heinemann.

Bion, W.R. (1967) *Second Thoughts: Selected Papers on Psychoanalysis.* London: Heinemann.

Brown, S. (1994) 'Autism and music therapy. Is change possible and why music therapy?' In *Journal of British Music Therapy* 8, 1, 15–25.

Casement, P. (1985) *On Learning from the Patient.* London: Routledge.

Clarkson, P. (1995) *The Therapeutic Relationship in Psychoanalysis, Counselling Psychology and Psychotherapy.* London: Whurr Publishers Ltd.

Copland, A. (1952) *Music and Imagination.* New York: Mentor.

Cox, M. (1987) *Mutative Metaphors in Psychotherapy: The Aeolian Mode.* London: Tavistock.

De Backer, J. (1993) 'Containment in music therapy'. In Heal, M. and A. Wigram (eds) *Music Therapy in Health and Education.* London: Jessica Kingsley Publishers.

Fiedler, F.E. (1950) 'A comparison of therapeutic relationships in psychoanalytic, nondirective and Adlerian therapy'. *Journal of Consulting Psychology 14,* 436–445.

Gelso, C.J. and Carter, J.A. (1985) 'The relationship in counselling and psychotherapy: components, consequences and theoretical antecedents'. *The Counselling Psychologist 41,* 2, 165–180.

Gomez, L. (1997) *An Introduction to Object Relations.* London: Free Association Books.

Harris, M. (1977) 'The Tavistock training and philosophy'. In M.H. Williams (ed) *The Collected Papers of Martha Harris and Esther Bick.* Strathtay: Clunie Press, 1987.

Hoskyns, S. *et al.* (1992) 'The relationship between music therapy and psychotherapy'. *Journal of British Music Therapy 6,* 1, 18–23.

John, D. (1992) 'Towards music psychotherapy'. In *British Journal of Music Therapy 6,* 1.

John, D. (1994) 'The therapeutic relationship in music therapy as a tool in the treatment of psychosis'. In *The Art and Science of Music Therapy: a Handbook.* UK: Harwood Academic.

Klein, J. (1993) *Our Need for Others and Its Roots in Infancy.* London: Routledge.

Langer, S. (1967) *Mind: An Essay in Human Feeling.* Baltimore, MD: John Hopkins.

McCormack, B. (1991) 'Thinking, discourse, and denial of handicap: Psychodynamic aspects of mental handicap'. In *Irish Journal of Psychological Medicine 8,* 1, 59–64.

Odell-Miller, H. (1989) 'Foreword'. *British Journal of Music Therapy 3,* 1, 3–4.

Papousek, M. (1992) 'Parent infant vocal communication'. In Papousek, Jurgens and Papousek (eds) *Nonverbal Vocal Communication*. Cambridge: Cambridge University Press.

Parsons, J. and Upton, P. (1982) *Psychodynamic Psychotherapy with Mentally Handicapped People: Technical Issues*. Paper presented to the British Psychological Society Annual Conference.

Pavlicevic, M. (1997) *Music Therapy in Context: Music, Meaning and Relationship*. London: Jessica Kingsley Publishers.

Pavlicevic, M. (1990) 'Dynamic interplay in improvisation'. *Journal of British Music Therapy* 4, 2.

Priestley, M. (1975) *Music Therapy in Action*. New York: St. Martin's Press.

Priestley, M. (1994) *Essays on Analytical Music Therapy*. New York: Barcelona Publishers.

Roazen, P. (1975) *Freud and His Followers*. London: Penguin.

Rogers, C. (1967) *On Becoming a Person: A Therapist's View of Psychotherapy*. London: Constable.

Rustin, M. (1989) 'Encountering primitive anxieties.' In L. Miller and M. Rustin (eds) *Closely Observed Infants*. London: Duckworth.

Schaffer, R. (1977) *Mothering*. London: Fontana.

Segal, J. (1985) *Phantasy in Everyday Life: a Psychoanalytical Approach to Understanding Ourselves*. Harmondsworth: Penguin.

Sinason, V. (1986) 'Secondary handicap and its relation to trauma'. In *Psychoanalytic Psychotherapy 2*, 2.

Steele, P. (1991) 'Aspects of theory and practice of music therapy.' Paper presented at the November conference of Scottish Music Therapy Council, Edinburgh.

Stern, D. (1985) *The Interpersonal World of the Infant*. New York: Basic Books.

Stiles, W.B. and Shapiro, D.A. (1986) 'Are all psychotherapies equivalent?' *American Psychologist 41*, 2. 165–180.

Stokes, J. (1987) *Insights from Psychotherapy*. Paper presented at the International Symposium on Mental Handicap, Royal Society of Medicine.

Sullivan, H.S. (1955) *The Psychiatric Interview*. H.S. Perry and M.L. Gawel. London: Tavistock.

Winnnicott, D.W.(1965) *The Maturational Process and The Facilitating Environment*. London: Hogarth.

Yalom, I.D. (1975) *The Theory and Practice of Group Psychotherapy* New York: Basic Books.

Dance Movement Therapy
A Case Study

Sara Bannerman-Haig

I have been working in the field of dance education and community dance both as a teacher and a lecturer for the last eighteen years, and more recently, as a dance movement therapist. During this time I have been particularly interested in, and worked extensively through, creative dance and dance movement therapy (dmt) with children, adolescents and adults who have severe or profound learning difficulties.

In this chapter it is my intention to share with readers the dmt process of an adolescent boy who has been diagnosed as having developmental delay.[1] The case study will indicate some of the changes that have taken place during the therapy process over the course of a two-year period, within an educational setting. The aims, working methods, theoretical influences, and dmt techniques employed while working with this individual, will be woven into the case illustration. For readers who might not be familiar with the label 'severe learning difficulties' I have outlined the way in which it is used within an educational context.

However before presenting the case study it is important to characterise dance movement therapy and briefly look at its development within an historical framework.

[1] The term 'developmental delay' has been used as this is what appears on his statement of special educational needs. However the terminology in the school system is 'severe learning difficulties' and this has been used throughout the chapter.

Dance movement therapy: General outline in relation to dance roots

Dance movement therapy is one of the creative arts therapies, alongside music, drama and art. Although dmt is perhaps the least well known of the arts therapies, this can be linked to the fact that the concept and practice of dmt in both Britain and Europe has only recently been established, with the first training course specifically in dmt in Britain being introduced in 1985. Both art and music therapy in particular, have been established for some time. Dance movement therapy however, has been taking place in the United States for a longer period of time. It is also important to note that dance has had a therapeutic role and function in many societies around the world. For instance trance dancing in countries such as Bali allowed men and women to be released from mundane conflicts and anxieties. Dance in these countries is seen as an important part of everyday life and has an essential role in maintaining a stable environment in the communities. Sue Jennings (1985), a drama therapist and anthropologist, refers to this in her writings concerning the Trance Dances in the Temiar society of Malaysia. She stresses how trance dancing is felt to relax the tension for everyone in the community, not just those entering a trance. 'In many primitive societies dance was as essential as eating and sleeping. It provided individuals with a means to express themselves, to communicate feelings to others and to commune with nature' (Levy 1988). Dance rituals frequently accompanied major life changes. These examples clearly reflect the ways dance plays an integral part in the life of specific communities in different parts of the world. From this it is important for us to realize what a substantial role dance can play for all of us, whether it be dance as a therapy, dance for recreation or dance with a therapeutic implication such as release or catharsis.

In this chapter, although my focus is work with an adolescent, I believe that it is necessary to mention that dance is a great equalizer and enables all of us to communicate through our bodies in our own unique way. It is primarily a non-verbal medium, therefore allowing communication to be facilitated at numerous levels. Franklin Stevens, said: 'We are all dancers. We use movement to express ourselves – our hunger, pains, angers, joys, confusions, fears – long before we use words, and we understand the meanings of movements long before we understand those of words' (*The Dance Notebook* 1984).

This statement creates an image which I would like readers to try to keep in mind throughout this chapter.

Historical context: United States

Historically dmt in the West can be traced to the roots of modern dance in the early 1900s, with the discipline of dmt emerging in the United States during the 1940s and 1950s. Dance therapy at this stage was very much influenced by modern dance and many of the earlier pioneers of dmt were dancers or dance teachers. Ruth St. Denis, a pioneer of modern dance in the United States around this time, said 'I see dance being used as a means of communication between soul and soul – to express what is too deep, too fine for words' (*The Dance Notebook* 1984). At the same time as dmt was being established, there were also some interesting developments in the field of psychology with psychoanalytical influences from practitioners such as Reich, Jung and Sullivan. Wilhelm Reich, an Austrian psychiatrist and psychoanalyst, was one of the first clinicians with a non-verbal orientation and Reich introduced the use of muscular manipulation to overcome armouring and thus facilitate the release of repressed psychological material (Levy 1988). It is important to stress that dmt is still very much an emerging profession and practitioners are still evolving their working methods and structures. Whatever the differentiation between individual therapists in their practice, the common denominator is the fact that dance movement is the primary tool for communication and it is through the body that we can express and get in touch with deep feelings in order to facilitate the process of change.

Britain: Context and definition

Dance movement therapy is concerned with personal growth through body–mind interaction, and expression. It is based upon an essential belief that one's movement expression reflects one's psychic state. Dance is the main tool for communication in the therapy process, and it is through the body that we can express and get in touch with deep feelings, with conscious and unconscious processes and emotions, in order to facilitate change. It is a process which furthers emotional and physical integration of the individual. Dance movement therapy, as currently defined by the Association of Dance Movement Therapy (UK) is: 'the psychotherapeutic use of movement and dance through which a person can engage creatively in a process to further their emotional, cognitive, physical and social integration' (E-Motion 1997a, p.17).

Some individual practitioners have made references I would like to include in order to help portray the essence of dmt. Dmt in its simplest form is the use of creative movement and dance in a therapeutic relationship (Payne 1992). Dmt is not only addressing itself to what a person feels, but also how and when these feelings are psychically and physically processed (Siegel 1995). Dmt encompasses a wide theoretical base and is concerned with the development and subsequent integration of the whole person (Leventhall 1980). Dmt is the psychotherapeutic use of movement as process i.e. the spontaneous movement interaction between therapist and child, which reflects the relationship between them at any given moment (Melville-Thomas 1987). From these we can see that dmt is concerned with relationship, with expression of feelings and with integration of the self.

Dmt is continuing to gain support and recognition in Great Britain, and is expanding in areas such as education and psychiatry. It is useful to note that dmt can be used with a wide variety of groups, such as the elderly, psychiatric patients, people with eating disorders, normal neurotics and those with disabilities, as well as many others. Dance movement therapists are now currently employed by the Health Service, Social Services and some Education Authorities, individual schools, learning support teams and child guidance centres and an increasing number are now working in their own private practices.

After several years of negotiations the professions of art therapy, music therapy and drama therapy have recently received approval from the Government and Parliament to become State registered. Dmt has observer status in these negotiations (E-Motion 1997b). The Association of Dance Movement Therapy UK must have a register of practising therapists and accredited training courses in place, before full government recognition is possible. Dmt is working towards achieving this status and has implemented registration criteria and a registration committee which receives applications for registered dmt status or senior registered dmt status.

The working context and personal practice

From the above definitions it can be seen that the dance movement therapist is very much concerned with the inward process which is consequently being expressed outwardly by the body. Themes are taken from what is happening in the here and now. Dmt is process based, an overall structure for each session is provided. Often this includes a warm up phase; a development phase and a closure. However within this framework it is the process of what

happens which is significant. It is through the individual or the group process that change can be facilitated. It is the process of ongoing therapy and some of the changes that have occurred, which I shall be paying particular attention to and exploring further, in the individual case study which follows.

It is essential to mention a tool specific to dmt, that is the tool of movement observation. Dance movement therapists are trained in movement observation and often use a combination of the methods of Laban, Bartenieff and Kestenberg, each one offering a different dimension. At any one moment, movement is simultaneously reflecting intrapsychic, interpersonal cultural patterns (Davis 1974), and these reflections must be visible to the dance movement therapist. Stanton-Jones (1992) stresses that: 'movement can show the intrapsychic processes of emotion, anxiety, defence mechanisms or unconscious symbolic communication' (Stanton-Jones 1992, p.61).

Movement observation is particularly useful in the initial assessment process, in making a diagnosis and setting specific movement goals. However it can also be utilized effectively to monitor development and change, to aid recording, to help interpret, for feedback, liaison and communication to other workers, for supervision purposes and of course in reflection and evaluation.

In my own practice I have been influenced by different practitioners and I feel that my own working methods are continually evolving and growing in response to both the individuals and groups I work with. The dance movement therapist Marion Chace who was known particularly for her work with groups, has formulated a model which I often refer to, and some of her basic techniques underpin my work, such as mirroring, clarifying and expanding an individual's movement repertoire, rhythmical expression, picking up on non-verbal cues and the use of verbalization. Chace's revolutionary contribution to dmt was the therapist involving him/herself in the movement relationship or interaction. This is now a fundamental concept in much dmt practice. Other practitioners who have influenced my own practice are Elaine Siegel, Diane Duggan, Marcia Leventhall, Helen Payne and Rachel Melville-Thomas. Duggan and Leventhall are both dance movement therapists from the United States, who have worked with clients who have severe and profound learning difficulties. Siegel also studied in the area of psychotherapy and psychoanalysis and was interested in integrating her understanding of dance and body movement with her psychoanalytical

knowledge. Payne and Melville-Thomas are practitioners in the UK who have worked with a wide range of children and adolescents. Payne has made key contributions, and has extended our understanding of dmt by her own practice and her many publications. Melville-Thomas is a great advocate through her teachings and writing. Her training as a child psychotherapist will influence the field of dmt in the future.

There are of course a number of theoretical framework that have influenced the creative arts therapies. For instance dmt practitioners such as Joan Chodorow and Mary Whitehouse write about their dmt work being influenced by a Jungian model. Evan and Espenak outline their link to Alder, believing that his work supported the use of body movement work in treatment. Siegel found that Freud's ideas were most suitable to her therapeutic insight. My own work has become increasingly influenced by the psychoanalytical theories of Klein, Winnicott, Bowlby, Bion and Stern, this is partly due to my observational studies at the Tavistock Centre. I have also been influenced by the work of a more recent child psychotherapist, Valerie Sinason who made a significant contribution in the treatment of those with severe and profound learning difficulties by recognizing the value of therapy work with this client group. Sinason (1992), 'shares a belief that there is meaning in the actions and feelings of people with severe learning difficulties and that if the therapist is able to lend himself adequately to the task, change will happen' (1992, p.77).

This simple observation has had profound implications for all therapists. In addition she has done a great deal to heighten awareness of the creative arts therapies, and to support their work in the field of severe and profound disability.

Because of the nature of the severe learning difficulties client group, there are many different professionals involved, ranging from teachers to care staff, from physiotherapists to osteopaths. It is perhaps inevitable that on some occasions their intentions and aims can be contradictory. For example the care worker who in their role, is encouraging development of socially acceptable behaviour, may find the free expression of a therapy session difficult to contend with.

From numerous observations when working in different environments, I have witnessed many negative exchanges and experiences which clients with severe learning difficulties have had to sustain from the variety of workers they constantly meet in their daily lives. This could be linked to a more sociological perspective in which people with disabilities are fighting for

more equal opportunity, access and respect in every aspect of their lives. Much work still needs to be done in transforming attitudes and raising awareness about these issues.

The dance movement therapist works very much on a body level he/she must be particularly aware of the delicate and sensitive issues of touch and physical contact, and provide adequate 'holding' and 'handling' in the physical sense as well as the emotional sense. This could then provide a new, changing experience through which a client is able to re-experience early developmental connections, a different kind of holding, which can contribute to facilitating change.

As I mentioned in the introduction I will be describing in detail the case study of Frank, an adolescent with severe learning disabilities. Through this I hope to illustrate some of the changes and developments in Frank's dmt process and give insight to some of the approaches and techniques that I used in my work with Frank. Before I go on to do this I would like to mention the terminology severe learning disability, and explain to readers who might be unfamiliar with the term, what it might denote in the context of education. Working within special education means that labels and categories are used, of which severe learning difficulty is one. Children who are diagnosed as having a severe learning difficulty, may have been impaired by one of the following; a chromosomal abnormality, such as downs syndrome; have an organic disease; suffered from an intrauterine infection during the pregnancy; experienced a difficulty such as asphyxia during the prenatal stage; or a disease such as meningitis or encephalitis at a later stage in their development. However 'for one-third of severely mentally handicapped children no primary diagnosis can be made' (Russell 1985, p.10).

Bearing this in mind, it is also useful to acknowledge that 'a medically based category of disability or difficulty, or even an educational administrative category, may give little direct indication of how to best help an individual child' (Norwich 1993). In relation to this point it is important to make reference to my own work as a dance movement therapist, I work from an holistic perspective, attempting to see the whole person as they present themselves. Although when working in a system which has labels and categories it is important to have an understanding of their meaning, none the less I believe in the philosophy that each person is a unique being with an individual set of circumstances and experiences, and that this must be foremost. However crippled someone's external functional intelligence might be, there can still be intact a complex emotional structure and capacity

(Sinason 1992). The dance movement therapist must bear this in mind in their work with this client group, and pay particular attention to the emotional needs of the client.

Frank

Frank is a 14-year-old adolescent boy who has been diagnosed as having severe developmental delay and has therefore been placed in a school catering for students with severe and profound learning disabilities. I have been working with Frank for a period of two years in the school setting in which he was referred. Frank was referred for dmt by the senior teacher via a child centred staff meeting. The therapy is still in process and I see Frank once a week for a thirty minute session. Frank has two other siblings, an older brother who also has severe physical and learning difficulties, which are more profound than Frank's, and a younger sister. Frank is the middle child. Recently I was informed that the mother is pregnant again and will be expecting her fourth child in September 1998. Frank's statement of special educational needs refers to him as having developmental delay. He spent some time at the Donald Winnicott Centre as a young child where it was also stated that he had delayed speech and behaviour problems and it was recommended he attend a school for children with severe learning difficulties. Apparently the mother had a normal pregnancy and a normal delivery when Frank was born. Although limited information regarding Frank's home life is available, one can speculate that Frank's home situation is complex, and one can empathize with the difficulties which face the parents who cope with the needs of two adolescents with severe learning difficulties. Frank presents himself as a sociable and very energized youngster. He has a very loud and piercing high-pitched voice and his language is limited and often repetitive. Until recently Frank looked physically much younger than he actually was. However reaching puberty has changed his physicality substantially. He is now much taller, possibly about five foot, slim and has dark hair and dark brown eyes. Previously Frank's body posture was very poor, his upper body stooped, maintaining a concave body position. The upper body in particular can reflect the body/mind state at the time, and he walked with a wide gait. Frank generally seems to have strong presence in the life of the school and is very much liked by staff in the school. Frank is a very lively person to be around.

Before the dmt commenced, there was concern about Frank from home and at school. The concerns related in particular to his scratching behaviour.

This was targeted at his older brother and certain individuals at school. There was also concern regarding Frank's inability to play, his high energy level, his touch sensitivity and his difficulties with social interaction. Frank was unable to stay on task for more than about two minutes in the classroom situation. However alongside these concerns Frank also had many strengths, he did have some verbal communication including limited language skills, was very independent, could competently dress and toilet himself, enjoyed coming to school and in particular, liked to do jobs in and around the school.

Dance movement therapy was to be introduced for Frank in addition to the normal school curriculum. The rationale for choosing dmt was that it would allow him initially to form a therapeutic relationship on his own with an adult, and it would offer him a safe contained place in which he could explore and express some of his unconscious feelings and anxieties through the medium of movement and dance. The most usual aim of therapy is dealing with problems of relationship. By the intentional use of relationship, therapy can aim to bring about durable, positive change with someone whose potential has become problematic (Payne 1992). It was felt that dance movement therapy would be the most suitable creative arts therapy medium for Frank as he generally seemed to enjoy movement and always had a lot of energy.

Before I began working with Frank, part of the assessment process involved me observing him in a classroom situation, at recreation, and talking to him. From this I was able to build a movement profile of Frank and set aims for the dmt. The initial aims for Frank were: to offer Frank a safe and supportive place in which he could begin to communicate and express how he was feeling through dance and movement; to help Frank develop more body awareness and an increased range of movement skills in order to establish a greater sense of self; to provide a place in which he could develop a trusting relationship with another adult.

Finding an appropriate space within the school for dmt can sometimes be difficult. The space has to be large enough to accommodate free movement and expression and it needs to be safe. We work in a classroom which is large and organized to create a free and safe place in which Frank can move. Maintaining a regular and consistent place in any therapy work is crucial, as Klein recognized (cited by Segal 1992) she, 'believed in the importance of maintaining conditions as constant as possible for the client' (cited by Segal 1992, p.106).

She advocated the importance of the setting and discovered how important it is for children to have a firm, regular setting, maintaining as much consistency as possible, and a constant time. Dance movement therapists alongside other therapists, need to pay a great deal of attention to this principle. Setting these ideas up within the working environment is crucial to the success and development of the therapy process.

In the dmt space, there were two chairs set against a wall, a tape machine and cassettes. Frank always spends time sorting and selecting music for the session. There is also a prop box which is always available. The box contains a selection of different props such as textured fabrics, some stretch fabrics, a ball, a balloon, elastics of various lengths, and a few musical instruments. More recently a tunnel was introduced, which is made of two screens and covered with a bright yellow piece of stretchy lycra.

In the first session Frank was naturally very unsure and uncertain as to what he was doing with me in this 'new' dmt space. It was extremely difficult for him to stay within the dmt space and a recurring theme was wanting to leave and finding ways to leave. He would continually ask the time, would ask to go to the toilet and then in his desperation, began to take down the screens which sectioned off the dmt space within the school hall and began to leave. As I verbalized that it 'must seem strange and difficult being in this new space and that a way out is to break down the outside of our space', he began to rebuild the dmt space by lifting up one of the screens he had knocked over. It is very important to pay attention to his very significant non-verbal communication and to begin to have insight into some of the very painful feelings that were being aroused in Frank at this initial stage in the therapy process. Handicapped children are still too rarely seen to have words and thoughts of value inside them and are too rarely provided with a means of interpreting them or having them interpreted (Sinason 1992).

At this stage it is important to mention that when working with children or younger people with severe learning difficulties, there is often less use of dance in the conventional sense. Movement tends to be more natural, less organized and less stylized. There could be more play in the movement and this might be manifested through games and improvisations. I will refer to this as movement play. However in this first session Frank refused to engage in any movement play with me and clearly stated 'no play' when I intervened by introducing some props. Certain groups of children have great difficulty using their imagination at all; some are hardly able to draw or play (Alvarez 1992). Certainly this observation could have been applicable to Frank. Frank

also totally resisted any attempts I made to intervene with short directive body awareness exercises.

Frank continued to resist any directive interventions from me, the time became structured in such a way that we had a hello ritual, a warm up and good-bye ritual and what happened between these times was non-directive. However it is important to remember that this structure was providing a 'holding environment' in which Frank could feel safe enough to be himself. Winnicott (as cited by Jacobs 1995) stated how: 'holding needs to be understood as metaphorical, holding the situation, giving support, keeping contact on every level with whatever was going on, in and around the patient and in the relationship to him' (Jacobs 1995, p.84).

Obviously this was very much my intention at this stage in trying to develop a relationship with Frank. It was brought to my attention by one of the teachers in the school, that most of the children have no opportunity to have ownership of a space and time and much of the school day is organized by others. Frank soon became familiar with the fact that we met at a certain time each week and that this time was solely for him. The importance of this is highlighted by Pick (1992) in a case study in which she links her work to Klein's theory, 'in this very retarded child, as in the young infant, in Klein's view, we see evidence of mental activity, linking, recognising, holding in his mind a continuity from one session to another' (Pick 1992, p.26).

This became apparent with Frank, in contrast to the earlier sessions in which he found it extremely difficult to stay in the dmt space, he had now progressed to realizing he had dance on a specific day, came willingly and did not try to leave.

As one would hope after four months of dmt, Frank began to feel more settled and comfortable in the session and started to expand his movement repertoire by initiating his own movement ideas. He began to use his torso more in a swaying action that moved from side to side. Frank also began to experiment with different aspects of time, by walking at different speeds, thus moving out of his rigid pattern of moving quickly all the time. Using the floor became a frequent activity, doing movement actions such as crawling, sliding and rolling. As I recorded in my notes at the time:

Frank got down on his hands and knees and began a crawl/slide movement. I joined him in this new movement and we propelled ourselves forward together across the floor side by side.

These are movements that appeared to belong to an earlier developmental stage. From Frank's movement behaviour it was clear to see that Frank was revisiting, regressing to a much earlier stage of development in the dmt session. He was playing and experimenting through manipulation of his body. Because of this movement behaviour one could speculate that Frank had not fully experienced these phases of in his development process as a young child, and that dmt was offering him an opportunity to work through important developmental movement stages at a later point in his life.

Frank's stepping actions, which in the beginning illustrated limited use of weight, were now exhibiting much more use of weight. This was particularly evident in a fast stamping action he began to use. This use of weight was very significant in Frank's dmt process as weight can be linked to intention, assertion and independence, something we often see in toddlers. Using one's weight has to do with physicality, being in one's body. Limited use of weight as we saw earlier can reflect little awareness of being in one's body. Frank's integration of weighty movements was a significant development marking Frank's growing awareness of his own body. Perhaps this stronger body movement was also linked to Frank being able to begin to express unconscious feelings, such as frustration or anger through his body action. From that point he began to make links for himself connected to his current feeling state.

Soon Frank became able to tolerate and even enjoy the props which I regularly placed at the edge of the dmt space each week. The props gave Frank something he could communicate through and from this point onwards our relationship began to develop more. Frank began to include me in his play and would interact with me. This could be an indication of how Frank was beginning to internalize the therapeutic relationship. Props can act as a safety net in the development of a new relationship, offering the child something through which they can relate. The movement play often consisted of playing ball together. Winnicott (1971) stressed that, 'playing implies trust… playing involves the body… only in playing is the child free to be creative… and it is only in being creative that the individual discovers the self-bound up with this is the fact that only in playing is communication possible' (Winnicott 1979, p.54).

Frank would initiate different ways of passing the ball, throwing, tapping, pushing and kicking, all expanding his limited movement repertoire. The ball offered Frank a means through which he could control the space between us, making bearable and exploring this relatively new

relationship. He began to give me instructions telling me what to do, and where to do it from.

> Frank walked towards the props and picked up a drum, telling me as he did this to 'come on'. Frank picked up a drum and walked across the space tapping a rhythm on his drum which accompanied his stepping actions, I walked alongside Frank joining in by stepping in time with him and clapping. He led us back to where we had just come from. I was now following Frank in his new role of leader. He stopped and told me 'to sit down'. We sat down and I sat opposite Frank. He put the drum between us and began beating it with a very strong action from his hand and arm. There was a lot of use of weight in this movement. Frank then saw a tennis ball to the side of where we were sitting and instructed me 'to go and get it'. I decided to get the ball and placed it next to the drum. Frank took the ball and began a very gentle game of rolling the ball to me. I rolled it back to Frank, we did this together a couple of times and then Frank moved backwards, making the space between us greater, then continued the ball rolling game.

I saw this as a positive sign in our developing relationship. He was obviously feeling much more secure in his space and I felt these strong actions were another healthy sign in his developmental process. A sense of trust was being established, such a crucial element in any therapy work and in establishing a relationship. This was obviously a significant development for a client who had been referred due to difficulties in forming relationships.

A sense of structure and therefore security can also be provided through the use of props alongside other tools dance movement therapists employ such as the use of rhythm, music, clarification of movement, spatial formations and images. Although Frank is no longer an infant, indeed he is well into adolescence, when there is regression he is now able to explore and work within a safe contained space. This reiterates the importance of providing a space in which clients can feel safe, contained and are able to express comfortably their feelings through movement. This idea can be linked to Bion's ideas from the field of psychoanalysis in which Bion (1959), explored the concept of the analyst as a container for the patient's intolerable experience, just as the good enough parent is the container of her baby's nameless fears. Soon Frank became interested in other props and movement and play was facilitated through balloons, a large bouncy ball, elastic and percussion instruments.

Frank looked at the props in his own time and chose a green balloon. He threw it up in the air in front of him screeching with delight as he did this. He watched it carefully, keeping constant eye contact as the balloon came down and caught it with two hands. He held the balloon close to his chest and cheekily ran away from me. I remained where I was although I felt there was a playful feel to his actions and I wondered if it was a cue from him for a chase game. He stopped, turned around to face me and patted the balloon to me. I caught it and patted it back. Frank caught it and threw it in the air again above him, again screaming with delight as he did this. The balloon landed behind him. He picked it up and began stepping in time to the music as he held it and travelled across the space.

McMahon (1992) states,

> that play is central to the development of autonomy and mastery and as Winnicott and Erikson have shown, to the development of a sense of self and self esteem. A child with disabilities who is unable to achieve this through unaided spontaneous play, needs help from an adult which fosters all the attributes of spontaneous play. (McMahon 1992, p.118)

Through the development of a more significant relationship with the therapist and the increased use of props, Frank's play began to develop. Frank began to choose props such as the fabric, or the elastic and to initiate games such as lifting and lowering the cloth together, and follow the leader inside the elastic.

> I asked Frank if he wanted to look at the props today? He said 'yes' and took a piece of fabric and began waving it around. I took the opposite end, linking us and we waved the cloth together for a few moments. This play ended with Frank collecting the cloth into a bundle, commenting that 'he was not playing anymore'. Suddenly he ran backwards to the other side of the space and a new game developed in which we were at opposite ends of the space, and we ran and swapped places. He shouted very clear instructions, 'on your marks go'.

This could suggest that Frank was beginning to value other structures connected to the session such as the containment and the props. In the above extract there is also evidence of the ways in which the props became a facilitating agent enabling Frank to initiate his own play, in this case a running game.

Frank's movement repertoire continued to increase and he began moving backwards with confidence. Non-movement specialists might wonder what is significant about moving backwards. It is interesting to note that children who have difficulty moving backwards, or who cannot move backwards, have little sense of where their back is (Meier 1997).

> Frank began to move away from me by moving backwards. He looked tentative, concentrating very much on what his body was doing. He was also sucking his thumb as if holding on to it for security, something familiar. I commented on how he was moving backwards all on his own. He continued until he reached the other side of the room, then turned around to come back towards me, still moving backwards. On the way back he seemed a little more confident, his posture was more upright and he was moving more quickly.

I saw this as a development of Frank's ego, he was illustrating a greater sense of self, a sense of who he is. Winnicott (as cited by Davis and Wallbridge 1981) also refers to the fact that, 'holding in the psychological sense is to provide ego-support, in particular at the stage of absolute dependence before integration of the ego has become established' (Davis and Wallbridge 1981, p.100).

By the development of the relationship through dmt Frank was able to feel held, and integration of the ego could begin to take place. There was a development in his body awareness which enhances connections between body and mind, instilling confidence. Freud (1923) stated, 'the ego is first and foremost a body ego ... the ego is ultimately derived from bodily sensations, chiefly from those springing from the surface of the body' (Freud 1923, p.26).

In someone like Frank, who may have little integration of the ego, the opportunity to develop ego strength through heightened body awareness is essential, even at a later stage in their development.

Frank then seemed established enough in his identity within the therapeutic relationship to be able to make clear cognitive links with what he had been doing in the session. The ending ritual developed, becoming longer to incorporate a time in which Frank could verbally reflect back to me as many aspects of the session as he could recall. At the beginning, this would involve one word answers, or him getting up and physically demonstrating what he had done, re-enacting moments from earlier in the session. His ability to be able to recall verbally much of what he had done on a physical

level is a clear example of integration in the mind and body relationship taking place.

Interestingly, at a similar time that these cognitive links were being made, Frank also began to be able to link individual movements together and make short coherent dance sequences. What follows is a detailed extract from my notes which I have included in order to communicate a descriptive feel of what Frank was creating on his own.

> Frank walked forwards towards me, clapping his hands in time with his walking action, and in time to the background music he had chosen. He stopped and swung his arms around his body, once, twice, three times. He continued to step and clap in his rhythmical time as he walked towards me. I then joined in Frank's dance as he beckoned me to do so. I accompanied stepping in time with him and his hand clapping. We stopped and Frank opened his feet to an astride shape. I mirrored his movement; we were standing side by side. He then brought his feet back in to create a narrow shape. Frank stretched one arm in front of him and then the other, then brought them down. He picked up a quick knee bounce and then walked off away from his side position next to me. Again this was very rhythmical, with a clap accompanying his stepping action.

This example is a relatively long movement sequence and is a clear example of how Frank was now sequencing his own movement material. There was a sense of synchrony and symmetry in this sequence which is a strong contrast to the fragmented asymmetrical movements typical of earlier sessions. The sequence also showed Frank's ability to improvise. All the movements were entirely his own and I was following his lead. In this instance he was in command and his movement validated his sense of being and autonomy. Encouraging improvisation is another technique dance movement therapists use in their work as a way of engaging with a client on a movement level and in facilitating the development of a stronger sense of self in the client. Improvisation is a process of non-verbal free association during which the individual permits his body to move spontaneously and unguardedly (Schoop and Mitchell 1974).

The previous extract also highlights a significant change in Frank's ability to tolerate the therapist mirroring parts of his dance and movement material. Sometimes mirroring a client's movements enables the therapist to introduce other techniques such as expanding and exaggerating the movement material created. This would be done in order to help the client develop a wider

movement vocabulary and/or to introduce a different movement quality that could provide a different feeling experience. Many of my previous attempts to engage Frank by using the technique of mirroring, seemed to have been too painful or persecutory. Frank would deal with this by employing his defences which included cutting off, stopping whatever he was doing and changing activity, talking maniacally or shouting. However in the above extract Frank actively invited me (for the first time) to join in with his movement sequence, allowing some successful mirroring to take place. This demonstrated his growing confidence in our relationship and in his ability to initiate.

Mirroring is another tool frequently used by dance movement therapists, we observe how the body moves and use mirroring as a way of reflecting back. This is similar to the way in which a mother reflects back facial expressions or actions to her baby. Using mirroring in dmt is a way of trying to get in touch with the quality of the movement the person is doing, therefore gaining access to the feeling state that is being represented through the movement. The dance movement therapist has learned to enhance their own skills in non-verbal interaction, particularly in the ability to replicate or mirror movement behaviour. S/he aims to be in synchrony with the patient so that feelings, motivations, inhibitions may be better understood (Melville-Thomas 1987). I would like to link the notion of mirroring in dmt to Daniel Stern's (1985) concept of affect attunement. Stern differentiates between affect attunement and imitation. In affect attunement (Stern 1985) states that: 'what is being matched is not the other person's behaviour per se, but rather some aspect of the behaviour that reflects the feeling state' (Stern 1985, p.142).

Therefore, mirroring is not just about imitating and copying but about trying to understand the person on a body level. Mirroring can also convey to a child the message that s/he is being seen and accepted as s/he is (Erfer 1995). Mirroring was a valuable tool in trying to establish a relationship with Frank.

Trying to involve Frank in more play was also an initial aim, and movement play did become apparent through the use of props and games such as chase and 'ready steady go'. However up until this point in the therapy there had been little evidence of symbolic play. Although Frank may have been using the props symbolically, it was hard for me to know and it could have been easy for me to attribute symbolic meaning when it actually was not there. Alvarez (1992) reminds us, 'a ball, a doll, or a teddy may not

have acquired and been lit up by symbolic meaning at all… a child or baby will play, even with the newest toys, in a desultory way' (Alvarez 1992, p.272).

Differentiating what is symbolic for Frank is something I struggle with in my work. However after one year of dmt Frank's movement play began to demonstrate a clearer symbolic element to it. He began to set up peek-a-boo games in the dmt sessions. It was interesting to note the timing of these in the therapeutic process, as they were always after a school holiday. Peek-a-boo/hide-and-seek play can be about coming to terms with loss. Breaks in any therapeutic process can be linked to the idea of loss and separation (Alvarez 1992). It seemed that Frank was using the games to master separation and there was a clearer symbolic element in Frank's play.

> Frank retreated to the corner of the space and got down on all fours and crawled under a set of tables (stacked in the corner of the space). I wondered to myself what Frank was doing. I then realized he was trying to hide his face behind the table legs. Although I could see other bits of his body, I could not see his head. I commented that I could not see him and wondered where he had gone. Frank then popped out laughing and I realized he was playing a peek a boo game. Frank then repeated this game again.

After the holidays, Frank would also often wander around the periphery of the space noticing specific things in the space. I saw this as Frank reaffirming the space after his absence, through his interest and awareness of the physical things that belonged to his therapy space.

This issue is probably more prevalent for therapists working in the education sector than in other area and powerful unconscious feelings might arise for clients about separation and loss. At the end of the summer break of 1997 when Frank and I had been working together for fifteen months, some new and interesting developments began to take place in the therapy process. Some of this could have been accentuated by the fact that we resumed the therapy in a different physical place within the school. In a sense there had been a double loss for Frank; a long summer break in which there was no school and no therapy, and on return no 'old' therapy space, instead a new room. Frank came back from the summer break with a lot of very intentional use of weight in his body movements and this was reflected in how he moved. Frank was moving around the dmt space using very slow and forceful stamping actions.

Frank crossed the space, making very large stamping actions. He lifted his knees high and this added more weight to his feet as they met the ground.

Earlier I mentioned an increase in Frank's ability to use weight in his movements and I would like to suggest that the quality and use of weight in that instance was linked to Frank's development. He was discovering the use of his weight as a youngster might in their normal developmental process. However slowness and sustained movement were now being utilized in a very different way. As we know there has not been much use of slow time in Frank's movement repertoire up to this point. Frank was also saying how 'angry' he was. Attempts to explore Frank's anger through verbal means proved difficult, and either Frank did not know consciously what the cause of his anger was, or the feelings were too painful to allow them to be expressed at a verbal level. However he was illustrating clearly through his body that he was very angry about something or someone. His emotion was being illustrated through his motion. One could speculate that his anger was being directed at me the therapist for abandoning him over the long summer period, as this was the first session back. When working with this client group it is particularly important to pay attention to how they make you feel through the non-verbal communication. This is the counter transference and it is an important tool for understanding what a client might be trying to communicate. Sinason (1992) writes in her work with non-verbal learning disabled clients that, 'I would learn from my counter transference response what the meaning of his action was' (Sinason 1992, p.323).

On this occasion I felt Frank was expressing anger.

Over time the proximity of Frank in relation to the therapist changed. As trust in the relationship developed he came closer and would take my hand to engage in running games across the space and under and through things. The therapeutic relationship developed to one in which there was now increased confidence in Frank and a greater rapport between therapist and client. However Frank was still experiencing difficulty with other areas such as slow movements, so I introduced a short movement sequence incorporating slow movements which he could follow, such as, a slow stretch, drop to the floor and uncurl slowly. For someone who moves predominantly in quick time, feeling slow movements in the body could open up a completely different feeling experience. Setting a movement sequence was another way to try to help Frank experience a different feeling state in his body. Initially this was very difficult for Frank and there was considerable resistance, however Frank

became able to sustain increased sitting in the reflection period at the end of the dmt session. I felt that being able to sustain some stillness through sitting was the first step in helping Frank feel a very different movement sensation. Soon after he managed part of the slow stretch in relation to the set material, and at a later stage became able to add the rest.

Later in the dmt process, at the end of a session Frank suddenly announced that he was leaving the dmt space on his own to return to his classroom. (Prior to this I had always accompanied Frank to the classroom.) This is another illustration of his increasing confidence and security in the dmt space, and demonstrated an autonomy which was entirely appropriate.

Frank is now at a point in which he fully identifies with the fact he has dancing on his own with me each week. In the session he often stands in front of me signalling through his arm gestures as he looks at me directly, and says 'dancing Sara'. I often assume this is a statement about what is happening in the moment, but I also sense there is still a need for reassurance that this time and space is his. This is something I believe he has grown to value. I have received feedback from his teacher, mentioning how he asks 'is it time yet?' several times during the morning prior to the dmt. As I collect him from his class, he talks and sometimes gallops down the corridor to the space. The therapy time has increased to a full thirty minutes. I should remind readers how on the first session he could not stay in the space and that the initial sessions were for twenty minutes. Recently after a school break he came into a session and began to move, then in an elated voice said 'dancing with Sara right now'. I was able to reassure him that he was correct, this was his dance space with me. Frank also has an amazing sense of time. This has been illustrated within the dance therapy session on numerous occasions when he is able to sense when there are eight minutes left. Now he initiates the reflection period in which we sit down and talk about what has happened in the session that week.

In recent months my approach has moved on from one of actively trying to engage with Frank on a movement level by using techniques such as improvisation, mirroring and movement play and by introducing various props, to the role of more of a witness/observer. Now I can place myself in the space and observe more fully what Frank is doing, paying more attention to the transference and counter-transference aspects of the relationship. However I continue to meet him on a movement level when I feel an intervention is necessary or appropriate. Recently there has been a performance quality to Frank's sequences, with him actively wanting me to

observe and witness what he can do. I am now able to verbalize his actions far more, and use my voice to pick up the energy in what he is doing and make verbal links while he is moving

I would like to include another extract as I draw towards the end of this case study. The rationale for this extract is its significance in Frank's individual process. It indicates a leap, in which he is able to associate and verbalize an image that comes to mind from his movement sequence.

> Frank initiated a swing that took him into forward bend and then back up to reach towards the ceiling. He did this again and then began to circle his right hand in a backward direction and then tried the same action with his left hand. I picked up and mirrored his last arm circling action and he said 'waving' as he continued with his own arm movement.

This signified an important development for Frank as he began to verbalize his actions as he was performing them showing a level of consciousness which he had not previously demonstrated.

In the last few months I feel there has been another major shift in the therapeutic relationship. Although Frank's defence mechanisms do operate effectively when situations or feelings become too painful to tolerate, such as his manic behaviour or noise; recently, it seems that Frank is not always employing them. Frank is beginning to allow some space in which to talk more coherently and is beginning to listen. Conversations are starting and Frank appears to want to be heard.

> He put the music back on and ran through the tunnel, knocking the side quite hard 3 or 4 times and a chase, peek a boo game began. This was short as he went and turned the music down saying 'it's too loud', then went on to say 'I went to the park with my dad yesterday'. I had a strong feeling that he wanted to make himself heard, turning the tape down, and then turning the tape off to make space to speak and be listened to. When he had finished talking he put the music back on.

Rather than always having the music on loud, when he has something to say, he has begun to turn the music down and will sometimes leave a space for me to reply. However there is a sense that Frank still does not have a sense of someone receiving his communication and that he wants to be in control – hence his choice and operation of when there is music and when there is not. This obviously raises questions about what kind of internal object Frank has. Is it someone Frank does not want to hear, or is it an uninterested internal object? Franks is still quick to revert to his safe familiar patterns when

feelings can be too painful to acknowledge. A recent example followed Frank having done a long synchronised movement sequence.

> Frank took a balloon from the prop box and began hitting the side of the box hard with the balloon. The movement had obviously triggered some angry feelings which Frank was expressing through his body action of hitting the balloon. As I made a verbal comment, relating to the fact that he seemed angry about something, he came and sat in the chair stating clearly it was time to go, to leave the space and finish.

This could be an interesting note with which to draw this chapter to a close; Frank's need to leave when emotions become too difficult or painful. This can be linked to the very first session in which Frank broke down the barriers. Now Frank contemplates leaving the space, rather than actually leaving as he did in the first session. It also indicates there is still considerable work to do in order to help Frank express and understand some of his strong feelings within a secure and contained place.

Summary

Frank's therapy is still taking place. This is because I am privileged enough to be working in a school which values the role of the creative arts therapies, and sees the significance of using alternative approaches in order to help a child who has difficulties, and needs support beyond the normal curriculum. The story of Frank is only one example of dmt with an adolescent with severe learning difficulties.

At this point it is essential to recall the fact that the dmt approach used in this case study is holistic and is concerned with dealing with the person in the moment. Each individual or group will have its own process, and every journey in the therapy space will be different. Here we have had some insight to Frank's process and journey in dmt.

Throughout the therapy one of my most difficult tasks has been to know what Frank was communicating. On many occasions I did not know. Movement observation has offered a tool in trying to understand and make sense of what was going on for Frank. I often had to try to find meaning in Frank's communications, searching for clues in his behaviour which would provide insight into his inner world. This involved making some meaning out of things that were not perhaps immediately meaningful for Frank. Skills such as trust, intuition and sensitivity had to be used, allowing the time necessary for Frank to be able to express himself. It is crucial to remember

that children, adolescents and adults similar to Frank, who do not have conventional means of communication and expression, should not be forgotten, neither should they be denied access to emotional expression. Everyone has feelings including those with learning difficulties.

For Frank verbal expression was limited, dmt offered him an alternative medium through which he was able to express himself and work with the many difficult issues which arose. There has been progress through the process. This has been seen in: his ability to express himself, physically and verbally; his ability to play, through the use of props and to engage with play with the therapist; his increased confidence, autonomy and control; his greater awareness of self; identification with the therapy session and keenness to come; ability to stay in the space and sustain the increased therapy time; increased use of language; less employment of defence mechanisms; more awareness of self and another; as well as the expansion of his movement repertoire. A teacher recently informed me that in the classroom situation Frank's concentration is now much better. Frank can focus on the task given to him independently, he is now able to sustain being in the classroom environment for the whole lesson. Frank can be seen playing at recreation with one or two other peers. Other feedback focused on his wider use of language and his ability to take control. Feedback such as this from Frank's teachers is useful as it suggests that some of the changes evident in the therapy are infiltrating other parts of his life.

The evidence although anecdotal, supports the belief that many changes have taken place through Frank's therapy. However measuring change can be difficult in any circumstance, and there are always the sceptics who rightly point out that this change might also have happened in any one of many other instances. However Frank's categorization as experiencing development delay could suggest that change might be slow. However, Frank has been lucky enough to be in a school which has allowed the therapy to continue for a prolonged period within an educational context. Through the process of dmt, he seems to be experiencing positive change and to value his role in the process.

References

Alvarez, A. (1992) *Live Company. Psychoanalytic Psychotherapy with Autistic, Borderline, Deprived and Abused Children.* London: Tavistock/Routledge.

Bion, W. (1959) 'Attacks on linking'. *International Journal of Psychoanalysis 40*, 308–315.

Davis, M. (1974) 'Movement as patterns of process'. *Main Currents in Modern Thought 31*, 18–22.

Davis, M. and Wallbridge, D. (1981) *Boundary and Space. An Introduction to the Work of D.W. Winnicott.* Karnac Books.

E-Motion. (1997a) 'Association for Dance Movement Therapy UK'. *Spring Quarterly 9,* 1.

E-Motion. (1997b) 'Association for Dance Movement Therapy UK'. *Summer Quarterly 9,* 2.

Erfer, T. (1995) 'Treating children with autism in a public school system'. In F. Levy (ed) *Dance and Other Expressive Arts Therapies.* London and New York: Routledge.

Freud, S. (1923) 'The Ego and the Id and other works'. *Standard Edition 19,* 19–27.

Jacobs, M. (1995) *D.W. Winnicott.* London: Sage.

Jennings, S. (1985) 'Temiar dance and the maintenance of order'. In P. Spencer (ed) *Society and the Dance.* Cambridge: Cambridge University Press.

Leventhall, M.B. (1980) 'Dance therapy as a treatment choice for the emotionally disturbed and learning disabled child'. *Journal of Physical Education and Recreation 51,* 97, 33–35.

Levy, F. (1988) *Dance Movement Therapy a Healing Art.* Virginia, USA: The American Alliance for Health, Physical Education, Recreation and Dance.

Levy, F. (1995) *Dance and Other Expressive Art Therapies.* London and New York: Routledge.

McMahon, L. (1992) *The Handbook of Play Therapy.* London and New York: Routledge.

Meier, W. (May 1997) Lecture on 'Movement Observation'. London.

Melville-Thomas, R. (1987) 'Focus on therapy, What is dance therapy?' *Dance Theatre Journal 5,* 1, 11.

Melville-Thomas, R. (1987) 'Focus on therapy, Dancing the blues away'. *Dance Theatre Journal 5,* 2.

Norwich, B. (1993) *Re-appraising Special Needs Education.* London: Cassell.

Payne, H. (1992) *Dance Movement Therapy: Theory and Practice.* London: Routledge.

Pick, I.B. (1992) 'The emergence of early object relations in the psychoanalytic setting'. In R. Anderson (ed) *Clinical Lectures on Klein and Bion.* London: Routledge.

Russell, O. (1985) *Mental Handicap.* London: Churchill Livingstone.

Schoop, T. and Mitchell, P. (1974) *Won't You Join in the Dance?; A Dancer's Essay into the Treatment of Psychosis.* USA: Mayfield Publishing.

Segal, J. (1992) *Melanie Klein.* London: Sage Publications.

Siegel, E.V. (1984) *Dance Movement Therapy, Mirror of Our Selves.* New York: Human Sciences Press.

Siegel, E.V. (1995) 'Psychoanalytic dance therapy: The bridge between psyche and soma.' *American Journal of Dance Therapy 17,* 2.

Sinason, V. (1992) *Mental handicap and the Human Condition, New Approaches from the Tavistock.* Free Association Books.

Stanton-Jones, K. (1992) *An Introduction to Dance Movement Therapy in Psychiatry.* London and New York: Tavistock/Routledge.

Stern, D.N. (1985) *The Interpersonal World of the Infant.* New York: Basic Books.

The Dance Notebook: An Illustrated Journal with Quotes (1984) Philadelphia, PA: Running Press.

Winnicott, D.W. (1971) *Playing and Reality.* London: Routledge.

Research in the Arts Therapies

Brenda Meldrum

Introduction

Being research minded is part of everyone's education. Being research minded means to have our awareness raised, to have open minds and to be able to examine the values we as arts therapists hold which affect our observations and interactions with our clients. This open-mindedness will help us resist a kind of 'preciousness' that pretends that therapeutic work is a magical mystery tour, unavailable for examination, monitoring and evaluation.

The notion that therapy is an art form whose creativity is lost if too closely examined has in the past led to the resistance of clinicians to empirical study. We recognize that therapy is a 'process' and as such is difficult to examine; research is often hard to do because of the complexity of the therapeutic relationship and because the findings are often difficult to interpret. Yet this should not put us off.

I shall argue that to examine the process of the therapeutic relationship, to monitor our practice and evaluate outcomes is necessary, not simply because life in the 'real world' of professional clinical audit requires us to do so, but because we owe it to our clients. Having said that, many arts therapists work in the Health Services where there is a renewed emphasis on Research and Development. As Parry and Watts (1996) say: 'Health Services everywhere have placed an increasing emphasis on the careful monitoring and evaluation of the services that are provided. Mental health professionals are increasingly required to monitor their own effectiveness' (p.xv).

It is up to us as arts therapists to accept that our practice is open to evaluation and monitoring. Being research minded is an essential condition

for our work with people. Being research-minded requires a questioning attitude to all our endeavours.

In this chapter, I shall consider first the question: What is mental health? I shall then place the work in a theoretical perspective of social construct-ionism which holds that the client and the therapist construct the therapeutic relationship together to find joint meanings of the client's narrative; I shall argue that the therapeutic alliance allows the client to tell the story of her or his life in such a way as to facilitate change and lastly, I shall briefly look at the beginning of the journey of the research enquiry.

What is mental health?

Mental health is about the health of the mind, that is the way we feel, think, perceive and make sense of the world. Mental Health is positive, more than just the absence of illness and when we speak of mental health we take into account emotional well-being, happiness, integrity and creativity and the capacity to cope with stress and difficulty. Mental Health refers to the capacity to live a full, productive life, as well as the flexibility to deal with its ups and downs. In children and young people, it is especially about the capacity to learn, to enjoy friendships, to meet challenges, to develop talents and capabilities.

The arts call upon the creative and healthy aspects of the self. Even when a child in play therapy is covering the paper with layers and layers of paint so that his picture ends up as a grey and formless mass, the fact that he is keeping to the boundary of the paper, is using colour, is engaging in the process of expressing his negative feelings, is a healthy sign. The play therapist is optimistic that eventually the child will allow himself to find the colour and the light and the confidence and self-esteem to make a picture. In group therapies like drama – and dance therapies – clients, within the boundary of the group process, explore relationships, resolve conflict and use their bodies and their minds in joint creative activity.

Arts therapists believe that their interventions help clients change and grow towards mental health. But there is a scepticism in society concerning the efficacy of counselling and therapies in general, which we can regard as healthy if it leads us as clinicians to ask ourselves the difficult question:

- How can I present evidence to show that therapy works?

And even

- Does therapy work?

Before we begin to answer these questions, we should set them within a theoretical framework and the paradigm I am using is that of social constructionism.

Social construction theory and therapy

The primary tenet of a social construction view is that a person can never directly gain access to an objective reality. All experience is mediated by the senses and a person's knowledge of the world is constructed through interactions with other individuals within a social, cultural and physical environment. Our knowledge of our world comes through observations and perceptions and actions and behaviour; we are both actor and spectator in our world.

Furthermore, our *identity*, our sense of self is constructed as a narrative of the self: that is to say that we know who we are because we are able to tell our stories: we can make narratives of our internal world and our social interactions.

Social construction theorists see ideas, concepts and memories arising from social interchange and mediated through language and the mind itself and the self or her/himself are both socially constructed. As persons, we live our lives through constructing *dynamic narratives* of our worlds, bound by the beliefs and maps and scripts that we have about the world and constrained by the expectations of others within our families and our social and cultural groups. The bedrock of these beliefs, maps and scripts is laid down in childhood.

As McNamee and Gergen (1992) say:

> Whether we locate a problem for which a solution is demanded – for example, an illness for which cure is required – depends not so much on what is before us as behind. That is, we come to the field of observation bearing a lifetime of cultural experience. Most important, we not only bear languages that furnish the rationale for our looking, but also vocabularies of description and explanation for what is observed.

Some therapists, including some arts therapists, think of themselves as the 'experts' in relation to their clients. And, indeed, often a client will come to the therapist as expert looking for advice and answers to their life problems. Social constructionism does not allow the therapist to think of him/herself as peculiarly expert in relation to others. While the expert-therapist construes

her/his observations of the client as objective and accurate, the therapist coming from a social constructionist viewpoint, 'sees' his/her observations as an outgrowth of the social process of the human relationship with the client, expressed in language and in the art form. And the client is seen as the 'expert' concerning her/himself and his/her life story.

When I was a child, I used to believe that the history I was taught in school was 'true' and that myths and stories in literature were 'fiction'. Furthermore, not only was Science dealing with facts, but in my convent, so was Religion. While scientific 'truths' were available for empirical examination, the 'truths' of religion were to be believed and were not open even to question. I now know that the facts of the historical past are interpreted by the historian-storyteller and that myths and stories of fiction and religion carry the norms, values, beliefs, fears and obsessions embedded in the reality of the culture of their time and are constantly reinterpreted in the telling.

From this theoretical base, arts therapists, like other therapists, construct their own understanding of the client's story, through interaction and the search for joint meanings. The therapy sessions are social constructions one of whose aims is to explore the narratives of the client through the stories he makes in the language of drama, dance, art and play. It is *through play*, as Vygotsky said (1978) that the child first rehearses the rules and the roles of her or his society and it is through their joint play that the arts therapist and the client co-construct meaning in the client's narrative.

Is there a definition of social construction theory?

There is no single description of social construction theory. There is no one characteristic which could be said to identify a social constructionist position. But we can say that a social constructionist approach has one or more of the following key assumptions (Burr, 1995). To take a social constructionist approach you would accept the following.

1. You must take a critical stance towards knowledge that is taken for granted

Social construction theory suggests we take a critical view of the world around us and this includes our beliefs and knowledge about ourselves. It challenges the view that what we think we know is based upon objective, unbiased observations of the world. Social construction theory suggests that we accept that our observations are influenced by all sorts of ideas, values,

learning, training that we bring to the observations. So we bring to our work all our ideas, prejudices, emotions, training, experience. It means that in our workplaces what is taken for granted as being a given, as being a fact, is often a social construction.

Burr gives as an example, gender. Our observations of the world suggest that the primary differentiation of human beings is into two categories: men and women. Often these categories are believed to be polar opposites. In dramatherapy, we can play the game of polarities; in a mixed group when you ask people to place themselves on a diagonal whose poles are male and female, there is a very clear division of the group between men and women; however, if you label the opposite poles of the diagonal masculine and feminine, you often find a more interesting picture.

Clearly there are anatomical and endocrinal differences between men and women but Burr asks, why do we place such significance on these distinctions? In her view it would be equally absurd to divide humanity between tall or short.

2. The second tenet of a social constructionist position is that of cultural and historical specificity

Our knowledge of the world, the categories we use to make sense of experience and the ways in which we share these understandings are specific both to the historical time in which we are living and to the culture of our society. Taking our example of gender, what we experience as the differences between men and women, their roles and the expectations we have of our girls and boys depends on where and when we live.

Social construction theory suggests that we should not assume that our ways of understanding are necessary any better in terms of being nearer some objective truth than other ways of understanding held by different cultures and different ages.

3. The third tenet of social construction theory is that knowledge of our world is sustained by social processes

Social construction theory reminds us that what we know about ourselves and our lives are not derived from some objective reality, but through the interactions we have with people. It is through our daily interactions with people, from the neonate until death, in the course of our social lives that our versions of knowledge are constructed, largely through language and

communication. Furthermore, the values of our society and our knowledge of the world are deeply influenced by the languages of the media of television, radio and written texts. Therefore, what we regard as 'the truth', that is, our current accepted ways of understanding the world, is the product of social processes in interaction with other people and is not the result of objective observation of the world.

Lastly, Burr says the following.

4. The fourth tenet of social construction theory is that knowledge and social action go together

We have said that knowledge is sustained by social processes. We have suggested that we make social constructions which we accept as 'truths'. Social construction theory says that each different construction invites a different kind of action. For example, take the debate about parental discipline of children. If you come from a cultural background where 'Spare the rod and spoil the child' is a widely held norm then you may think it is perfectly acceptable physically to punish your child and resent any interference by external busy-bodies who would seek to prevent you. If, on the other hand, you believe that physical punishment of children is often the thin end of the wedge called 'physical abuse', then you will endeavour to curb your anger and use other, perhaps 'withdrawal of love' techniques. Or you may make clear to your child where the boundaries of acceptable behaviour lie in your family system and by creating a place of security and respect communicate to your child that delinquent behaviour is unacceptable and despite it you will still care for them. In summary, your social construction of parental discipline prompts different social actions.

So when the arts therapist approaches research, it is as well for her or him to take a critical stance towards what is taken for granted as the 'truth', remembering that we live in a particular society within an historical context and that our knowledge is culturally and historically relative; we should examine our own social constructions and contemplate the actions that we take as a result of these constructions.

Therapy as narrative

Ann Cattanach in *Children's Stories in Play Therapy* (1997), talks of the very special quality of a therapeutic relationship based on storytelling. Ann says

that the story acts in the middle, between the storyteller and the listener to negotiate a shared meaning between them.

In play therapy, children tell stories as containers of their experiences, in a playful way. The therapist listens to the child's story in an equal relationship and together they share the drama of the story as its meaning unfolds. The story is not 'true', but believable, however fantastic it may be. The story is co-constructed between therapist and child and the story teller must be nurtured so that the story line can flow.

In *Storied Lives*, Rosenwalk and Ochberg (1992) present a number of stories which adults have told them about their lives, not because they wish to make an anthology of human experience, but because they wish to bring these stories to support the following argument.

First, the stories people tell about themselves are interesting not only for the events and characters they describe but also for something in the construction of the stories themselves. How people actually tell their stories, what they emphasize and what they leave out, whether they speak of themselves as heroes or as victims all tells us something of the way they construct their identities.

Second, they believe that the identity forming nature of personal stories may be constrained or stunted. They say that 'the misfortunes of childhood may censor both memory and desire, impoverishing both the narrative past and how that narrative might seize the future'. That is to say, that sometimes their childhood experiences were so hard and so unhappy, that adults may actively refuse to remember or to bring to mind their misery and this inability to tell their stories affects their lives.

Third, they assume that all stories are told and that all self-knowledge is understood within the narrative frames each culture provides its members. These constraints may limit the power of personal narrative. For example, a child may censor a story because she has been told not to be rude. A man may not feel able to tell of his fear or weakness because of cultural constraints.

Fourth, they imagine it is possible to enlarge the range of personal narrative. If a person sees how his social situation, relationships, culture and so on are limiting his story about himself, maybe he can do something about it, perhaps with help from the researcher who is conducting a case study or therapist to whom he is telling his story. And in our work with children using narratives and stories, we can, if they wish, help children find alternative endings.

Gergen and Kaye tell us that a story is not simply a story – it is also a performance.

> It acts so as to create, sustain, or alter worlds of social relationship. In these terms, it is insufficient that the client and therapist negotiate a new form of self-understanding that seems realistic, aesthetic and uplifting within the dyad. It is not their dance of meaning that is primarily at stake. Rather, the significant question is whether the new shape of meaning is serviceable within the social arena outside these confines. (1992, p.178)

A woman tells the story of herself as the heroine leading as well as nurturing the family; how does this role affect the dependent role she plays in 'real' life? What action does the 'new meaning' imply? As therapist and client co-construct the story a context for new endings and different meanings can be negotiated: for example, the cultural context of the story which may trap the heroine can be framed, perceived and the ending changed. The story could be told from the imagined point of view of another member of the family, which would supply insights to the client, and so on.

Narratives in therapy give creative meanings to clients' lives.

Often clients find it hard to use words to describe their stories and arts therapists use their skills to help the client tell his or her story through art or drama, role play and myth and through dance and the body.

Arts therapies and research

Helen Payne edited the *Handbook of Inquiry in the Arts Therapies*, and the foreword was written by John Rowan who spoke of the difficulties the practitioner-researcher encounters; indeed he says: 'the lot of the practitioner-researcher is generally an unhappy one... and it is almost impossible to carry it out'. Commenting on the quality of the research presented in the book he says: 'Some of this research is agonisingly unsatisfactory; some of it is embryonic and incomplete.... But it all shows a remarkable spirit of wrestling with intractable materials, which can only encourage and inspire future researchers who go into this field.

Since 1993 there has been much more interest in research in the arts therapies through the establishment of higher degree courses, such as the MA programmes in Play Therapy, Dance Movement Therapy, Art Therapy and Dramatherapy at the Roehampton Institute and The University of Hertford. The MA dissertations are often research based and the student is given a crash course in research methodology and decides upon a research

question linked to their own working practice. They are therefore, in Rowan's phrase 'research practitioners', which is a very difficult role to play.

As I wrote in 1994, the problem with research and evaluation is that it is hard (and some would say impossible) to think of them in parallel with therapy. Therapists attempt to be non-judgemental, yet research and evaluation often means making judgements.

Debra Linesch (1994) finds herself frustrated with the epistemological inconsistencies between clinical and research practices in the field of art therapy. 'Although the clinical work of the art therapist is subjective, open-ended, intuitive and qualitative, our research efforts have historically been attempts to reorient our approach and become objective, narrowly focused, empirical and quantitative'.

Linesch tries to find compatibility between clinical approaches and scholarly practices through the theory of hermeneutics. In my training on research methodology, I argue that we should address research creatively, realistically and with as much objectivity as we can muster to find tools and instruments as suited to our therapeutic practice as we can make them.

So having acknowledged the difficulties, arts therapists can still be research-minded and address their own practice and try and answer the questions: does my therapy practice work for clients and if it does, what is the process?

Starting the research journey

Hodgson and Rollnick (1996) warn that: 'Trouble awaits those unwary souls who believe that research flows smoothly and naturally from questions to answers via a well-organised data collection system… The problems encountered in carrying out a research investigation must be clearly anticipated' (1996, p.3).

And they clarify these warnings:

1. Getting started will take at least as long as the data collection. You have to decide on the research question, work on a design, go through ethical committees, collect the client group, obtain permissions and so on.

2. You will inevitably have problems with the client group. People withdraw or move or leave the group.

3. Completion of a research project will take twice as long as your last estimate and three times as long as your first estimate. Anyone who

has embarked on a research project will know that no matter how realistic you think you are being, you always get the timing estimates wrong!

4. A research project will change in the middle. If, for example, you end up with only two clients left in the group you may have to change your plans mid-way and the closed focused group you planned my have suddenly to become open.

5. The effort of writing up is an exponential function of the time since the data were collected. If you put the raw data away in a drawer and leave it there while you collect more data, the likelihood is that you will never write your dissertation. Part of the discipline of research is to engage with the data as you collect it.

With these precepts in mind, and having prepared oneself for a challenging time, what are the next steps? Robin Higgins says that research is an act with an objective. 'When we begin our research, we begin a journey of exploration where our steps may move outwards into the world about us, or, inwards into our memories and experiences or, more usually, in both directions simultaneously or successively' (1996, p.2).

First steps

Before you start it is a good idea to make list of all the things you have to consider.

Questions to ask before you start the research: What is my focus? What are you interested in? What do you want to gather information about? Are you interested in a clinical case, for example, or in a particular problem, e.g. bullying, or social exclusion? Are you interested in a particular technique that you find clinically helpful with your client group? It is a good idea to start by putting your interests into writing.

The literature search: once you have decided on your focus then it is time to do a literature search on your chosen area. Libraries nowadays have information technology which will give you access to databases on your given topic. Supposing you chose social exclusion, for example, as your focus of interest, you know that this is a topic in the forefront of governmental and public interest and there will be a number of relevant publications which should be relatively easy to access.

What is my research question? Once you have decided on your topic and have read around it, seeing what others are doing in the way of research, then

you formulate research questions, as many as you can on that topic, which you will then hone down to the question informing your research.

What is the appropriate research methodology? Am I going to use quantitative methods, or am I going to us qualitative methods? Am I going to do a case study? Will I be using questionnaires, or semi-structured interviews, or interviews? What is appropriate to my research question?

What are the practicalities? You will be looking at ethical issues and the permissions you will have to seek. You will be identifying the client/s and where you will meet them, the time constraints, and who is going to help you, supervise and tutor you.

How will you collect the data and what will you do with it? One often has a large quantity of paperwork and it is best to be as systematic as you can in the storage of the material. Computer software and databases are available but are often expensive. If you have quantitative data (numbers) to be analysed, it is best to seek advice from experienced researchers. The qualitative data – the words – will usually be analysed by the researcher and can be very time consuming.

The Writing-up: how you report your research will be dependent upon who it is for. If you are writing-up your MA dissertation, then your college will have given you instructions and guidelines for the writing of the report.

Conclusion

In this brief section, I have put the research endeavour into the context of social constructionism and I have suggested that therapy is a joint enterprise to tell the client's stories, helping him or her find new meanings.

I have suggested that research into the process of therapy is not an easy undertaking and it requires thought and planning. There are some good textbooks which will really help this planning and design process, they are *Real World Research* by Colin Robson and *Approaches to Research: A Handbook for Those Writing a Dissertation* by Robin Higgins. Vivien Burr's *An Introduction to Social Constructionism* is the best text for theory.

In my work I find research exciting, infuriating and stimulating and I send my best wishes to all those who are inspired to become research practitioners.

References
Burr, V. (1995) *An Introduction to Social Constructionism.* London: Routledge.

Cattanach, A. (1997) *Children's Stories in Play Therapy.* London: Jessica Kingsley Publishers.

Gergen, K.J. and Kaye, J. (1992) 'Beyond narrative in the negotiation of therapeutic meaning.' In S. McNamee, and K.J. Gergen (eds) *Therapy as Social Construction.* London: Sage Publications.

Higgins, R. (1996) *Approaches to Research: A Handbook for those writing a Dissertation.* London: Jessica Kingsley Publishers.

Hodgson, R. and Rollnick, S. (1996) 'More fun, less stress: How to survive in research'. In G. Parry and F.N. Watts (eds) *Behavioural and Mental Health Research.* UK: Erlbaum Taylor and Francis.

Linesch, D. (1994) 'Interpretation in art therapy research and practice: The hermeneutic circle'. *The Arts in Psychotherapy 21,* 3, 185–195.

McNamee, S. and Gergen, K.J. (1992) *Therapy as Social Construction.* London: Sage Publications.

Parry, G. and Watts, F.N. (1996) *Behavioural and Mental Health Research: A Handbook of Skills and Methods* 2nd ed. UK: Erlbaum Taylor and Francis.

Payne, H. (ed) (1993) *Handbook of Inquiry in The Arts Therapies: One River Many Currents.* London: Jessica Kingsley Publishers.

Robson, C. (1993) *Real World Research: A Resource for Social Scientists and Practitioner-Researchers.* Oxford: Blackwell.

Rosenwalk, G.C. and Ochberg, R.L. (1992) *Storied Lives: the Cultural Politics of Self-Understanding.* Yale: Yale University Press.

Vygotsky, L. (1978) *Mind in Society.* Cambridge, MA: Harvard University Press.

Links between the Arts Therapies

Ann Cattanach

...the ignorant should all know; societies exist in colours, sounds and phrases, and there are regimes and revolutions, reigns, politics... They exist unconditionally and without metaphysics in the instrumental ensemble of symphonies, in the organic whole of novellas, and in the square feet of a complex painting, where the coloured postures of warriors, lovers or symbolic figures find enjoyment, suffer and mingle together.

(Pessoa 1991, p.255)

The Portuguese poet and writer Fernando Pessoa wrote *The Book of Disquietude* as Bernardo Soares one of the literary personae with which he created the Theatre of Himself. In this particular text he describes the interconnections between the two realities; the world of the arts, imagination and dreams, his inner world, and the world outside.

In the arts therapies we explore this interconnectedness between the arts and life and act in the space between the two. This exploration focuses on the healthy aspects of our clients and their capacity for resilience through the development of the imagination and the relationship with the therapist.

Arts processes as therapy

In reading the descriptions of process in art, drama, play, music and dance movement therapy in this book, I was struck by similarities of meaning and structure. All authors describe the uniqueness of each art form and how that impacts on the therapeutic relationship. In all the arts therapies the relationship between client and therapist is mediated through the art form.

Meldrum describes the theatre form as her process and states that theatre is both creative and structured: the actor is given permission to show anger, sadness, joy and love through roles and characters and above all to play with others in a social group motivated by the same sense of purpose. She states that theatre is a metaphor of the therapeutic process.

Sobey and Woodcock emphasize developing a relationship but considers that both music and client-therapist relationship are regarded as essential therapeutic factors.

Ward defines art therapy as the externalization of processes of change through transformation of media. Bannerman-Haig describes dance as the main tool for communication in the therapy process and it is through our bodies that we can express and get in touch with deep feelings, with conscious and unconscious processes and emotions, in order to facilitate change.

Daniel describes play in the playroom as a blank canvas ready for a child to create and communicate to bring the place alive with their imagination as a means of exploring their fears, wishes and desires.

Mitchell states that once the animateur has a means to devise their own rituals, they know what to do and to what depth. The skill of the dramatherapist is to bring the individual or the group member to the point of departure.

All the authors emphasize the need for the therapist to be skilled in the art form both as a practitioner and as a therapist. A shared joy in the art form is a healing force in every intervention. It is this absorption in the medium, which can lead to transformation, which helps the client to change or develop.

Aesthetic distance

In all the processes the meeting between therapist and individual or group is mediated through the art form. Working through the art form creates a distance from everyday reality and it is this fluidity which makes exploration of self through the art form safe.

Langer (1953) described aesthetic illusion in the arts as an otherness from reality, a detachment from actuality. She stated that all forms of art are abstracted forms in the context of illusion.

This means that we can examine this illusional world free from the constraints of real circumstances. There are no chance accidents to obscure the logic of the illusional world so we can develop new meanings for ourselves uncluttered by the constraints of our own reality.

The relationship is established in the interplay between the client, therapist and the art. For example Bannerman-Haig describes how Frank developed from a person fearful of the space and relationship with the therapist to a person who can identify with the fact that he is dancing on his own with the therapist each week. As he himself stated 'dancing with Sara right now'. This is a process of exploring ourselves through the creative experience. We make the relationship through the medium so Frank could make his connection to Sara by his developing skill in the dance. Frank's verbal expression was limited but through his skill in dance, he was able to express himself and work with the many difficult issues, which arose. Jennings (1998) described this process in the theatre and states that:

> The paradox of this distance is that both actor and audience come closer not just to each other but to the themes and characters of the plot and subplot, images, metaphors and subtexts resonate for use as we are guided through this theatrical journey being communicated within the dramatic reality.

Meldrum echoes this when she describes the concept of aesthetic or dramatic distance. She states that the exploration of motivations, emotions and conflict through a character in a play, paradoxically gives the person a greater freedom to examine their own issues within the drama.

Sobey and Woodcock describe the decisions to be made by the therapist when choosing how to play with the client's output. They state that alongside their clinical aims there is a sense in which when they listen to the music of a session, they continue to employ their musical aesthetic sense.

Ward describes the creative struggle with the medium as a physical struggle and contact between the medium and the body the core of the process because it is through the struggle that creative solutions are found. Aesthetic distance is present for participant or audience so as we watch and hear the play, the music, the dance, explore a picture, we are moved by the experience and we take away what has meaning for us but still maintain the safety of the me/not me experience of distance. We can choose to say that I recognize me or this is not me in any experience of the arts.

Playfulness

A key concept in all arts therapies is playfulness, which is at the root of all imagining.

Huizinga (1949) considered playfulness an important feature of our cultural life. He suggested that in play there was something 'at play' which transcended the immediate needs of life and imparted meaning to the action. It was a stepping out of 'real' life into a temporary sphere of activity. Play was intense and absorbing and a safe place for the participant to create fictional worlds free from the constraints of 'ordinary' life.

Jennings (1998) described two realities; the reality of our day-to-day experience and the reality of our dramatic imagination. We enter the dramatic reality when we say 'let's pretend we are monsters'.

Mamet (1997) in *True and False* described the way we act out dramas not only in regard to personal events but also in regard to fantastical ones. We perform these dramas all day long and the audience is ourselves. These games and fantasies are highly dramatic and idiosyncratic.

Play is the central medium or art form for the play therapist but playfulness is present in all the arts therapies.

Jamie told me he liked the rules and structure of play with me and he loved the freedom to play and make up stories about 'good' and 'bad' things. Sobey and Woodcock describe the initial act of providing a simple accompaniment to a client's steady walking pace. A clear invitation to playfulness but they describe the great difficulties of getting it just right and to the client's satisfaction. There are many levels of meaning in any simple playful exchange.

Ward describes so well those moments of playfulness as she starts to use clay. 'Now, in this moment, I am shaping ears, animal ears, cow-like … now tiger-like. The clay is soft and willing. I am sculpting a jaw and eye-sockets and a strange concave brow. What is this creature? What is its pedigree or story or meaning?'

Bannerman-Haig describes Frank's desire to use movements that appeared to belong to an earlier developmental stage. She describes how he got down on his hands and knees and began a crawl/slide movement. She joined him in this new movement and they propelled themselves forward together across the floor side by side. She states that from Frank's movement behaviour it was clear to see that Frank was playing and experimenting through manipulation of his body.

This playfulness of mind through any art form is an important step to develop imagination, and imagination is that reality which is the flesh and bones of the arts therapies.

Vandenburg (1986) described humans as myth making and believing beings for whom reality is a trusted fantasy.

Mitchell develops these ideas in his theatre of self-expression and his exploration of ritual in the dramatherapy process. He states that the animateur first needs a process where they can feel safe with the group and therapist as well as with the dramatic tools the group uses. This will involve learning theatre skills, identifying their parallel dramatic story, and the client demonstrating to the group, through the ritual enactment of their chosen scene how wounded their lives are and the wish to have this acknowledged by the group and dramatherapist.

Vandenburg also stated that to be human and to live in a meaningful way within a culture requires that we live in and through a very sophisticated, abstract system that is largely imaginary. To be incapable of fantasy is to be barred from human culture.

Fonagy *et al.* (1992/1994) in his paper on 'The Theory and Practice of Resilience' described reflective-self function and the understanding of the nature of mental states as being closely linked to the capacity for pretence. He stated that the capacity to suspend the demands of immediate physical reality and contemplate alternative perceptions yet retaining the distinction between what is fantasized and what is real must offer a tremendous advantage to the individual in dealing with life's adversities.

Metaphor in the arts therapies

All the therapists writing in this book describe the process of therapy as a kind of metaphoric journey.

In *The Metaphoric Process* (1995) Fiumara defined metaphoricity as a basic mode of functioning whereby we project patterns from one domain of experience in order to structure another domain of a different kind. It is through our metaphoric capacity that we develop a sense of coherence amongst our innumerable experiences. We employ creativity to extend inchoate structures because it is through this transference of models that we shape a more comprehensible world so we can reflect on the concepts we use.

Winner (1998) stated that whenever a child renames an object without previously transforming it through a fictional action, the metaphor remains based on some degree of physical resemblance such as calling the letter J 'walking stick'. Symbolic play is thus the condition for the embryonic metaphors rooted in a functional similarity created by means of fiction. The

metaphors used to describe the therapeutic journeys of this book are many and varied.

Mitchell describes his process as a ritual theatre form, and through this ritual the animateur, having defined his or her issues, comes to a place where they can address the process of initiation. This is a rite of passage between the private domain of the dramatherapy studio and the public domain of their everyday lives.

Sobey and Woodcock describe a process of mothering where the improvised music is used as a communication and the relationship is described as a fluidity of 'attuning'.

There are similar descriptions from Bannerman-Haig using mirroring with a client as a way of reflecting back. This is similar to the way in which a mother reflects back facial expressions or actions to her baby.

Ward uses the relationship to the medium as a metaphor for the relationship between humans. She says that the medium has its own qualities; it responds and reacts and has to be grappled with, in the same way as a human relationship does if it is to progress.

Daniel describes the playroom as a blank canvas ready for a child and the room becomes a world for the child to explore and both Daniel and myself explore the metaphors used in play and storytelling as ways for children to make sense of aspects of their lives.

Meldrum uses the theatre process as a metaphor for the therapeutic journey and explores the work and theories of theatre directors and animateurs to frame the therapeutic process and help the group find insights into emotional difficulties, face fears and work with potentially destructive patterns of behaviour.

Conclusions

Arts therapists have a unique approach to the process of therapy and their ways of working offer clients a creative perspective in which to explore the parameters of change.

There is safety in these explorations by the rules and boundaries which are present in the structure of each of the arts and this enables the client in therapy to project their difficulties and insights through the medium. These imaginative explorations are always journeys, perhaps never-ending stories as we live our lives.

References

Fiumara, G. (1995) *The Metaphoric Process.* London: Routledge.

Fonagay, P. Steele, M. Steele, H. Higgitt, A. Target, M. (1994) The Emmanuel Miller Memorial Lecture 1992. 'The theory and practice of resilience'. *Journal of Child Psychology and Psychiatry 35,* 231–257.

Huizinga, J. (1949) *Homo Ludens.* London: Paladin Books (1970).

Jennings, S. (1998) *Introduction to Dramatherapy.* London: Jessica Kingsley Publishers.

Langer, S. (1953) *Feeling and Form.* London: Routledge & Kegan Paul.

Mamet, D. (1997) *True and False.* London: Faber and Faber.

Pessoa, F. (1991) *The Book of Disquietude.* Trans. R. Zenith, Manchester: Carcanet.

Vandenburg, B. (1986) 'Play, myth and hope'. In R. van der Kooij and J. Hellendoor (eds) *Play, Play Therapy, Play Research.* Lisse: Swets and Zeitlinger. BV.

Winner, E. (1988) 'Early metaphors in spontaneous speech'. In *The Point of Words: Children's Understanding of Metaphor and Irony* Cambridge: Cambridge University Press.

The Arts Therapy Profession
Come to the Edge

Michael Barham

This chapter details recent developments in the arts therapy profession in Britain focusing on the journey to become 'state registered' with the Council for Professions Supplementary to Medicine (CPSM) under the 1960 Act. As with other journeys this involves a constant looking forward, as well as looking back, in order to be clear about where the profession is now. From this study I would like to suggest possible ways forward both for the professional associations and for the training organizations. I shall begin by documenting recent developments, then discuss the composition and structure of the federal Board for the Arts Therapies at the CPSM, illustrate the benefits of state registration and finally explore the implications this has both for the profession, our clients and the public.

I have detailed elsewhere (Barham 1994) the historical developments, composition and structure of the then proposed Federal Board for Art, Drama and Music Therapists and listed in full the benefits of State Registration. Briefly, the art, music and dramatherapists submitted their application in 1990/91. The dance movement therapists decided that they were not yet ready to make their submission (and by the time of writing this chapter have still not applied). Put succinctly, the duties of this Federal Board for Art, Drama and Music Therapists are:

- identification and registration of the professionally competent;
- recommendation of approval, for purposes of registration, of qualifications, examinations and training courses. These are all made independently of schools/institutions;

- publishing statements of 'infamous conduct' and enforcing professional discipline sanctioned ultimately by striking-off the register.

Just prior to the submission to the Privy Council, on 6 September 1993, representatives from the three arts therapies met with officers of the CPSM, to discuss how a Federal Board might be constituted in order to present firm proposals to the Department of Health and thence the Privy Council. After much discussion it was agreed that the minimum workable basis for a Board would be nine elected members, that is three for each Arts Therapy. This, it was felt, would minimize the difficulties of too heavy a workload falling on any one member, of it being difficult to find competent members in disciplinary cases, or of the inadvertent 'disenfranchising' of one of the arts therapies in the event of a member of that profession being Chairperson and another member sick. Even though there is a considerable discrepancy in the size of the membership of each of the three professions (at that time there were approximately 700 qualified art therapists, 300 music therapists and 200 dramatherapists) it was felt important that each profession had equal representation on the proposed Board.

A great deal of discussion concerned the balance of members in the UK constituents and ensuring fair representation on the Board, bearing in mind that any scheme of a comprehensive nature that would represent all three arts therapies across all four UK constituents would be impossibly large and cumbersome. Eventually the meeting accepted that it would not be appropriate to seek specific Scottish or Welsh representation for each arts therapy, when this could be met at Board level in the election scheme. Similarly, a single representative could be co-opted as the Northern Irish non-voting member.

On 22 May 1998, the Board held its first meeting. As stated earlier, it had been agreed that the minimum workable basis for the Federal Board would be nine elected members (that is three members elected from each arts therapy). Whatever profession any Board at the CPSM represents, that profession has to be in the majority on the Board, so this meant that there would be vacancies for eight appointed, non arts therapies, members. It has not proved easy finding representatives from other credible organizations, however, the following are now represented:

- the Royal College of Psychiatrists
- a leading educationalist
- the NHS Confederation
- the Royal College of Physicians
- the Association of Directors of Social Services Departments and the Local Government Management Board
- a cognate profession
- a consumer representative (Alzheimer's Disease Society).

This was to be the first time that a consumer representative could make a valuable contribution to the deliberations of a Board at the CPSM. The Scottish Medical Colleges are in the process of making their appointment as this chapter goes to press.

Elected members would be eligible to sit on the Board for four years. It was agreed to defer consideration of observers until early in the Board's business, but with a presumption in favour of considering them from a relevant existing Board within the CPSM, the Occupational Therapists, and from the Association for Dance Movement Therapy. (See Figure 10.1 for a pictorial representation of the Board's structure.)

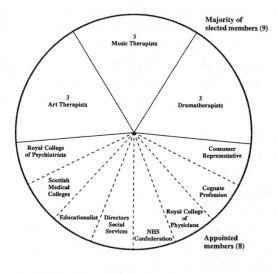

+ One non-voting member from Northern Ireland
+ Observers at the discretion of the Board, e.g. Member of the Association for Dance
 Movement Therapy U.K.
a Member from an existing CPSM Board such as Occupational Therapists

Figure 10.1 Indicative structure of the Arts Therapists Federal Board

All of the arts therapists agreed that a strong subordinate body structure would be the appropriate way to carry out the work of the Board, focused on a Joint Validation Committee for the Arts Therapies. (There was considerable discussion about the nature and volume of work such bodies would need to transact.) It was felt that the Registration Committee might also be a suitable vehicle for delivering advice to the Board on EU matters.

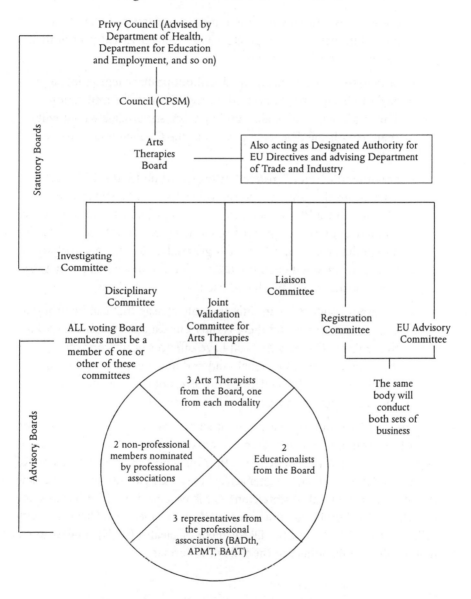

Figure 10.2 Outline structure of the Arts Therapists Federal Board

For a variety of reasons, some of which are detailed below, the Professions Supplementary to Medicine Act (1960) is in the process of being replaced. The wheels of government grind very slowly, but this change does seem to be inevitable and sorely needed. These reasons include:

- the 1960 Act fails to provide an adequate, effective level of public protection;

- the Act was written when the registrant professions were small, limited in their scope of practice and received virtually all of their patients by medical referral;

- little in the Act can be changed without primary legislation, a great deal of business has to go to the Privy Council for ratification. This is a slow, cumbersome and unnecessary process which will change with the delegated powers to the Council under the new Act;

- only the title 'state registered' is protected under the 1960 Act. This means that anyone can call themselves an Occupational Therapist, or a Physiotherapist, for example, and set up in practice. Similarly, any state registered practitioner struck off the register for misconduct can drop the 'state registered' and carry on working. Under the new Act common titles will be protected and only those state registered will be able to use them;

- infamous conduct is currently the only charge that can be brought against registrants, and there is only one sanction – removal from the register. The new Act will have offences of misconduct/ misconduct of a professional kind and incompetence including for health reasons. This will allow for levels of offence and, hence, levels of sanction in a single coherent structure.

In 1996, J M Consulting were commissioned by the NHS Executive, on behalf of the UK Health Departments, to review the Professions Supplementary to Medicine Act (1960). This report produced a number of recommendations which I summarize below. Obviously when the new Regulation of the Health Professions Act is produced it will differ in some ways from J M Consulting's initial report, however, meetings I have had with officials at the CPSM and the Department of Health (DoH) suggest to me that it will broadly adhere to the following format.

There will be a new, enlarged Council for Health Professions (CHP). So, no longer will we be 'supplementary' to anyone. An important point for which many of us have been lobbying for a long time. This new Council will monitor standards of education, training and conduct for health professions.

The principles that govern membership of this Council will be:

- at least one third of the members will not be registered professionals
- each professional group is to be represented equally
- professional representatives are to be elected by registrants
- other interests to be represented include: medicine, other health professions, consumer, educationalist, employer, (private, social services and NHS), lay
- some nominations and appointments will be made by the Secretaries of State or Privy Council, who would also ensure appropriate country representation.

Here, one can see that consumer and lay representation is clearly included and the current high level of medical representation is diminished. Below Council level, there will be four statutory committees to carry out all of the main statutory functions:

- Preliminary Proceedings Committee
- Professional Conduct Committee
- Health Committee
- Education Committee.

These replace the current Investigating and Disciplinary sub-committees, as well as the Validation sub-committee.

One can also see that the numerous Boards that constitute the current CPSM, with all of the duplication of both work and processes, have gone. J M Consulting commented on CPSM's internal constitutional weakness (1996, p.5):

'The CPSM's professional Boards are powerful, autonomous and dominated by the profession being regulated. This can lead to unnecessary differences of approach between professions ... there is a risk of the Boards pursuing sectional interests'.

The Boards will be replaced by non-statutory Professional Advisory Committees. These 'panels' of professional advisers will provide:

- members of working parties
- members of committees
- members of course validation panels
- members of Education Committee's working committees
- a source of consultation on specific issues affecting one or more professions
- technical groups to advise on issues as they affect a particular profession.

The benefits of state registration

In discussing the benefits of state registration, I am referring to the current situation with the CPSM, not to possible future developments under a Council for Health Professions, although the benefits will be similar.

Arts therapists currently work in a wide variety of environments. Since the establishment of the Department of Health's current regulatory scheme, the National Health Service reforms have been instituted and 'Care in the Community' has been developed. Whereas arts therapists might once have been perceived as mainly hospital based, they now also practise, *inter alia*, in:

- prisons (and other Home Office institutions)
- private hospitals
- charitable institutions
- NHS Trusts
- GP fund-holders' practices
- Community Trusts (and their equivalents)
- Family Health Service Authorities (elsewhere in the UK)
- partnerships with other medical and health care professionals
- private practice
- consortia of other arts therapists (as charities) (e.g., the Mosaic Trust in Ealing, Roundabout in Croydon)
- local authorities – social services, education.

(NHS Trusts, Community Trusts, social services and now prisons, insist on state registration as a statutory requirement where it is available.)

The state registration of arts therapists defines a universal standard, public and published and governed by a body independent of Government or employers. All of the sectors previously mentioned will benefit from this, as will the public, the users of our services.

The title 'State Registered Arts Therapist' will be protected in such a way as to indicate to the public that its holder has achieved certain educational and clinical standards and will abide by a disciplinary and ethical code for the profession. Any person claiming to be a 'State Registered Arts Therapist' when he or she is not will be open to prosecution. Similarly, any 'State Registered Arts Therapist' who, for example, abuses the trust of clients will face disciplinary proceedings with the possibility of being 'struck off' the register.

Arts therapists often deal with clients who are in no position to exercise informed judgements in a free market, clients such as children or long-term residents of a psychiatric hospital. At one remove, the parents or guardians of clients who might benefit from an arts therapies input may themselves be stressed and vulnerable. They, too, can benefit from the help and support offered by a statutory regulatory system to relieve them of the concern that inappropriately trained or wrongly motivated people may be purporting to offer treatment.

In our history there do not appear to be any significant problems concerning our relations with other (registered) professions or with health funding agencies because of our lack of state registration. However, this might not always have been the case if we had stayed outside the CPSM. It is foreseeable that medical insurance companies could take a less generous view of the profession if we were to remain unregulated. It is also possible that financially constrained NHS Trust authorities might seek to distance themselves from a profession with whom they enjoy no formal statutory links. State Registration will provide a proper formal framework to allow an art, music or dramatherapist in, for example, a small charity to interact with a psychiatrist, physiotherapist or occupational therapist in an NHS hospital and for cross–referrals to take place with proper authority.

The British Medical Association (BMA) and the General Medical Council (GMC) have both endorsed state registration for arts therapists. One of the specific benefits here will be that arts therapists can play a full role in a GP's practice or be full partners in a GP fund-holding practice.

I can really do no better to highlight the advantages of State Registration, than to quote from notes which were included in the Annual Report of the Council for Professions Supplementary to Medicine for 1988 (p.4):

- by separate enactment under NHS legal powers, state registration provides access to employment in the NHS and in local authority Social Services departments. I stress that the enactment is separate from the legislation which established the Council. State registration applies to all aspects of practice including the private sector and there are NAHA guidelines to registering authorities which stress the importance of the employment of properly qualified staff in private institutions and draw attention to state registration as a proper standard of qualification;

- state registration also provides a public declaration of the quality of a registrant's own education and clinical training and suitability as a practitioner;

- it provides quality control of that education and training;

- it provides for public confidence in a registrant as a practitioner and some distinction for a profession from the activities of those not covered by state registration; although it does not imply any adverse judgement on the standards of those not seeking state registration;

- it provides a forum for representing interests either in parallel with a professional institution or where the interests of several professions coincide.

Certainly for the general public, registration guarantees competence *at the time of registration.*

To summarize, state registration provides:

- a standard of competence in theoretical training at the time of registration;

- a statutory standard of professionalism and of high ethical performance (rather than merely professional status);

- a standard of what is true therapeutic activity which can be applied in other statutes;

- a standard which can be used by employers for employment in certain capacities.

One final obvious benefit is that we will have a much more powerful voice as part of the CPSM. All of the Arts Therapies professional associations currently have the largest membership in their history, which is very encouraging. However, we have to be realistic and accept that we are very, very small as far as professional associations are concerned. There are currently over 100,000 people across all the professions registered with the CPSM. This gives a power to all of the professions and their members that none of them would have as individual, isolated professions.

Our entry to the CPSM raises many questions for me. I am not saying that I have or can even suggest answers to all of them, but I feel it is important that they are asked, that they take on a life outside of me, so that we can debate them and ensure that the high standards of training and practice continue. The main areas that contain these questions are:

- the training to become an arts therapist
- continuing professional development
- the professional associations.

I shall now look at each area in turn.

Training to become an arts therapist

Access to training has been set at post-graduate level. The minimum entry criteria for the courses is set at an appropriate first degree or professional qualification and usually three years post-qualification work experience. Trainees need to have experience of the art form as well as experience of working in a medical, caring or health environment.

The training courses vary in length from one year full-time, two years part-time to two years full-time, to a minimum of three years part-time modular study. Approval to run these training courses is given by the Executive Committee of each of the professional associations on the recommendation of their Training and Education Sub-Committees. Only those courses which have Association approval can lead to full membership of the professional association. With dramatherapy and music therapy, for example, there are post-qualifying requirements concerning supervision that have to be fulfilled if one wishes to retain ones full membership. This only applies in art therapy if one wishes to set up in private practice.

State registration is applied for on successful completion of one's approved training programme. There are at present no post-qualifying

requirements. In fact, the award has to be concomitant with the completion of a qualification. Interestingly, this could result in some people being state registered without having fulfilled the professional association's requirements, and so not belonging to that professional association.

However, the existence of a profession, or the membership of a professional association, does not necessarily mean, or even in any way guarantee, that members of the public will receive a good service. Further, there is at times, I feel, a reluctance by some arts therapists to continue training and research and hence understand more about how and why the arts therapies work. The need for research to be undertaken and published is, I feel, a vital one at this stage in our development. We have established the professions and now need to move into a more self-critical period. However, in a chapter of this length I can only highlight this subject. Perhaps there are issues here about the length of training to become an arts therapist allied to the anomaly of the level of the pay scales, where pay scales exist, of course. Certainly there is considerable debate about the length of the training courses to become an arts therapist. In 1992 the British Association of Art Therapists (BAAT) voted to effectively double the length of their training courses. This has generated a lot of debate within the British Association of Dramatherapists (BADth). Recently (1998) the Training Sub-Committee of the BADth has produced a new set of training guidelines advocating the raising of the minimum time for training to two years.

In the light of this information, and if we examine the financial return expected on the investment a student makes in their training, can we justify lengthening the courses? With our joining of the CPSM, for the first time we have professionals who are not art, music or dramatherapists involved in the accreditation of our training programmes (see Figure 10.2, for the membership of the Validation sub-committee). What kind of questions are they going to ask? Will they want to know why it seems to take longer to produce an art therapist, say, than a music therapist? This is going to be an interesting period.

Interestingly, too, this is all happening at a time when the government is trying to standardize the teaching in higher education. These post-graduate diplomas are an enormous amount of work, for what, at the end of the day, is only a diploma. Initially we were advised by the Department of Health and Social Security to set entry to the profession at this level, but I wonder if the time has come to standardize with other psychotherapeutic professions and revalidate the qualifications at Masters level?

Let us explore this further: the supreme advantage of occupational closure based upon credentials is that all those in possession of a given qualification are deemed competent to provide the relevant skills services for the rest of their professional lives. There is no question of retesting abilities at a later stage in the professional career. Members of the lay public are deemed not competent to sit in judgement on professional standards which means that the qualification is a meal ticket for life. As we are arts therapists, let us look to the arts world for a comparison. Here the skills and abilities of the actor, dancer, painter or musician are kept under continuous open review by the public; those who consume the services are themselves the ultimate judges of an individuals competence and hence their market value. There can be no resort to the umbrella protection of a professional licence when the ability to entertain is felt to be in decline in the eyes of the public who pass collective judgement. This leads us effectively into the next area.

Continuing Professional Development (CPD)

So, it could be argued that credentialism is a doubly effective device for protecting the learned professions from the hazards of the marketplace. For not merely does it serve the convenient purpose of monitoring and restricting the supply of labour, but also effectively disguises all but the most extreme variations in the ability of professional members, thereby protecting the least competent from financial ruin.

There is a growing perception that current registration systems based on 'acquired rights' owned by current or putative members of the professions is inconsistent with the current situation of a rapid expansion of the knowledge base of the professions, an equally rapid expansion of the scope of the professions into new practising environments (e.g. private residences), and the growth of awareness in equal opportunities and 'consumer rights'. Certainly it could be argued that the consensus position of consumer interests is that the current lack of any link between registration and Continued Competence (CC) is against the public interest and needs reviewing. Interestingly, this is another reason for the review of the 1960 Act. Under the original CPSM Act a registrant can come on to the Register, lapse, not practice for ten or twenty years, apply for restatement as of right, or take no steps to maintain competence. The new Act will require registrants to demonstrate CPD as a requirement for continued or re-registration to help create safer practitioners.

It could be said that the logical extension of this argument is to denounce professional closure structures as a restriction of trade, as nothing more than elitist protectionism by the professions. At least this certainly seems to have been the thinking behind a speech given by the Competition Directorate in the European Community (EC) in November 1992, stating that health professions be deregulated to further the EC's competition policy. This stimulated a great deal of concern, not least amongst many health professions and professions allied to medicine, resulting in questions being put to Sir Leon Brittan, Vice President of the Commission and EC Commissioner for competition affairs, who replied:

> When you are talking about professions you are talking about occupations which I believe are skilled, and where the degree of skill could not possibly be known by the consumer or customer, and the possibility of lack of skill can be lethal, and therefore I think it is quite unrealistic and undesirable to talk about deregulation.

Let us return to the specific case of the arts therapies as a profession in Britain. Is it not anomalous that at a time when there is a growing awareness of the rights of the consumer, when we are constantly being informed that all practices have to be customer led and there is increasing concern for public protection, the only kitemark of competence for the protection of the public available from the professional associations is that provided *at the time of registration*? There is no provision for the linking of continuing professional competence with the maintenance of registration. Currently the successful completion of a post-graduate diploma entitles the art, drama or music therapist to become a full member of the Association and to be entered on the register. Even if that member stops practising for a number of years, there is, at present, no mechanism for checking their continued competence to practice.

Other professions in the meantime have moved towards linking registration to Continued Competence (CC) and from there to Continued Professional Development (CPD). These include nurses, solicitors and doctors.

It could be argued that arts therapists have supervision to enable them to focus on their professional development. This, they believe, places them firmly amongst the psychotherapeutic practices. In dramatherapy, for example, 1991 saw the formal adoption of this positive policy on supervision and in 1993 the Association established a national network of supervisors and published a register in order to maintain the highest possible

standards. What do they mean by supervision? It is a formal arrangement for dramatherapists to discuss and explore their work regularly with someone who is experienced in dramatherapy. Ideally the supervisor will be an experienced practising dramatherapist. In fact I would argue that the less experienced the dramatherapist, the more experience the supervisor should have. The supervisor should be sufficiently experienced and qualified in dramatherapy, or in a closely related field, for members to have confidence in their professional skills. Why is supervision so necessary and how could it be said to be a form of CPD? I should like to quote from the *Register of Supervisors* (BADth 1994, p.6):

> Dramatherapy, like all other therapies, makes considerable demands upon the therapist who may become over-involved, overlook some important point, or have undermining doubts about their own usefulness. It is difficult, if not impossible, at times to be objective about one's work and the opportunity to explore it regularly, in confidence, with an appropriate person is an invaluable and essential component of good practice.
>
> Through the supervision process the supervisor can ensure that the dramatherapist is addressing the needs of the client. Though not concerned primarily with training, personal therapy, or line management, supervisors will encourage and facilitate the continuing self-development, learning and self-monitoring of the Dramatherapist.

However, it must be pointed out that in 1991, when the notion of supervision was embraced by the Association, it was only introduced as compulsory for newly qualified dramatherapists wishing to remain as Full Members. The motion stated: 'Supervision is necessary for effective Dramatherapy practice. All newly-qualified Dramatherapists are required by the British Association for Dramatherapists to undertake forty sessions of supervision within the first three years of practice and supervision is recommended for all dramatherapists throughout their working life'.

Similarly in music therapy, The Association of Professional Music Therapists (APMT) insist that for a music therapist to gain entrance to the profession's register, they must complete a certain number of post-qualifying supervision sessions within a certain time scale. I appreciate that all associations have to start somewhere, but if music therapists and dramatherapists are saying that supervision is so important, and I feel that they are, then surely it is time that it became mandatory throughout one's working life rather than a recommendation. This would give a much clearer

message to the arts therapies' own membership, to their clients and, by extension, to the public.

It is worth noting that midwives have had a statutory CPD scheme since the 1930s and the United Kingdom Central Council for Nursing, Midwifery and Health Visiting (UKCC) has instituted a new procedure as from 1994. This is a scheme for 'effective registration' which requires that each registrant, 'should undertake a minimum of five days (or equivalent) study for professional development every three years…' in order to remain registered. More recently still the Royal College of Surgeons of London has exhorted all its members to undertake a coherent scheme of updating its expertise combined with strictures against practising techniques with which they are unfamiliar.

We can all learn from this. Obviously arts therapists will first have to embrace the idea of renewable registration and then following long discussion and research with all interested parties, including the CPSM and the various training organizations, produce a workable system that lays down minimum requirements. This could follow the UKCC's example of five days' (or equivalent) study every three years or be different. This is to be decided. These days could be taken as whole days on one course, or part-time on a number of training events, whatever is most effective in meeting individual need. However, I would suggest that the study activity must be relevant to the professional registration and role of the individual. Some people may think that this is a punitive way of thinking, but I don't view it that way at all. I think it is really exciting to accept that the current training is in a sense an introduction to that particular arts therapy as a way of working. It is a 'good enough' introduction, but the embracing of renewable registration will enable arts therapists to continue training throughout their working lives. (They can specialize in certain areas, undertake intensives in working with masks, group-painting, clinical improvisation, stories, puppets, or one-to-one work: areas that might have been just touched upon in their post-graduate diplomas.) Bearing in mind that as the arts therapies are still an emerging profession, the 'Body of Knowledge' is growing rapidly and this will enable arts therapists to inform their practice with the latest developments. In this way the Association allied with the CPSM will be able to ensure that there is an effective match between qualifications, area of practice and role, in order to safeguard and improve standards.

The professional associations

Throughout this chapter I keep referring to the arts therapies. This is the new generic name by which we are increasingly going to be known. The Department of Health (DoH), for example, has recently produced a glossy A4 sized booklet on 'Careers in the NHS for Graduates in the Arts Therapies', as part of their 'Health Service Careers' portfolio. This adoption of the generic term, rather than the individual professional term, art, drama or music therapist, is a new development in the UK, which, it could be argued, started with the application of the art, drama and music therapists to create a federal Board for the arts therapies at the CPSM. If one looks at the classic texts of Lockwood (1958), Weber (1948, 1968), Berg (1973), Dore (1976) and Millerson (1964), one can see clearly documented how a profession develops (Barham 1995). If nothing else, the one thing that I would like to argue is that the professions of art, drama and music therapy are now established. The period of clarifying our boundaries and setting very clear gateposts is maybe drawing to an end and we now need to have the courage to step into space, a new space, a new way of being in the world, as 'arts therapists'. With the establishment of the Board for the arts therapies, the DoH and other governmental agencies now think of us as arts therapists, so it seems to make sense to move towards having one professional association, an association of arts therapists. This can only improve communication between the different modalities, stop the unnecessary duplication of work, and present a very clear 'picture' to employers, clients and the public.

I recently attended the conference and AGM for the British Association of Dramatherapists. On at least two different occasions members of the Executive Committee exhorted the membership to volunteer more of their time to the association. I suggest that we cannot continue to offer a professional service either to the public or to our members like this. There is too much work to do. Life is changing too fast. This is 1998, not 1968, those days are over and we need to accept this and move on. It is interesting to note, too, that no one came forward from the membership to act as Chairperson. No one has a large amount of spare time anymore to give to the professional associations. What we need, I suggest, is one professional association, an Association of British Arts Therapists, with paid workers to perform the work of the association, ratified by committees of elected arts therapists, so that the work load is more manageable. There can, of course, be

sub-organizations within the main association, to which the art therapist, dramatherapist, music therapist and dance movement therapist can belong.

Earlier in this chapter I highlighted the importance of belonging to the CPSM, one reason being the power one has available as part of a large organized group. The same is true for the professional associations: we will be a more effective group as one large group, rather than four separate smaller groups. I can appreciate that not everyone will agree with my interpretation. This is a time of rapid change. We are standing on the threshold of many major changes and we don't know how they will work out. All I can suggest is that we walk forward boldly, together.

In the words of the French poet, Guillame Appollinaire:

Come to the edge, he said
No, we will fall
Come to the edge, he said
No, we will fall
We came to the edge, he pushed
...and we flew

References

BADth (1994) *Register of Supervisors.* Swanage: BADth.

Barham, M.W. (1994) 'Towards state registration'. *Dramatherapy Journal 15,* 3, 22–26.

Barham, M.W. (1995) 'Dramatherapy: The journey to becoming a profession'. *Dramatherapy Journal 17,* 1 and 2, 33–39.

Berg, I. (1973) *Education and Jobs: The Great Training Robbery.* Harmondsworth: Penguin Books.

Brittan, L. (13/11/1992) *Speech to the Kangaroo Group.* Press release (14/12/1992). London: CPSM.

CPSM (1988) *Annual Report 1987–1988.* London: CPSM.

Décaudin, M. and Adéma, M. (eds) Appollinaire, G. (1956) *Œuvres Poétiques.* Paris: Pléiade (own translation)

Dore, R. (1976) *The Diploma Disease.* London: Allen and Unwin.

Gerth, H.H. and Mills, C.W. (eds) (1948) *Max Weber.* London: Routledge.

Health, Department of. (1997) *Arts Therapists: Careers in the NHS for Graduates in Arts Therapies.* London: Health Service Careers.

J.M. Consulting (1996) *The Regulation of Health Professions.* Bristol: J M Consulting Ltd.

Lockwood, D. (1958) *The Blackcoated Worker.* London: Allen and Unwin.

Millerson, G.L. (1964) *The Qualifying Association.* London: Routledge and Kegan Paul.

UKCC (March 1994) *The Future of Professional Practice: Position Statement on Policy and Implementation.* (p.3) London: UKCC.

Weber, M. (1968, and in Gerth and Mills, 1948) *Economy and Society.* New York: Bedminster Press.

Contributors

Sara Bannerman-Haig, MA, SRDMT, is a senior registered dance movement therapist. Initially trained in dance and later in dance movement therapy and psychology, she has worked extensively with dance in education, community dance and as a dance movement therapist. A great deal of her experience has been in the area of learning disability. Currently her therapy work is predominantly with children and adolescents in educational settings. She also lectures on the post-graduate training course in dance movement therapy at Hertfordshire University and is Secretary of the Association of Dance Movement Therapy UK.

Michael Barham has over sixteen years' experience in the field of personal growth and development and twenty-three years' experience in drama and theatre, having worked with emotional and physical expression with children, adolescents and adults in therapeutic, educational and artistic contexts. He is a freelance dramatherapist, trainer and supervisor with a private practice in Bristol. From 1991–95 he was the Chairperson of the British Association for Dramatherapists and in 1997 was invited to become the Vice Chairperson of the first Federal Board for Arts Therapies with the Council for Professions Supplementary to Medicine. He is the Co-ordinator for the Division of the Arts and Play Therapies as well as the Convener for the MA in Dramatherapy at Roehampton Institute, London.

Chris Daniel is qualified both as a dramatherapist and play therapist and has recently achieved an MA in Play Therapy. She is a registered practitioner and supervisor in both professions and currently works for Chester and Halton community NHS Trust. She has regularly lectured at the Roehampton Institute and was course convenor for the Play Therapy certificate. The Play Therapy Post-Graduate Diploma course at Liverpool Hope University College was developed by Chris where she is now a senior lecturer.

Brenda Meldrum, B.Sc., M.Phil, LLAM (hons), ALAM (hons) has worked with Dr Ann Cattanach on the Play Therapy courses at Roehampton Institute from the beginning and is now a Consultant on the MA programme. Trained as a psychologist, dramatherapist and play therapist, Brenda is currently Head of Training and Research in *The Place to Be,* a charity offering emotional support to children in primary schools.

Steve Mitchell has been a full-time Dramatherapist for the Morcambe Bay Community NHS Health Trust for twelve years, and Course Director of the dramatherapy programmes at The Institute of Dramatherapy at Roehampton London. For the past thirty years he has explored the interface between theatre, therapy and personal development, first as a theatre director – where he had contact with Peter Brook, Grotowski's Laboratory Theatre, Anna Halprin – then after his degree at Dartington, as director of Pathfinder Studio – continuing his practical study with Gabrielle Roth and Paul Rebillot. This research gave rise to the ritual theatre form of dramatherapy 'The Theatre of Self-Expression' he describes in numerous publications which include Mitchell, S. (ed) (1996) *Dramatherapy: Clinical Studies,* Jessica Kingsley Publishers.

Kay Sobey was a professional musician working mainly in education for twenty years before training as a music therapist in 1985. She subsequently spent six years working mainly in the fields of adult learning disability and mental health before becoming one of the convenors for the Graduate Diploma/MA in Music Therapy at Roehampton Institute, London. Since then her clinical work has concentrated on individual work with young children with a wide range of physical, mental and emotional difficulties.

Cathy Ward has a background in fine art and community arts. She is a registered art therapist, with later training in family therapy. She manages a social services family centre and lectured in art therapy for many years at the City University, London. She is also a lecturer on the play therapy diploma course at Roehampton Institute, London.

John Woodcock has worked as a music therapist for fifteen years and has been involved in student training since 1990. His experience is mainly in the fields of adult learning disability and mental health, but includes therapeutic work with children and students in training as well as supervision on a private basis. He is currently a member of an Arts Therapies team within the NHS Mental Health Service, as well as joint convenor for the Graduate Diploma/MA in Music Therapy at Roehampton Institute, London.

Subject Index

Author Index

Aigen, K. 133
Alvarez, A. 151, 164, 171–2
Axline, V. 56, 57

BADth 211
Balint 144
Bannerman-Haig, S. 9, 155–80, 192, 193, 194, 196
Barham, M. 198–214, 198, 213
Bartram, P. 141
Beail, N. 134, 150
Berg, I. 214
Bick, E. 134, 135, 140
Bicknell, J. 150
Bion, W.R. 135, 146, 147, 149, 150, 160, 167
Boal, A. 37, 38, 39, 46, 47
Brecht, B. 37, 39, 51–2, 53
Brook, P. 20, 29, 36, 37, 53
Brown, S. 132
Bruner, J. 87
Bryson, B. 69
Burr, V. 79, 182, 183, 189

Campbell, J. 10, 11, 17, 18, 19, 22, 104
Casement, P. 149
Cattanach, A. 8, 56–7, 78–102, 117, 184, 191–7
Chace, M. 159
Chodorow, J. 160
Churchill, C. 8, 38, 40, 44, 53
Cieslak, R. 23, 29
Clarkson, P. 143
Conrad, J. 85–6
Copland, A. 142
Corsaro, W. 81
Cousin, G. 40
Cox, M. 137
CPSM (Council for Professions Supplementary to Medicine) 206

Daniel, C. 8, 55–77, 192, 196
Davis, M. 159
Davis, M. and Wallbridge, D. 169
De Backer, J. 147
Department of Health 213
Dore, R. 213
Duggan, D. 159
Dwivedi, C.N. 54

E-Motion 157, 158
Erfer, T. 171

Fiedler, F.E. 143

Fiumara, G. 195
Fonagay, P., Steele, M., Steele, H., Higgitt, A. and Target, M. 89, 195
Freud, S. 16, 105 (n.3), 143, 144, 160, 169

Gelso, C.J. and Carter, J.A. 143
Gergen, K.J. and Kaye, J. 186
Goffman, E. 81
Gomez, L. 144
Grimm Brothers 41
Grotowski, J. 20–1, 23, 24

Halprin, A. 20
Hardy, T. 21
Harris, M. 135
Hayward, M. 114
Higgins, R. 188, 189
Hillman, J. 10, 11, 14–17, 21, 32
Hodgson, R. and Rollnick, S. 187
Huizinga, J. 194

Ibsen, H. 22

Jacobs, H. 165
Jennings, S. 24, 57, 103, 112, 156, 193, 194
JM Consulting 202, 203
John, D. 149, 151
Jung, C. 15, 20, 129, 157

Klein, J. 147
Klein, M. 160, 163, 165
Klein, M., Heimann, P. and Money-Kyrle, R.E 105 (n.3)
Kline, S. 86
Kolankiewicz, L. 24

Landy, R. 17
Langer, S. 142, 192
Lax, W. 81
Le Vay, D. 82
Leventhall, M.B. 158, 159
Levy, F. 156, 157
Liebmann, M. and Ward, C. 104
Linesch, D. 187
Lockwood, D. 213
Lowenfeld, M. 55–6, 57, 65

McCormack, B. 149
McMahon, L. 168
McNamee, S. and Gergen, K.J. 181
Malone, M. 81
Mamet, D. 194
Mathews, N. 117
Meier, W. 169
Meldrum, B. 7, 36–54, 38, 179–89, 187, 192, 196
Melville-Thomas, R. 158, 159, 160, 171
Milgrom, J. 104

Millerson, G.L. 213
Mitchell, S. 7, 10–35, 14, 24, 27, 192, 196
Murphy, J. 114

Newsom, E. 57, 70
Norwich, B. 161

Odell-Miller, H. 151

Papousek, M. 148
Parry, G. and Watts, F.N. 179
Parsons, J. and Upton, P. 134
Pavlicevic, M. 141, 151
Payne, H. 158, 159–60, 163, 186
Pessoa, F. 191
Pick, I.B. 165
Priestley, M. 133, 151

Rebillot, P. 10, 11, 12, 19, 29, 30–1, 32–3
Reich, W. 157
Robson, C. 189
Roezen, P. 143
Rogers, C. 143
Roose-Evans 12, 14
Rosenwalk, G.C. and Ochberg, R.L. 185
Roth, G. 32
Rowan, J. 186, 187
Russell, O. 161
Rustin, M. 135

St. Denis, R. 157
Schaffer, R. 139–40
Schoop, T. and Mitchell, P. 170
Segal, J. 135, 163
Siegel, E.V. 158, 159, 160
Sinason, V. 150, 160, 161, 164, 173
Slavson, S.R. 54
Sobey, K. and Woodcock, J. 8–9, 132–54, 192, 194, 196
Stanislavski, C. 21, 36, 37, 39, 48, 49–51, 53
Stanton-Jones, K. 159
Steele, P. 136
Stern, D. 141–2, 160, 171
Stevens, A. 11, 20, 22
Stevens, F. 156
Stiles, W.B. and Shapiro, D.A. 143
Stokes, J. 150
Sullivan, H.S. 145, 157

Toledano, A. 117
Turner, V. 11, 12, 13, 21, 28–9

Vandenburg, B. 195
Van Gennep 11, 12
Vygotsky, L. 182

Wadeson, H. 104